Historic Tales
of the
HARLEM VALLEY

Historic Tales
of the
HARLEM VALLEY

LIFE AT THE END OF THE LINE

TONIA SHOUMATOFF

THE
History
PRESS

Published by The History Press
Charleston, SC
www.historypress.com

First published 2023

Manufactured in the United States

ISBN 9781467152075

Library of Congress Control Number: 2023932165

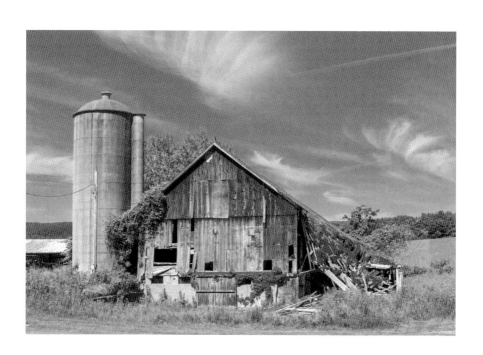

CONTENTS

PREFACE

*T*he stories in this collection mostly represent my thirty years spent documenting the changes in a small hamlet in Upstate New York's Harlem Valley. When I moved to Wassaic in the town of Amenia in 1987, there were eighteen farms in what had once been known as Milk Valley, Home of Borden's Condensed Milk. The region provided much of the fresh milk for New York City, conveyed down to the city by railroad when the train still came up to Amenia until the 1970s. The main employers for the area were two state institutions, which are now closed. And today, there is only one of those farms remaining.

I originally named this book *Life at the End of the Line*, because we are the last stop on the Metro–North Harlem Line, since the railroad was extended to Wassaic in 2000, coming up from Grand Central in New York City.

I moved into the area as a stranger with my artist husband, Joel Foster, commuting down to the city as a filmmaker. I gradually found work in the area, mostly freelance, transitioning to living upstate full time. I covered the people, places and events in this book as a broadcaster for several local radio stations, as a feature writer for *Dutchess* magazine and as a reporter for the *Millbrook Independent*. These stories serve as dramatic witness to a changing way of life, as they describe a community struggling to retain its ties to the past while trying to find a new destiny for itself in a shifting world.

One by one, the farms closed and sold their cows, and then the land was sold as well. The sense of loss was tragic. One farmer up the road on Route 22 in Copake, New York, shot all fifty-one of his cows and then himself. As

the farms and institutions that had kept families alive declined in the region, some creative new entities emerged and flourished. Gradually, the area has become more suburbanized as developers have cast their eyes on its beauty, treasured views and open space.

My only prior contact with the area had been as a student at Kent School, a prep school in Kent, Connecticut, just over the border. I visited the area's two state institutions, the Harlem Valley Psychiatric Center and the Wassaic Developmental Center, as a volunteer with the Committee of the Concerned. We were bused over from Kent every week to visit patients, providing comfort to the mentally ill and the disabled. I remember a little girl there who could only say, "Up!"

Many people from Connecticut did not even know how to get to Wassaic, a mere eight miles away. When I told my doctor in Sharon, Connecticut, that I lived there, he asked with great curiosity: "What's it like over there?" as if I were reporting from Timbuktu or some strange, exotic place.

A few weeks after we moved to Wassaic, we had to cope with an unseasonably early October snowstorm that left us without power for five days, doing untold damage to the trees that had not yet shed their leaves. Huge branches snapped from the weight of the snow. As we huddled in the cold, I rethought our decision to move to an area that seemed so bleak.

That was when I found the heart and soul of the little hamlet: the Wassaic Fire Department. The firefighters arrived at our back door, offering us a Coleman stove and Kero-Sun heater and inviting us to come by for hot cocoa at the firehouse. We were still sleeping on a futon on the floor and had only flashlights and candles for light. Our little toddler was thrilled. I wanted to turn around and go back to Katonah in Westchester.

I started producing shows for WKZE, the local radio station, then quartered in Sharon, and wrote for *Dutchess* magazine, part of the Taconic newspaper chain. I had just come back from working on a feature film in Switzerland, Greece and New York City, and I quickly found out that my media background did not impress. If anything, it was a liability. But it did enable me to expose environmental travesties that I would make public in the media over the years.

In succeeding decades, I was witness to the changes in the Harlem Valley from a community based on its agriculture and institutions to one consisting mostly of weekenders, local artists, artisans and contractors. Developers bought and sold the Harlem Valley Psychiatric Center campus several times. It now belongs to a Christian university, Olivet, composed mostly of Asian evangelical students. Half of the Wassaic State School campus was

purchased by an architect, Allan Shope, who wanted to build carbon-neutral homes there. Later, another architect, Anthony Zunino, purchased half of—and, later, the entire—property for future use by the artists residency called the Wassaic Project.

While living in Wassaic, I have met odd and eccentric people and artists and interviewed farmers, auctioneers, photographers, bicyclists—men and women of all sorts—while trying to get a handle on this strange area. My explorations have taken me into caves with waterfalls within them and preserves of sand made by limestone. I have traipsed up and down streams and into gravel pits to investigate dumping as the watershed manager for a nonprofit protection group called the Housatonic Valley Association, a position I held for thirteen years.

I was interviewed by federal investigators about the illegal dumping of toxic waste in the local landfill. A state assemblyman accompanied by bodyguards with ankle holsters held a secret meeting with me and other watchdogs. The dumping led to a multimillion-dollar cleanup after I blew the whistle about the town having initially ignored it in 1992.

The history of the region isn't all about cows, it turns out. I discovered that the poet Edna St. Vincent Millay lived in our area among many other authors and artists. When I answered an advertisement in a local paper, the *Moonlite Trader*, to "be a companion to an aging writer," the writer turned out to be Lewis Mumford, the famous social philosopher and *New Yorker* staff writer. I was able to document his last days. My story about him was purchased by the *New York Times*'s Sunday magazine and later ran in *Lapis Journal*.

Young people who were graduates of the Rhode Island School of Design and other distinguished art schools discovered the village of Wassaic and started an art residency and festival here that brought thousands of people to see unique art pieces displayed in the seven-story now-converted grain elevator that had previously provided the feed for the cows in the area.

Their Wassaic Project attracts young artists from all over the country and even the world to exhibit their work in this former agricultural setting. The architect Anthony F. Zunino renovated the agricultural building, which enabled his daughter Bowie and her two friends, Eve Biddle and Elan Bogarin, to start the project, not expecting it to take off the way it did. Jeff Barnett-Winsby, later Bowie's husband, also became a director, helping establish the residency program.

I met one of the leaders of the movement for nonviolence from the 1960s, Bill Henry, who purchased the Luther farm and told me his story. Ardent

activists who had converged at Zuccotti Park in New York City's financial
district for Occupy Wall Street started arriving at his barn in Wassaic—a
scraggly bunch indeed. They represented youth struggling to redefine
themselves in a crumbling world. Knowing Bill was supportive of their
movement, they came to Wassaic to live on the former Luther farm with the
dream of forming an alternative society and learning how to farm. They are
still attempting to do that many years later.

I have gathered this selection of stories to serve as witness to the rich
history of the past and the creativity that will define the future of this
community. Many of my stories were first published in *Dutchess* and the
Millbrook Independent. I have also included a few of my unpublished stories
documenting my personal journey, along with running commentary.

ACKNOWLEDGMENTS

I am deeply grateful to Stephen Kaye, the publisher of the original *Millbrook Independent*, without whom many of these stories would not have been written. His editing and guidance made me a better writer. To my talented copy editor and friend Veronica Towers, who assiduously checked and rechecked my stories, both when they were originally written for the paper and for this book, I express unending gratitude. Her support and patience were invaluable throughout the arduous process of preparing the manuscript for submission. I am grateful to David Reagon for sharing with me rare photographs from his files and from the Amenia Historical Society and to Lazlo Gyorsok for allowing me to use his vivid photographs of the area. I would also like to thank Elizabeth Strauss of the Amenia Historical Society and Bill Jeffway, the executive director of the Dutchess County Historical Society, for providing photographs vital to illustrating many of the historical stories in the book. And thanks also to Charlie Champalimaud of Troutbeck in Amenia, New York, for sharing early photographs of the Spingarns, longtime owners of Troutbeck. To all the living subjects of my stories—too numerous to mention—I must express my fervent thanks for their generosity and patience in allowing me to tell their stories.

Deep gratitude goes to Banks Smither for acquiring this book for The History Press and for his encouragement and assistance every step of the way. Ashley Hill skillfully handled page and proof corrections for the book. I would also like to thank my brother, Alex Shoumatoff, for his courageous

example as a writer and journalist who, through his books and articles, was able to raise awareness about threats to the environment.

Most of all, I am grateful to my husband, Joel Foster, whose quiet and steady presence allowed me to finish a project that has taken many years to complete.

1

THE END OF AN ERA

*A*menia (Amoenia), meaning "beautiful to the eye" in Latin, adorns the historic marker for the town. The views of vast open fields ringed by forests are what warrants the name. Rain-washed corn and grain catch the early morning and late afternoon light.

It is not unusual to see double rainbows over the fields, looking across the valley from Delavergne Hill. It was this celebrated view that Franklin Delano Roosevelt came over to see in his hand-operated car when he needed to get away to reflect on the problems of the world.

Huge round hay bales festoon the bare fields after they are harvested. Tractors and other farm machinery still hold up traffic. And yet the town is a mere thirty or forty miles away from New York City suburbia.

In contrast, many of the roads of Westchester and Connecticut typically have a canopy of trees that block the light from the sky. It is because of the farms that there is so much open space in Amenia. Now, there is only one dairy farm left, with new boutique farms and community-supported agriculture farms (CSAs) replacing them. When I met Ramblin' Jack Elliott, the legendary folksinger who came to perform at a restaurant called Charlotte's on the way to Millbrook, he said, "You know, I have rambled all over this country, and I have never seen such beautiful country as this."

And yes, the local landscape has a lot of magic in it. There is Stone Church, a waterfall inside a cave, where Native people hid when they were chased out of Connecticut by British colonists after King Philip's War. When I was the watershed manager for the area, I used to call it the "jewel in

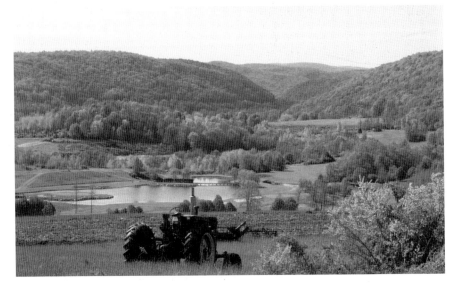

The iconic view from Delavergne Hill, with tractor. *Dave Reagon.*

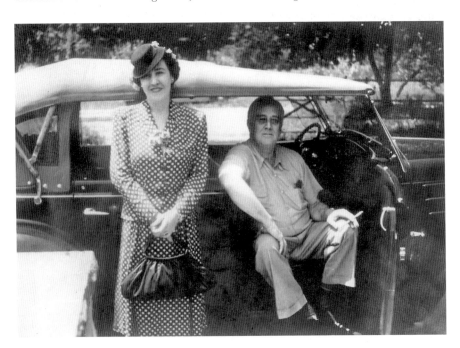

Franklin D. Roosevelt takes the author's grandmother, portrait painter Elizabeth Shoumatoff, for a spin in his hand-driven car in Hyde Park, Dutchess County, New York. Her unfinished portrait of FDR hangs in the Little White House in Warm Springs, Georgia. *Nicholas Robbins.*

The silhouette of a great blue heron. *Peter Greenough.*

the crown" of our watershed. The Ten Mile River sparkles with ripples of light as belted kingfishers hover and plunge into the waters with staccato screeches, and shy blue herons stand stock-still on their delicate-looking long legs, waiting for native brook trout and froglets to swim by. The area is a delicate balance of streams, forests, fields and stone. Stone walls in the forest testify to the fact that sheep and dairy farms were formerly widespread throughout the area.

The boundary between New York and Connecticut in Amenia Union has shifted over the years, starting in the colonial American period. The Native peoples used to call the Oblong Valley of South Amenia the "valley where the angels dance," according to a Schaghticoke elder, Trudy Lamb Richmond, a direct descendant of Chief Mauwee. The Pequot, Algonquin, Munsee (known as the Lenape) and Schaghticoke peoples would all gather together in this one place, which they called a happy trading place or a pleasant valley.

With that backdrop, I wrote about many of the last farmers in the area and how they were forced to leave because they could no longer afford to farm after the dairy industry's profits fell off. When I first moved to Wassaic, I would go to the Luther auction every Tuesday morning to buy dozens of eggs and look at the small animals for sale, dreaming of getting a goat.

I wondered how and why I ended up in this area, so close and yet so far away from the suburban culture just an hour south. I just happened to be there in time to document the flight of the last farmers and the influx of people who connected with the land in a new way.

The Harlem Valley had been considered by some to be the armpit of Dutchess County—a pretty armpit, but an armpit nonetheless. It was a place where people were dumped: the mentally ill and the severely disabled, alongside large amounts of industrial waste. It was peopled year-round by farmers, workers in the state institutions, ultra-rich weekenders, artists and writers. The ancestors of many of the older families in the area were Scotch Irish and had come up to work in the iron and steel industries in the 1800s. Some had helped build the railroad and lived in an area called the Squabble Pit. Some of their descendants are still squabbling.

There are times in life when one wonders how one got to where they are. For me, landing in Wassaic from Katonah in Westchester in 1987 with just

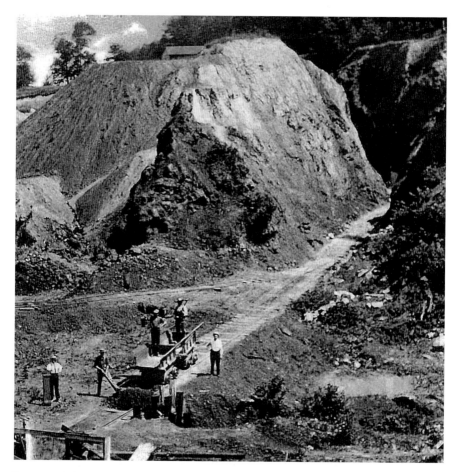

Iron ore mining in Amenia near the "Squabble Pit," circa 1870. *Amenia Historical Society.*

a futon, a toddler and an artist husband who left the house at 7:00 a.m. was one of those times.

I ended up in Wassaic in a strange way. I asked a psychic. The choices were Woodstock, Warwick or Wassaic. She said Woodstock would be familiar to me, with hippie types from the sixties, but that I would not easily find work there. I was already going up to the Tibetan Buddhist monastery on Overlook Mountain in Woodstock and knew the scene, but I did not particularly want to live there full time. Warwick was a nice town, but it was in Orange County—too far from my familiar territory. Wassaic, the psychic said, was the place to go. "If you go to Wassaic, you will be able to make a difference. You will hook up with a movement that might help save the world." Intriguing, I thought, since I already had somewhat of a New Age bent.

Thus, we bought the sweet little Victorian house across the street from the general store and the post office, and I somehow had the feeling that it was better to move into a place that had not yet been discovered than go somewhere that had already been gentrified.

But when I actually arrived in Wassaic, it seemed so bleak, I wanted to turn back. There was no one there with whom I could identify. Red pickup trucks careened past me while I took walks with my toddler in my backpack. I feared men who yelled out to me, "Tan-ya, I think you're beootiful."

I was in culture shock.

Thus began my adventure in the Harlem Valley.

WASSAIC

Wassaic was a sleepy little hamlet that was frozen in time when NYS Route 22 cut it off in 1948. It is at the bottom of a steep gorge coming down Deep Hollow Road, off Route 22. In the center of the village is a tall brick chimney affixed to a large factory building, once the headquarters of Borden's Condensed Milk. The Native people who used to live in the area called it *Washyak*, a Lenape word for land that is difficult to get to. It felt like something out of the 1950s when we moved here, with an auction barn, a bar, a box factory, a post office and a dilapidated park. The town seemed dead, except for the farm auction that took place every Tuesday and Betty Jo Luther's dance classes in the old post office, which my little daughter participated in. The only game happening in town was the fire department. It was like the town from the short story "The Body," by Stephen King, where ten-year-old boys find a body by the railroad tracks.

Many people did not even know this hamlet existed.

But in the late 1800s through the 1940s, Wassaic was a bustling place, with a hotel, three grocery stores, a tavern, restaurants and two major industries. Borden's Milk had been an ongoing concern since the late 1850s, when, at the height of the dairy industry, Gail Borden invented condensed, or evaporated, milk. The product was soon in high demand for soldiers during the Civil War, as the canned milk could be shipped and had a long shelf life. Gridley's iron ore business went back to the early years of the nineteenth century.

Later, the largest auctioneering enterprise in the tristate area, Luther's Auction, brought farmers from miles around to buy and sell their farm animals. Entire herds were put up for sale in the green Luther barns (often

Main Street, Wassaic, with Calsi's General Store and Maxon Mills before its restoration. *Photograph by Dave Reagon.*

because the farmer could not pay his bills or there had been a fire at a farm). Some of the cows were ferried down to New York City on freight trains. Maxon Mills in Wassaic, now a landmark, provided feed for most of the dairy farms in the region. Until the late 1940s, Route 22 went right through Wassaic and was called the Post Road, or what is now called Old Route 22 or Old Post Road. Our house was still zoned for commercial use because it had been on the main drag.

After Borden's and Gridley's closed and Route 22 bypassed the village, Wassaic's principal employer was the "State School," better known as the Wassaic Developmental Center, or, later, the Taconic DDSO, part of what used to be called the New York State Office of Mental Retardation. At the school's height, there were five thousand developmentally disabled patients there. The Tri-Wall box factory took over the Borden plant and became an important employer.

By the sixties, there was no tourism in the area; only the box factory, Luther's Auction and Maxon Mills remained. Patrick Nelligan's mother and father ran a lunch counter, as well as a funeral parlor, there through the sixties. By the seventies, the town was down at the heels, and as the farmers went out of business, eventually, even Luther's Auction fell apart. The heyday of the town was forgotten, and most people across the border in Connecticut did not even know Wassaic existed.

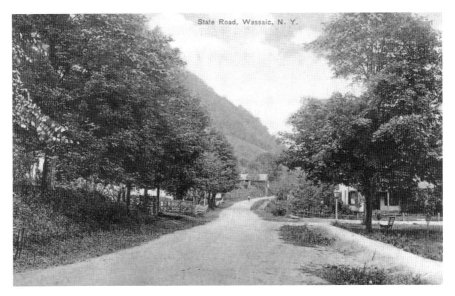

State Road was just a widened dirt path when it ran through Wassaic. Originally called Post Road, it ran from Manhattan to Albany. *Amenia Historical Society Digital Collection.*

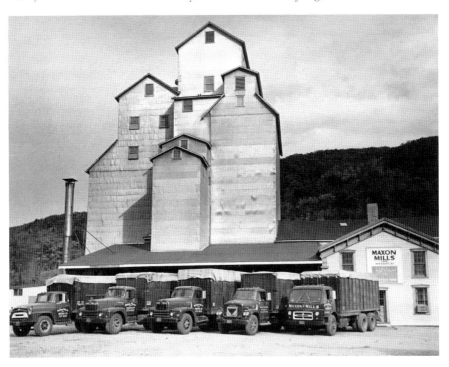

Trucks line up at Maxon Mills to load grain for farm deliveries, circa the 1950s. *Amenia Historical Society.*

THE WASSAIC FIRE COMPANY

When we arrived, the Wassaic Fire Company hosted everything: there were carnivals with spectacular fireworks, Halloween parties with apple bobbing and surprise parades. The costumes for Halloween were spectacular, with the incentive of a prize for the winner of each category. Dry ice "smoke" came out of cauldrons, and one year, there was even a real coffin. Farm trucks with hay bales pulled up in front of children's houses to ferry them to the firehouse with sirens blaring.

The members of the fire company commandeered and remedied many disasters: floods when the entire village was underwater, car accidents and, of course, fires. Our old wiring sparked in the living room from an ancient overhead fixture on Christmas Eve one year. The fire department was there in a flash. At one point, young Dave Luther flung himself headfirst through our second-floor bathroom window to rescue my then-five-year-old daughter and her little friend, who had locked themselves in the bathroom.

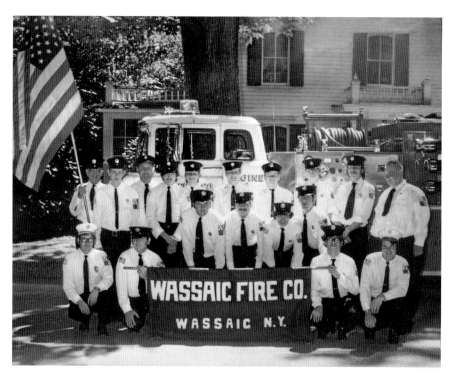

Wassaic Fire Company, circa the 1970s. *Amenia Historical Society.*

There was also a strange tradition, when we arrived in town, of teenagers being allowed to smash pumpkins on streets throughout the town on Halloween. It was not frowned on for people to leave everything from old TVs to washing machines, old furniture, couches and even junked cars at the end of their driveways. The teenagers would have a ball dragging the junk away, piling it all up and smashing it up on the green across from the bar called the Lantern Inn. The highway department hauled it all away the next day. It was a good way to get rid of stuff. And shortly afterward, that same little green served as the site for the launch of the Christmas season, with Santa Claus always arriving on a fire engine decked out with garish lights.

THE BORDEN PLANT

The Borden building, now owned and operated by the Pawling Corporation in Wassaic, stands as a monument to a history that is not well known. The building, which was built in 1860 for the Borden Condensed Milk plant, has some fascinating architectural elements, such as the little arches made of brick at regular intervals all along the main wall in the manufacturing area of the building.

"This is where the ladies in the bell-shaped dresses soldered each can individually, and the lead fumes went up the little vents inside each arch," explained Jason Smith, president and CEO of the Pawling Corporation, which manufactures rubber products. The previous owners, the Tri-Wall box factory, he said, bricked over the windows because they were worried that their workers would spend too much time looking outside.

"The train that [Cornelius] Vanderbilt brought up to Wassaic came right into the building to pick up the milk, so we had to fill in that whole area," he added. The railroad spur off the main line enabled freight trains to pull right up to load up the fresh milk that was then shipped down to New York City.

Gail Borden's original contract for local dairy farms hangs on a wall of the Pawling Corporation's front office: "The milking of his or her cows shall be done in the most cleanly manner and that milk shall be strained through 100 meshes to an inch of wire cloth strainers."

Former Amenia town historian Ann Linden elucidated the Borden plant's effect on the whole region:

Borden bought milk from all the local farms and changed the economy of the entire valley. It became known as Milk Valley, and at one point, there were eighty farms producing milk in Amenia and its surroundings. Before that, farms were growing grain and raising sheep and hogs. Once Borden set up shop, you were pretty much guaranteed to be able to sell your milk if it was clean and you brought it in on time. They would even bring milk down from Millbrook on horse-drawn carts, which would carefully navigate Deep Hollow Road.

Deep Hollow Road runs along a steep gorge and is a rutted, single-lane dirt road that used to have a tollbooth. It charged five cents. At one point, a sculptor carved spooky faces into the trees. One false move and your car could end up at the bottom of the ravine.

When Cornelius Vanderbilt, known as the Commodore, brought the railroad up to Wassaic, he built a house that he rarely stayed in. (The phenomenon of the super-wealthy building homes in the area continues to this day.) Gail Borden had met Noah Gridley on the train coming up from New York City. Gridley already had an established business in Wassaic, the Gridley Ironworks. There were steelworks south of the town going as early as 1770. It was Gridley who persuaded Vanderbilt to bring the train up to Wassaic. Gridley's thirty-two-foot-tall iron ore furnace, established in 1826, smelted the iron that was later used to produce steel and guns for the Civil War.

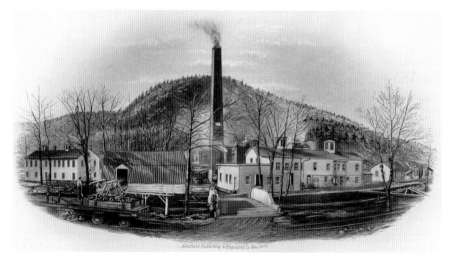

Borden's Condensed Milk factory with the railroad pull-off. *Amenia Historical Society.*

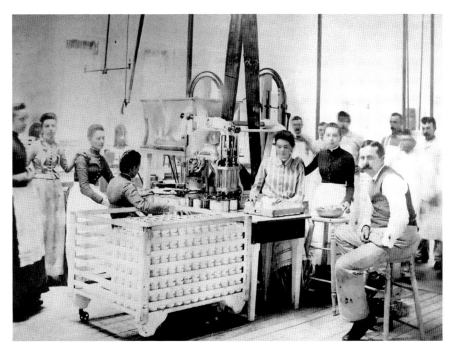

Borden's kitchen, with workers producing cans of condensed milk, circa the 1870s. *Amenia Historical Society.*

Charcoal was used to fire the big blast furnace that smelted the iron ore. Two large stone beehive-shaped kilns were built at the bottom of Deep Hollow Road to make the charcoal. Long pieces of wood were placed through an opening at the top of the kilns and took three weeks of slow burning to transform into charcoal. The kilns are all that remain today of the Gridley Iron Works. The surrounding hills were heavily denuded, trees stripped bare, to provide the wood for the charcoal.

Gridley persuaded Borden to come over from Connecticut, where Borden's food condensing operation was just not taking off. Wassaic offered the three things that Borden needed for his business to thrive: an abundant supply of milk, a railroad down to the city and waterpower.

The Borden plant, then trading as the New York Condensed Milk Company, was up and running as soon as it was built in 1860. During the Civil War, Borden got a contract to supply the Union troops with condensed milk. Even though Borden's production could never quite meet the huge demand of the army, it really put Wassaic on the map and was a boon to the local dairy industry.

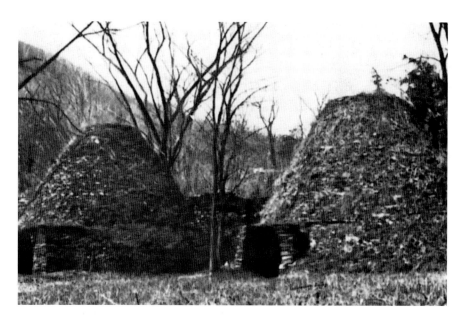

Wassaic kilns, 1898. Wood was burned into charcoal here to fire the Gridley Ironworks furnace. *Amenia Historical Society Digital Collection.*

Soldiers soon spread the word about the milk that stayed fresh without refrigeration, and Borden's started its campaign of advertising its product with large posters showing babies holding spoons in a ring around a can of condensed milk, clamoring for more. An 1886 poster suggested that babies would be far healthier if fed Borden's Eagle Condensed Milk (which was actually what we call evaporated milk today). Thus, "condensed" milk became an important part of the dairy industry.

As women started baking with condensed milk, the famous "Elsie the Cow" trademark was born. In 1899, the company's name was changed to the Borden Condensed Milk Company and, in 1919, to the Borden Company. Borden also pioneered the practice of selling milk directly to consumers in glass bottles with a lip for the cream.

Borden had become interested in the concept of condensing foods after he observed children dying on ships coming from England due to scanty milk production by shipboard cows. His research took him up to New Lebanon, New York, where he observed how the Shakers were condensing juice in vacuum pans. He then invented a copper vessel with a heating coil inside that enabled the milk to be heated up slowly, without scalding, somewhat like an enclosed double boiler. Since milk is 75 percent water, what was left was evaporated milk. No one else had been able to do this, though many

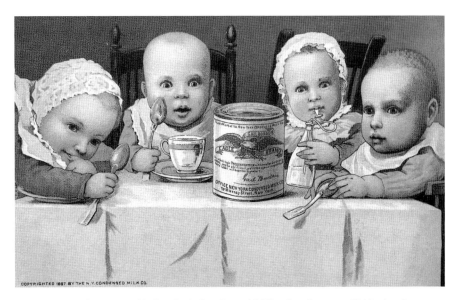

COPYRIGHTED 1887 BY THE N.Y. CONDENSED MILK CO.

Babies clamor for more milk. Borden's Condensed Milk advertisement, 1887. *Amenia Historical Society Digital Collection.*

had tried. Borden later applied his methods of dehydration to fruit juices, tea, coffee and cocoa.

Borden also imposed stricter standards on farmers who wished to sell their milk to him, requiring that they wash all udders, sterilize all strainers and sweep out stalls. Any speck of dirt or hay found in a milk sample resulted in rejection. The Committee of the Academy of Medicine declared that Borden's milk was "unequaled in purity, durability, and economy." Unscrupulous milk sellers in New York City had been doctoring milk, watering it down and adulterating it with additives, such as chalk, plaster dust and even formaldehyde from embalming fluid. The quality of Borden's milk made it a favorite.

Gridley's iron business was going strong and providing the best-quality iron ingots for Civil War steel production. Noah Gridley built a hotel called the Wassaic House on the site of the current Maxon Mills building for his managers to stay in. Borden stayed there as well, because he liked to look out the windows to see who showed up for work and when. Borden had a coach house built next to the Gridley Chapel and kept a fire engine there for use in the town.

Wassaic was booming. Several stores opened. Gridley built the Gridley farm and barns on the site that later became the Luther Auction property.

After farmers got paid, they picked up groceries, the newspaper and their mail at the Mahoney and Crosson General Store, called the Big Store, at the same location as the current Wassaic Post Office.

"Noah Gridley's wealth allowed him to essentially grow the community of Wassaic by building a chapel, luring Gail Borden's Condensed Milk factory to the town, and convincing Commodore Vanderbilt and Jay Gould to continue the train north up to through the Harlem Valley to Wassaic. The village of Wassaic essentially became a company town, with Borden and Gridley bolstering the local economy," stated a 2014 cultural resources survey completed by the Town of Amenia in conjunction with the New York State Office of Parks, Recreation and Historic Preservation.

Elmer's glue was born as a byproduct of the Borden's industry. The prime ingredient of the glue was the protein in milk, casein. After World War I, the Borden Company expanded its dairy business and became a prominent brand name, coinciding with the spread of refrigeration. The company branched out into other lines of foods, including pasta, and its name was changed to Borden Foods Company. The industry left Wassaic in the late forties. Today, Borden's exists locally only as a memory shared by many of the region's older dairy farmers and not much else. But it is still a name recognized by all.

THE EXODUS OF THE FARMERS

After Borden's moved out of Wassaic to Baldwin Place in the late 1940s, its farm in Mahopac, along with its farms in other locations, moved with it, and the farmers in the area had to scramble to find new purchasers for their milk. The steam engine–powered milk train was still active up until the early 1960s. It came from Burlington, Vermont, to Chatham and Wassaic and ran all the way to the city, a trip that took up to six hours. The small milk producers were able to find buyers, such as Dairylea in Poughkeepsie. Maxon Mills feed was also ferried down to the city in two to three cars a day. But by the late 1950s, that was over as well. Wilson Eaton still sold dairy cow feed and equipment in Wassaic until the seventies. But the farmers were not able to get enough money out of the milk to make a living, and the New York State taxes were killing them. All of this coincided with the arrival in Wassaic of D. (Delos) Luther and Sons in 1948, the auctioneers who helped farmers sell farm equipment and auctioned up to 150 cows a day.

THE LUTHERS

The town was filled with Luthers: there were little Luthers, middle-aged Luthers and older Luthers. Big Dave Luther, the auctioneer, was the patriarch, larger than life, lording it over all the others, most of whom were his children (from three wives) and grandchildren. His father, Delos, known as D. Luther, was the original auctioneer who had come to Wassaic from the livestock market in Wingdale and sold untold numbers of cows from all the farms throughout the region. D. Luther passed away in 1981.

Then D. Luther's son Dave, or Big Dave, took over as auctioneer, and Dave's mother, Queenie, the formidable matriarch of the family, ran the auction with Dave's oldest son, Delos. Every generation had the same names, so it got very confusing. Big Dave told me that in the late 1940s and 1950s, Wassaic was extremely busy, since the main drag, the Post Road, ran through town.

Big Dave Luther told me there were 44,000 dairy farms in New York State when D. Luther started his auction business in the forties. When Dave finally left the area in 2002 to go to Tennessee, as there were no more farms here to sell, he told me, "I left one of the most beautiful places in the world, and there were only 22,000 farms in the state." Now, there are fewer than 4,500.

In 1987, there were still dozens of Luthers in town. Little Dave Luther, the son of Big Dave, was on the town board, and Dave's wife, Nancy, ran the general store. Her former father-in-law headed up the feed mill Maxon Mills, and her first husband worked at the huge Bel Aire Farm, which milked 750 cows in three shifts.

THE BETTY JO LUTHER DANCERS

Big Dave's third wife, Betty Jo, was quite the hoofer and studied tap and ballet in New York City. There was even talk of her going on Broadway. She started a dance troupe in the hamlet that performed at county fairs and captured small-town America's agricultural spirit in a unique way, with little boys wearing tiny cowboy hats and fringed vests and girls performing in crinoline-hooped petticoats.

She made all the costumes herself. There was a vaudeville quality to all her shows, in which she used music from as early as the 1920s.

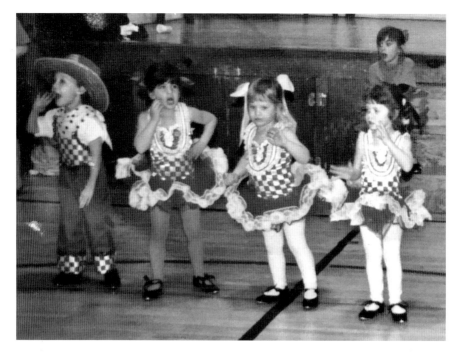

Betty Jo's tiny dancers sing Lead Belly's children's song "Ha-Ha This a Way." *Luther family.*

Betty Jo's frilly costume in the musical *Barnum. Luther family.*

Her own girls, Tabitha, Ketorah and Hadassah, had serious star quality. They all won innumerable trophies. Tabitha directed plays in regional theaters, such as Sharon Stage and TriArts in Pine Plains, which included Broadway-caliber actors and talented students from the local Webutuck High School. The performance of *The American Tale* in 1990 featured 108 kids from the school. And little Hadassah performed at Dolly Parton's Dollywood for over five years, recording twelve country-western albums of her own.

DAVE LUTHER: AUCTIONEER, PIED PIPER OF FARMERS

Dutchess magazine, December 1989–January 1990

In a time before supermarkets, farmers would trade their wares from the backs of trucks and wagons in open-air markets and livestock auctions, coming together in the wee village of Wassaic in the land of green they called Milk Valley. Swarms of people from towns all around would gather there and trade all day long, taking home the produce and canning it— the good old-fashioned way. To this day, on Tuesday mornings (which used to be called Marketing Day), old men in western shirts and cowboy hats come, bearing boxes full of rabbits, doves, ducks, geese and even the occasional exotic creature, like a peacock or a llama, to be auctioned off at the Luther's Livestock Commission Market, located in Wassaic, just off Route 22.

Although the market's owner-operator is a formidable older woman named Queenie Luther, and her grandson, Delos Luther, is the sales manager, the most impressive presence by far is that of her son, the man wearing the fedora with feathers in the hatband. He is one of the region's top auctioneers, David D. "Dave" Luther, the second of three generations of Luthers who have watched development creep up from Westchester into Dutchess County. Through his eyes, one can gain insight into the demise of the agricultural way of life in this area.

On the morning of a farm machinery auction day, Luther looks like the pied piper with a microphone, a colorful crowd of men wearing plaid shirts and CAT caps following along behind him. As he moves from one piece of equipment to another, he works the crowd, greeting familiar faces, telling jokes and keeping everything moving along: he's in total command. A farmer wearing overalls and a John Deere cap waves his hand and says, "Yup, yup,"

Dave Luther revs up the auction. *Dan Delaney.*

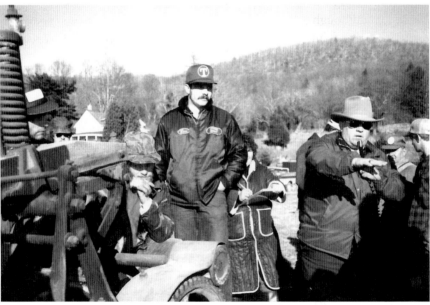

Big Dave works the crowd at the Wassaic auction. *Luther family.*

while a man whose uniform jumpsuit says "Custom Tractor Service" whispers under his breath, "That bailer's not worth the money."

The crowd runs the gamut, age-wise, from old codgers to young bucks, and there are even a handful of preppie types on hand. Within two hours, the bulk of the equipment is sold off. Luther puts on quite a performance, keeping the audience at a fever pitch.

"Oh, yeah, Joe, I know you've got all those sheep. You need something to keep 'em in."

"I ain't got sheep. I got cows."

"Well, whatever you have, this'll keep 'em in."

Farmers are some of the toughest people to get laughs out of, but Luther manages to keep them chuckling. As things start to slow down and the equipment stock grows thinner, he tells a self-deprecating joke: "You know, folks, a research scientist said to me this morning, 'You're an auctioneer, aren't you? We been using monkeys, but we've found that auctioneers can do things that monkeys would never dream of doing!'" The joke falls flat. The faces remain dour. Luther quips, "Well, hell, I heard it on the radio!" Then he gets a good laugh. His comeback is as professional as Johnny Carson's.

From people in the crowd, he gets high ratings; most of his customers agree that although some of those in the auctioneer profession have a tendency toward hucksterism, Dave Luther is one of the finest salesmen around, and he overcomes any stigma attached to his profession with his honest approach.

Later, when asked about his gift of the gab, he chortles, "Oh, yeah, when you're in a pocket or a pickle, you've got to keep 'em laughing." The best schooling Luther received was at the knees of another great auctioneer: his father, D. Luther, who was responsible for selling off the contents of the many farms that were closed in central and northern Westchester, Putnam and Dutchess Counties during the fifties and sixties. Luther said:

> As time went on, we watched these little farms leave. First, of course, was the central Westchester area—Mount Kisco, Yorktown—and then Jefferson Valley and the Peekskill area. And we saw these little farmers with twenty, forty or sixty cows sell off their herds, and then the land would go into development—Mahopac, Carmel, Somers, and North Salem. Then, in the early sixties, all hell broke loose in northern Westchester, and then we started to do so many farm sales and things got so hectic that we stopped taking any other kind of auction.

Auction spectator. *Dan Delaney.*

The developers were really coming in fast, and those areas were mushrooming. Consequently, there weren't enough days in the week in the spring and fall of the year to disperse cattle and machinery for these farmers. And within weeks of the closings, houses were going up on the land.

He continued:

You could see the trend was set. They were creeping north. Creeping suburbanization, I guess, is what you would call it. And of course, those with a lot of money came first. They bought big chunks of land and kept what they wanted, and the developers came in, and while all this was going on, we were selling out these little farms.

We didn't like to see it, but whether you liked it or not, it was happening. We used to get the Rockefellers' cattle from Pocantico Hills, cows from James Cagney, the actor in Stanford, New York, and calves from Gene Tunney, the boxer, in Stamford, Connecticut....All these areas were experiencing "progress."

It was such a radical change in such a short period of time—from agricultural to residential. We were dealing with different kinds of people with different kinds of ideas. And everyone came up from the city and wanted to live in the country.

Then they wanted to reach back and bring up all the amenities from the city and have them in the country, and when they did that, it was no longer country; it was suburbia with city attitudes. And that's what is beginning to happen here in Wassaic and Amenia.

He added: "After we dispersed a farm's cattle and equipment, it was goodbye to that farmer. We may have lost a customer, but we never lost a friend. And the friendships that were cultivated back then exist today."

Although, for some farmers, dealing with an auctioneer may be as dreaded and inevitable as death or taxes, for others, the auction is a social time, a time to get together and chat. Luther has known many of the visitors to the Wassaic Auction Market since he was a child.

You take Ted Sisky, who's in his late eighties. He recently had to give up his driver's license, but someone still brings him here every Tuesday to buy fifteen to twenty dozen eggs and visit with the old-timers. I've known Ted since I was a kid in the late forties, when he took cattle to Wingdale Livestock, where my father was the auctioneer. He still owns land up there in Chestnut-land in New Milford.

Then you have Frankie Lala, who comes up from Rye and buys eggs, and a lot of old fellows from over in Bristol, Connecticut, and they assemble here with their wives. And old Uncle Alphonse Capone and Uncle Joe Scibone, and they're nice old men who come with and for the little animals, ducks, rabbits and chickens. Uncle Joe moved up here to Pine Plains from the city.

All these men who were old enough to be my father were not necessarily farmers but were involved in agribusiness in one sense or another—either they raise goats or sheep or rabbits or something to put in their stew pot. These guys are in their seventies or eighties, and they love what they are doing, because it reminds them of the old country.

Luther's father, D. Luther, was in cahoots with many of these fellows way back. He had started out as a cattle dealer in the late thirties in the Cold Spring area. He was on the road a lot and would take them to New York City to the stockyards in the meatpacking district.

David remembers riding down with him during World War II. D. Luther was instrumental in forming the New York Livestock Association and was well-liked and respected in the industry.

At the time, every transaction was done on an approved note. A buyer signed a note to the farmer saying he would pay in 60 to 120 days. Then a couple of farmers from the Fishkill area hired D. Luther for a cattle auction, and he set it up as a "cash or good checks on day of sale" arrangement.

Dave recalled:

> *Well, it was a rip-roaring success. The McEnroes, farmers from over here in the valley in Amenia, read about it in what was then called the* Poughkeepsie New Yorker, *and they had the auction on the farm, and everybody came. Old Ray Mac told me a good many times that what Dad had done was the greatest thing that ever happened to the farmer in this area, because it took the farmer and stood him on his feet.*

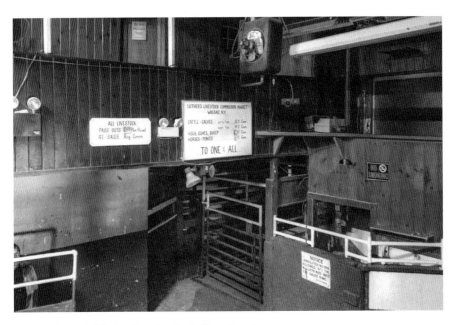

Luther Livestock Market, interior. *Lazlo Gyorsok.*

And that was the beginning. At the time, there was only one or two livestock markets on the entire East Coast. Most of your cattle was shipped to Jersey City stockyards, or the packer had to go to the country and physically drive them down to the city. So, Old Uncle Joe approached Dad about putting on a livestock market in this area.

D. Luther was a success, but he wanted a bigger piece of the action and decided to strike out on his own. He built his own place in Wassaic and opened it on June 8, 1948. Soon, he was handling all the livestock from Westchester, Putnam, Dutchess, Litchfield and Columbia Counties. It was not unusual for him to run anywhere from 150 to 250 cows and up to 1,000 calves on any given Tuesday.

The Wassaic auction was the core of Luther's business, and all of the other ventures—real estate, farm machinery and antique sales—sprang from that. Because young David was brought up around farmers, he learned to have a keen understanding of and sympathy for their attachment to the land. He said:

I've seen farmers choke up and cry when you're having an auction for them. It's a sad day for some and a happy day for others, and you have to treat these sales in a very respectful manner. After all, when you're finished that day, what you have accumulated for that man may be the greater portion of what he's going to live on for the rest of his life. He's handed you his life's work and said, "Here's my life's work. I'm going to move on or retire. Sell it for me."

THE BENSONS: THE LAST FARMERS OF DOVER PLAINS

Millbrook Independent, April 4, 2011

That was a different period in agriculture.
It was wall to wall farms, and they were all Bensons.
—*Stanley Benham,* Rural Life in the Hudson River Valley

Lewis and Norm Benson are the last of a breed of farmers in the Harlem Valley who actually made a profit from dairy farming. "The Bensons owned East Mountain, Nellie Hill, Plymouth and Hog Hill and the whole valley.

The Bensons arrived in Dover in 1742 with seven sons, and each one of them had a farm," explained Norm Benson, who headed up the Dutchess County Soil and Water Conservation District, part of the U.S. Department of Agriculture, for many years. (The Dutchess District was one of the earliest such districts in the United States.) Benson wrote a book about that period called *Raised a Farm Boy.*

I interviewed Lewis Benson, aged ninety-two, at his home on Old Route 22 in Dover to discuss what farming was like in the 1940s through the early 1980s, when his brother sold the family farm to a lawyer from Pawling named Malcolm Fooshee.

"Lewis and Frank Jr. sold the farm when the price of milk went down and the taxes went up and it was impossible for us to hold on to the land and make a living," explained Norm. "They did not regret getting out when they did."

A wiry and energetic man with a great sense of humor, Lewis Benson pulled out his first milk check from 1940. He sold 152 cans of milk (eighty-five pounds per can) to the White Plains Dairy for $357.05. "We put the cans in a double-decker milk truck—in summer, they were in jackets—and delivered them directly to White Plains. That way, we could make more money than [by] selling it to Borden's."

He reminisced about growing up on his father Frank Benson's farm. "I realized I could learn more from my father in two days than I could learn in a month at ag school in Cobleskill and begged to come home."

His father owned about two hundred acres, including all of Nellie Hill, which is now a nature conservancy preserve (part of the federally protected Great Thicket National Refuge), and milked almost one hundred cows back then.

Lewis said, "Our land was some of the best land in Dutchess County— flat and easy to work. We ploughed the fields with horses and mules until we got a two-cylinder John Deere 115 diesel tractor that we called a put-put, with noisy steel tires on the back."

It was an era when coal was plentiful and hardwood was cheap. "If a house had two woodstoves burning, they would use twelve to fifteen cords of wood per season," observed Stanley Benham in his book on agricultural life (*Rural Life in the Hudson River Valley*). Benham had been supervisor of the Town of Washington and had a farm up on Tower Hill. Lewis Benson pulled out Benham's book as he described the lifestyle back then.

Lewis Benson was called "Little Doc" because he lived in Pawling with his uncle, who was a veterinarian, and went out on calls with him. "My father

The Bensons in front of their barn. *Tonia Shoumatoff.*

had Holsteins, and he could tell if a cow was going to produce good milk by feeling the 'milk vein' on her stomach."

Lewis remembered his mother putting up fresh eggs for the winter by putting them in a limy solution called water glass and then into a crock with salted water. Water glass was a sodium silicate solution that came as a powder and sealed the pores of the eggshells to stop them from going bad.

The Bensons had a lot of apple trees, and Lewis and Norman remembered their grandmother making cider with a press. "My grandpa had a lot of friends. There was a white pitcher for the hard cider, but when it was finished, they were not allowed anymore," said Norm.

Lewis described the icehouse and how they built a dam across the brook and cut the three-foot blocks with ice saws. Horses pulling an ice plow with runners would score the ice, and then it would get sawed up and packed in sawdust for the summer. The icehouse was located on a stream to keep it cold.

"We had a pump in the house from the cistern, and my mother would heat up the water on the stove so all seven of the children could take a bath—first, the three girls and then the four boys."

There were kerosene lamps and pitchers of water in the bedrooms that would freeze up at night. Buffalo robes were used in the sleighs, and warmed-up wooden logs were placed at their feet. "In November, we would take the hogs to Culligan's Market in Dover, who would butcher them, and then we would put up the pork meat for the winter in crocks with lard," said Norm.

All the Bensons belonged to the Dover Grange, which was near the New York State trooper station on Route 22. "It had 130 members and was established in the mid-1800s as a cooperative so farmers could buy seed at a cheaper rate by buying in quantity." The Grange League Federation also provided insurance for the farmers. "It also provided a lot of fun and comradery," Norm observed.

After he retired from farming, Lewis, along with his wife, traveled to many places, including Europe and the American Southwest. But he and his brother continued to play practical jokes on their farming friends, entertaining his buddies. Lewis now has a TV that replaced his wind-up Victrola record player. He keeps every scrap of history from his farming days, from postcards to old milk cans, all meticulously organized. As we were leaving, Lewis pointed out an old engraving of the Thorndale estate in Millbrook, which belonged to the Thornes in the 1800s, that was printed in a Dutchess County history book covering the late 1600s through the 1800s, since he knew that I was writing for the *Millbrook Independent.* "We had a Benson reunion years ago, and there were over a hundred of us. There are very few of us left now," sighed Norm. "We never thought of ourselves as poor, because we ate well and grew everything ourselves, and we were allowed to listen to *The Lone Ranger* for a half-hour per week on the radio."

THE LIFE OF A FARM WIFE

Millbrook Independent, August 2011

It's morning, time to milk the cows, feed the chickens and make breakfast.
It will be a hard day. I must pick herbs, churn butter and braid straw.
—*Elizabeth Hadley, diary, August 22, 1803*

Ginny Tatsapaugh Meili is one of the very few farm wives left in Amenia. She is married to Joerg Meili, a descendant of three generations of Swiss farmers who has a herd of 180 head of cattle, mostly Holsteins and a few

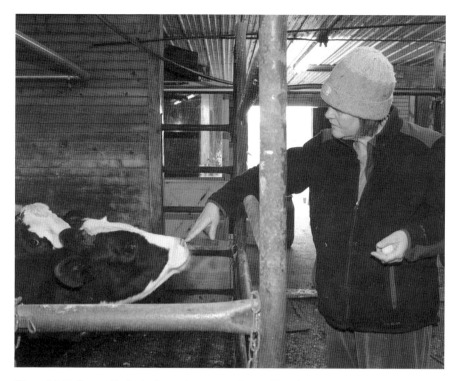

Ginny Meili, farm wife, lovingly tends to a cow. *Lauren Hermele.*

Jerseys. He milks 80 cows per day. He is one of the last dairy farmers in Amenia. At any one time, there are around 10 calves that need to be hand fed and a bevy of heifers in a pen.

Ginny and her ten-year-old daughter, Sarah, get up at 6:30 a.m. to feed the calves and help with the chores. Little Sarah is so proud that she managed to train a two-day-old calf, Cloudy, to go from the bottle to the pail in one day. She shows how she achieved this by sticking her fingers into the calf's mouth and then directing her head into the pail. Sarah names all the newborn calves.

The life of a farm wife is not glamorous, but Ginny has learned to do her own thing, despite being the support person for the farmer, who is always busy. Joerg is tired at the end of the day, after milking, feeding, cleaning, doing field work in the summer and fixing the equipment. Ginny always serves a home-cooked hot meal. Joerg's father, Hans Joerg, was the manager of Bel Aire Farm for many years before he got his own farm in Amenia. Joerg learned the business from the farmhands and grew up with 150 cows.

He went to Cornell. His father and grandfather farmed in Switzerland. So, farming is in his blood. Ginny Meili said:

> *Joerg works all the time. He's over-tired, and we never go anywhere, but I am used to it. He was going to come to my sister's for Easter dinner on Canaan Mountain, but ten minutes before we were supposed to leave, a calf got stuck being born, and it took four hours to get it out, so of course, he missed the dinner. A lot of times, he misses family occasions because of the cows.*

But Ginny also speaks of the quality of life that she has and the benefits of being a close family who is together a lot. It is obvious that the farm has had an extremely wholesome effect on her children, who have all been homeschooled. They have done well in school, with Sam, the eldest, now on the dean's list at Dutchess Community College. Summer, the middle child, is on the honor roll at Kent School, the prep school in Kent, Connecticut, and the youngest, little Sarah, is following in the dance steps of her older sister as an aspiring Rockette at Radio City Music Hall.

With calves, farm bookkeeping, laundry, dinner, homeschooling, dance classes and cooking, Ginny has her hands full. She is also a very accomplished artist. And guess what she paints. There are murals of cows, ducks and ears of corn adorning her house. Now, she is working on a series of falling-down barns. She has a business called Tatsahooves, which sells caricatures of cows that she has turned into cards, T-shirts and posters. She had her own shop in Salisbury, Connecticut, for many years. She said, "People tell me to just do my artwork, but they aren't married to a farmer, so they don't know that art always gets the bottom rung."

In the barn, Ginny and Joerg's son, Sam, is sweeping up the leftover feed husks and spreading them as bedding for the cows. Sam is eighteen and is now helping on the farm, which Joerg is grateful for, since he has only one farmhand. He used to have up to three farmhands, but that is no longer possible due to the difficult economic climate. Sam feeds the cows from the silos and explains how the unloading system works by conveying the feed on a chain.

Up the road, Joerg's father raises Dutch Belts, a rare and unique-looking breed of black cow with a dramatic white band around its middle. Joerg explains that they are the only belted breed of cattle that can trace their lineage back to the original belted, or "canvassed," cattle from the Appenzell region of Switzerland and the Tyrolean Mountains of Austria. Joerg says he prefers his Holsteins because they are not as finicky as the Dutch belts.

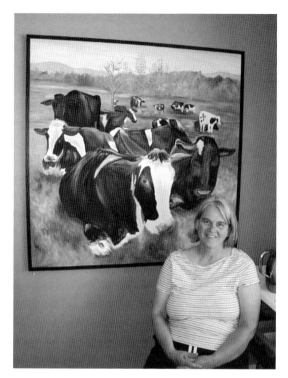

Left: Ginny's cow paintings exhibited at the Cozy Corner Restaurant. *Tonia Shoumatoff.*

Below: Ginny and her daughter Sarah feeding a calf. *Tonia Shoumatoff.*

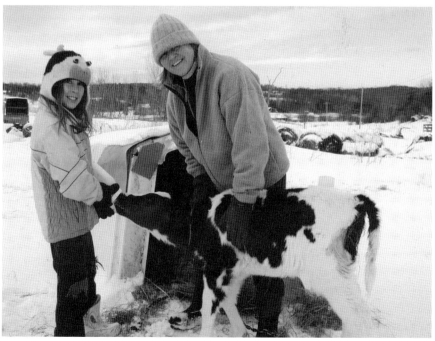

Back in the farmhouse, after the chores, which take around two hours, Ginny recounts how she and Joerg built the farmhouse themselves back in 1992, when they were still living in a trailer. It has beautiful wide floorboards. Joerg comes in and says he needs the milk check. Ginny said, "You would think that our life would be repetitive, but it's actually never the same. Every day has its unique challenges. One of the most extreme weeks came right before Christmas a couple of years ago, when it was freezing. We had to pull around ten calves, and our farmhand quit in the middle of the night."

Joerg goes back to spreading manure, and Ginny settles in for a math lesson with her daughter, who is memorizing the nonsense poem "Jabberwocky" from Lewis Carroll's *Through the Looking-Glass*, the sequel to *Alice's Adventures in Wonderland*. "Kids who grow up on farms are stronger emotionally and mentally, because they see real life and death," Ginny says. "They also learn to become self-sufficient, because they have an overwhelming amount of freedom compared to other children."

Ginny Tatsapaugh Meili passed away in 2018, after a valiant battle with cancer. Joerg sold all his cows and is no longer in the milking business.

TROUBECK

The hamlet of Amenia had a fine educational system and an intellectual tradition going back to the early generations of the Bentons and Spingarns of Troutbeck. Authors, artists and poets, as well as renowned change makers, were drawn to Amenia.

The Bentons welcomed some of the most distinguished American literary figures of the day to stay at their writers' retreat cabins. Henry David Thoreau's last letter was sent to Myron Benton at Troutbeck. Later, Joel E. Spingarn purchased Troutbeck in the early 1900s and hosted important conferences and gatherings there. It was under Spingarn's auspices that the NAACP, the National Association for the Advancement of Colored People, unified the early twentieth-century civil

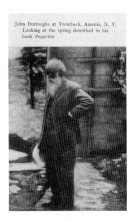

John Burroughs at Troutbeck, Amenia, N.Y. Looking at the spring described in his book Pepacton

John Burroughs was a frequent visitor to Troutbeck. *Private collection.*

rights movement at a 1916 conference that he hosted at Troutbeck. And in 1933, a second Amenia conference recast the civil rights movement for a new generation.

Myron Benton, known as "The Poet of the Webutuck," christened the ancestral home of his father and grandfather "Troutbeck" because it had a never-failing spring, and the trout there were so friendly that they came up to your hand. Myron was a romantic nature lover and the first cousin of Joel Benton, who started the *Amenia Times*, later called the *Harlem Valley Times*. Myron Benton made Troutbeck a center of interest to fellow nature lovers, corresponding with Emerson, Walt Whitman and Thoreau. John Burroughs, the nature writer, often drove over from his Woodchuck Lodge in the Catskills.

Myron's poems from *Songs of the Webutuck* (1906) speak his tribute to the natural beauties of the locality around the Webutuck River, its valley, those sheltered banks and that magical farm, Troutbeck, that he loved so much:

> *Blithe Webatuck, in all thy devious sallies,*
> *Past groves and meadows echoing with song,*
> *Countless green coves, no sweeter ones I seen,*
> *Thy waters find in all their paths serene,*
> *From cool springs that bubble in Taghkanic,*
> *To where they join the troublous Housatonic....*
> *Oh Webatuck, from thee what coolness pressed,*
> *What azure calm, upon my throbbing head...*
> *To mystic realms by light unearthly led.*

Another great man whose heart yearned for the tranquility of Troutbeck was the great social philosopher Lewis Mumford, who has a chapter in his book *Sketches from Life* called "The Domain of Troutbeck."

> *Troutbeck, the "Big House," which dominated the upland village of Leedsville—then the classic Chinese-style hamlet of ten houses—nestled in the hollow below where the Troutbeck Brook and the Webatuck River joined. As friends of the family, we had the freedom of the Spingarns' large domain. What a domain it was! For its eight-hundred-odd acres—roughly the size of Central Park—embraced very aspect of the extraordinary landscape, from the wooded top of Oblong Mountain, where rattlesnakes nested on rocky ledges, to Troutbeck Lake, fashioned from an old ton-ore bed, from a swamp at whose edges the beautiful leaves of the elecampane*

plant flourished…past a remote ore bed to the further bridge over the Webatuck.…In less than an hour's tramp we could sample the most varied experiences of nature. How we came to value that.

The Mumfords lived in the Maples Cottage and then the Century Cottage at Troutbeck before they bought their house on Leedsville Road. Mumford describes how many interesting people stayed at Troutbeck, including poet Stephen Spender, Sinclair Lewis, Thomas Mann's daughter Elizabeth Borgese and Justice Thurgood Marshall, the Supreme Court's first Black justice: "What an interesting parade of personalities that was: artists, poets, novelists, journalists, anthropologists, psychologists, educators and people serving in public life." Members of the Troutbeck community of literary intellectuals, from the way Sophia Mumford described it to me later, were all considered an extended part of the Spingarn family and household.

THE AMENIA CONFERENCES SHAPE THE NAACP

One day, I picked up the phone while working at the New York City headquarters of the World Peace Prayer Society, which also had an office in a remodeled old milking parlor in Wassaic. A gentle voice at the other end said, "Hi, this is Coretta Scott King." I almost fell off my chair. She told me she was raising funds for the Martin Luther King Jr. Center for Nonviolent Social Change in Atlanta and asked us to contribute. When I told her that our group was based in Amenia, New York, she told me that her husband, Dr. King, had received the NAACP's Spingarn Medal in 1957 and that she knew Joel Spingarn, the owner of the renowned Troutbeck estate, had lived in Amenia. The medal had been given every year since 1915 (except 1938) to outstanding Black leaders.

This is how I discovered that Amenia had been a major gathering place for leaders of the NAACP and many others who influenced the incipient civil rights movement. At two critical moments in the first half of the twentieth century, conferences held at Troutbeck, the country home of Spingarn and his wife, Amy, helped unify and direct the movement.

Joel Spingarn, an internationally known literary critic, civil rights activist and publisher, served as chairman of the board and treasurer and as the second president and first Jewish president of the NAACP. Spingarn was

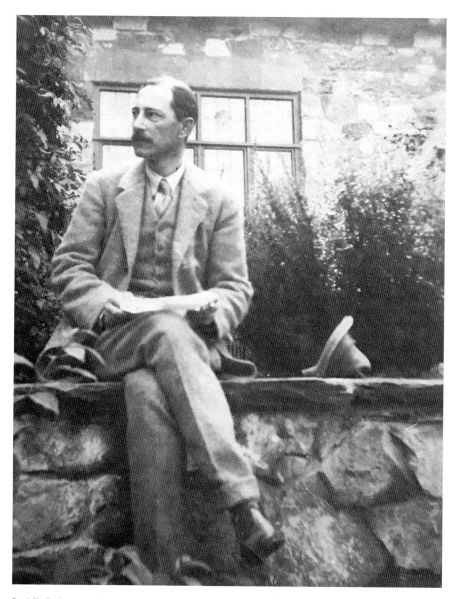

Joel E. Spingarn, the first Jewish president of the NAACP, at his Troutbeck domain.
Troutbeck Archives.

active locally as well, becoming the owner and publisher of the *Amenia Times* newspaper, which he renamed the *Harlem Valley Times.* Both of the Amenia conferences were organized with major input from W.E.B. Du Bois, a prominent founder of the NAACP, editor of its publication *The Crisis* and

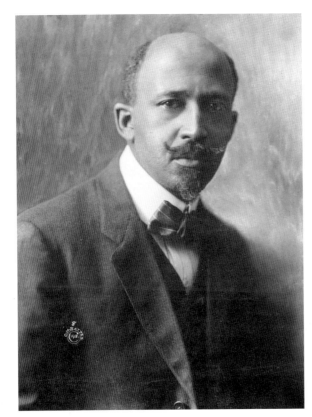

Left: W.E.B. Du Bois, Joel Spingarn's close friend and co-organizer of both Amenia Conferences in 1916 and 1933. *Library of Congress, visual materials from the NAACP Records.*

Below: Amenia Conference attendees in 1933, including Ralph Bunche, W.E.B. Du Bois, Abram Harris, Roy Wilkins and Walter White, among many other leading Black leaders. *Amy Spingarn; Library of Congress, visual materials from the NAACP Records.*

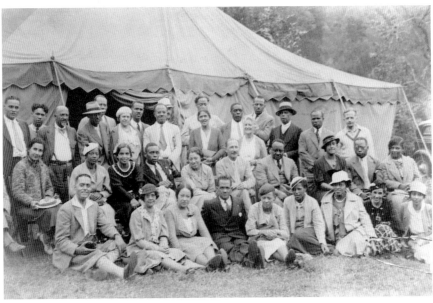

transformative figure in the twentieth-century struggle for Black civil rights. He was also a close friend of the Spingarns.

The first Amenia Conference took place in August 1916, following the death of Booker T. Washington in November 1915. At this perilous moment, the Black civil rights movement was riven with dissent over whether to pursue the accommodationist strategy personified by Washington or turn to the activism advocated by the NAACP. The conference was limited in its practical effects, but it did much to enable the dissenting factions to come together in a unified movement to combat lynching, Jim Crow laws and racist discrimination.

By 1933, the influence—and membership—of the NAACP had noticeably dwindled, and Spingarn and Du Bois thought it was necessary to change course. They called a second Amenia Conference at Troutbeck in the hopes of rejuvenating the organization, inviting a new generation of Black activists to come together to discuss and set priorities for the future of the civil rights movement. Du Bois and Spingarn handpicked conferees who were dynamic and not "fixed in their ideas"; Du Bois's own role at the conference was deliberately muted in order to empower a younger generation of Black leaders. Among the twenty-six invitees who arrived at Troutbeck in August 1933 were professors, lawyers, librarians, doctors and activists, and many of them were women, who, in the shadow of the Great Depression, were as acutely aware of the economic disparities among the masses of Black people as they were of the long-established movement goals of political and social equality.

The 1933 conference's Findings Committee particularly stressed the need for the NAACP to develop a substantive economic program to help struggling Black people.

Activist and NAACP assistant secretary Roy Wilkins assessed the conference's effects, writing, "In many ways, this was the most significant conference of all the racial and interracial conferences which have been held within the last thirty years." Indeed, the conference fostered alliances among many who later strongly influenced the civil rights movement. Other conference attendees of note were Ralph Bunche, first Black American to receive the Nobel Peace Prize; activist Walter White, who led the NAACP for twenty-five years; and Sterling Brown, a folklorist, professor and poet also known as the first poet laureate of the District of Columbia.

Like its 1916 predecessor, the 1933 conference never came up with a specific agenda or timetable to carry out the vast work that was required, and in fact, it explicitly declined to do so. Nevertheless, Franklin D. Roosevelt's secretary

Rev. Martin Luther King Is Named Spingarn Medalist

NEW YORK.—Martin Luther King Jr., the young clergyman who headed the dramatic and successful Montgomery, Ala. bus protest movement of 1955-56, has been chosen as the 42nd Spingarn medalist, Roy Wilkins, executive secretary of the National Association for the Advancement of Colored People, announced here last week.

The medal, awarded annually to a Negro American for distinguished achievement, will be presented to the Rev. Dr. King at the

Association's 48th annual convention in Detroit, June 24-30. The presentation is scheduled for the night of June 28.

(CONTINUED ON PAGE 2, COL. 1)

Joseph Rauh To Speak at NAACP Confab

Martin Luther King Jr., the winner of the NAACP's Spingarn Medal in 1957. *From the* Black Spectator, *June 7, 1957.*

of the treasury, Henry Morgenthau Jr. (who had a farm in Dutchess County and was a friend of Spingarn), made a surprise appearance at the conference with the intention of selecting a "Negro advisor" to serve on the Federal Farm Board (which later became the Farm Credit Administration). Elmer Carter wrote that Morgenthau's commitment to naming a Black advisor to the New Deal "assured that the second Amenia Conference would become as historically significant as the first Amenia Conference." The Spingarns' neighbor Lewis Mumford, who stopped by after the Saturday evening session of the conference, said he was impressed with the "keen discussion" that was taking place. Some of the younger attendees spoke disparagingly of the NAACP, calling for a more radical approach to social change and civil rights.

Many years later, in 1957, Dr. Martin Luther King Jr. sent a letter to Amy Spingarn, thanking her and the board of the NAACP for choosing him to receive the Spingarn Medal that year: "Let me express my appreciation to you for the great part that you and your late husband have played in the struggle for freedom and human dignity for all people. The names of the Spingarns will go down in history as a symbol of the struggle for freedom and justice."

THE AMENIA SEMINARY

Millbrook Independent, January 2010

The site of the brick schoolhouse in Amenia also has a distinguished educational tradition that goes back further than that of many of the prep schools in the area, which include Hotchkiss, Millbrook and Kent Schools. The site, known as Cook's Hill, named after Major Simeon Cook, whose wife's family home had been located there, became the locus of the Amenia Seminary in 1832. It was a fine private academy of higher learning that taught ancient languages, among many other subjects, and was run by Methodists.

There were no trains or cars in Amenia at that time, and students had to take the ferry up the Hudson River to Poughkeepsie and then board a stagecoach that brought them to Amenia. The Amenia Seminary hosted up to three hundred students at a time.

The catalog for the seminary spoke of Amenia in glowing terms: "Amenia is proverbially pleasant, healthy and favorably situated, being in the midst of a highly moral and cultivated community, removed from the temptations of larger towns." The principal of the school later became the first president of Wellesley College.

The school's term fee was thirty dollars, which included a furnished room and ten pieces of washing per week. This was a school where students could study Greek and Latin, science, mathematics, "common English," French and German, as well as music and oil painting for a small extra fee. Its library contained 2,500 volumes, and for twenty-five cents, students had complete access to it. Books were rare in the countryside in those days, and people who could read them were even rarer.

The seminary, which was a series of connected wooden structures, had a chapel with a bell in the main building that summoned its students to class and worship. What was also unusual about the Amenia Seminary is that both girls and boys attended; it was a coeducation boarding school, but there were

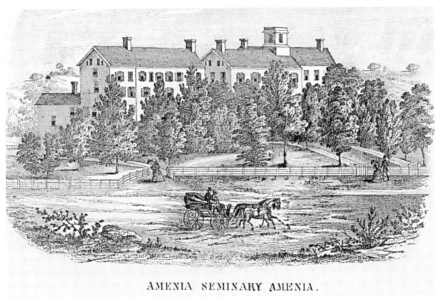

AMENIA SEMINARY AMENIA.

Amenia Seminary, one of the earliest coeducational institutions in the United States, 1835. *Amenia Historical Society Digital Collection.*

The Amenia Seminary sign in front of what is now the Amenia Town Hall. *Tonia Shoumatoff.*

also day school students. The girls lived in the building farthest to the north. The Litchfield Female Academy had already been established in 1792 and was one of the first major educational institutions for women in the United States, but secondary school education for young women was still rare. At that time, secondary school coeducation was extremely unusual.

By the mid-nineteenth century, Horace Mann had helped establish the requirement for secondary school education to be offered as part of the federal public school system. Common school law in 1804 required school attendance from only first through eighth grade. The seminary closed its doors in 1888, and a public school was built across the street. The first graduating class of the public school was the class of 1895.

Meanwhile, after the seminary closed, a number of reuses for the building were attempted; it became a hotel, a mineral spa (which was discontinued when it was discovered that its "minerals" were actually buried rusty farm machinery), a tenement house and even a dance hall.

THE AMENIA FREE UNION HIGH SCHOOL

Millbrook Independent, January 2010

The Amenia Free Union School, a white wood-frame building across from the Presbyterian church, was designed for grades one through twelve. High schoolers could study Latin, biology, physics, English history and American history or take technical courses of study, which included trades such as land surveying and secretarial work.

"Our schoolhouse was rural, consisting of three rooms with but three teachers. There were no classrooms or study halls, and not much attention was paid to lighting….On dark days, we only had kerosene lamps for light," wrote Lila Barrett of the first graduating class of 1895. Miss Barrett

married John R. Thompson, and one of her sons, Paul Thompson, served as Amenia's town judge until the 1960s. He was a great railroad buff and the town historian. His son sold us our house in Wassaic in 1987.

Judge Thompson remembered, when I interviewed him, how the seventh- and eighth-grade boys "found out that if we got a rhythmic cadence going with our feet, we could get the building trembling, and the ceiling gas lights below would start swinging back and forth." The rickety building was torn down when the still-existing brick schoolhouse was built across the street.

In 1928, the School Board District No. 9 proposed a bond of $165,000 to build the new brick school on the site of the fabled seminary. It was to be of fireproof construction, with fourteen rooms, an auditorium that could seat two hundred and a modern gym. That auditorium hosts plays and meetings to this day.

In 1929, the *Harlem Valley Times* reported that the Amenia Free Union School had no bell: "The students were greatly agitated, although the Town Fathers paid but little heed. Bill Banks got up in front of the town fathers and said: 'You may need a biscuit, but we need a bell!'" The appeal for a bell initially went unheard, but a new bell was transferred on a tin wagon to the school. The old bell from the Amenia Seminary was never resurrected or rung again in the brick school building.

But after the new school got its own auditorium in 1929, the drama department took off and soon developed a fine reputation. To this day, Webutuck High School, the public high school located up the road that serves the school district that includes Amenia, Millerton and Wassaic, is known for its fine theater performances and sets.

Arlene Iuliano, later the town supervisor and town historian, who graduated from the brick school in 1944, remembered learning tap dancing: "It was the Shirley Temple era, and everyone wanted to tap dance. We were great jitterbuggers, and we had an orchestra. Big band was in, and I loved the Glenn Miller Band. Even though I was the tallest girl in the class, I was quite the dancer." Iuliano served as Amenia's town supervisor and later historian for many years until she was in her late eighties.

In 1951, the Webutuck School District consolidated, and the Amenia School became an elementary school only. Since the Webutuck School District offered the building to the town for one dollar, it is now the location for the Amenia Town Hall. So, once again, the historic site has undergone a transformation.

THE OLD ONE-ROOM SCHOOLHOUSES, REDISCOVERED

The children of Wassaic and South Amenia attended one-room schoolhouses until the 1960s. Some of those students are still living. Since the 2010s, there has been a movement in the Harlem Valley to restore and reuse the few remaining historic one-room schoolhouses. Two of the schoolhouses, those in Wassaic and Amenia, have been restored to their former glory. The Irondale Schoolhouse in Millerton, north of Amenia, has also been restored and placed at the end of the Harlem Valley Rail Trail for use as a museum and information center.

The Indian Rock Schoolhouse in Amenia has been restored to how it looked in 1858, with reconstructed period desks and little chalkboards. Local children are taken there to experience how school used to be in the 1800s.

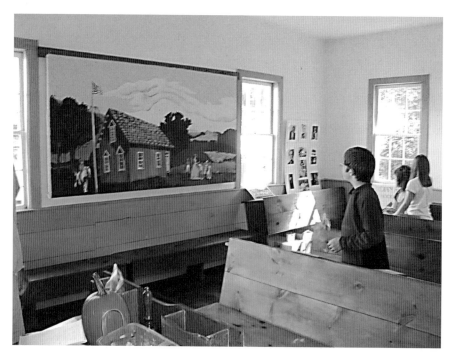

Children visiting Amenia's Indian Rock Schoolhouse. *Tonia Shoumatoff.*

WASSAIC SCHOOLHOUSE RESTORED FOR USE BY ARTISTS

Millbrook Independent, July 15, 2012

In the old days, when children used to skip rope and play jacks, the three-room schoolhouse in Wassaic was the biggest little red schoolhouse in the district. Built in the 1860s to accommodate the children of the workers from the Borden's Milk factory, the school featured ornate Victorian molding, a rolled cinder playground, a potbellied stove and a bell that rang in a huge bell tower to summon the village children to school.

The last school to close in the Webutuck School District (in 1942), the little school is still fondly remembered by a number of local residents. "My favorite subject was geography. We lived in such a little village, and I loved to learn about the larger world," said Joyce Rebillard, who attended the school until 1942, at eighty-three years old. "We used to play hopscotch and marbles in the playground out in front of the school."

Now, almost seventy years later, the charming building with the gingerbread trim is getting a new life as a two-family residence for artists. Anthony Zunino, who renovated the Maxon Mills landmark, purchased the building and gave the schoolhouse a major facelift. "We did not really want to buy it, because it is so historical. But because it was falling apart, we decided we had to do something about it," said Zunino.

The renovation comes at a good time for Zunino's daughter Bowie (named after David Bowie), who is one of the innovative artists who created the Wassaic Project, a site-specific interactive art experience called *Art, Music and Everything Else* that has drawn many people to the area and has been twice reviewed in the *New York Times.*

Bowie and her partners have created an artist residency program that offers artists the opportunity to live and work in the heart of a rural community by providing studio space in the Wassaic hamlet. In the final month of their residencies, artists either complete an installation or contribute work to be included in the Wassaic Project Summer exhibition.

The Wassaic Project initially received seventy applications from as far afield as Berlin and London, California and Maine, and admitted seventeen artists in different shifts throughout the summer. They are housed at the old Wassaic schoolhouse and several other buildings around the hamlet. One of the artists whose mission statement sounds particularly intriguing is Christopher Robbins of the WPA Project: "I will work with community

Wassaic's one-room schoolhouse before renovation as an artists' residency. *Lazlo Gyorsok.*

Wassaic Schoolhouse after renovation by Anthony Zunino. *Tonia Shoumatoff.*

members to identify needed public works and hire unemployed people to achieve them, all under the auspices of the 'USA WPA 2010.'"

Zunino, who has already made a significant contribution by restoring the Maxon Mills building, has added to his Wassaic commitments by restoring the old schoolhouse and giving it a new mission. He has turned it into a functional modern building with two-family-sized spaces, complete with new kitchens, bathrooms and radiant heating. "We found huge doors that could open and close off the spaces into different classrooms behind the walls," said Zunino. "The basement had a tin ceiling and was used for an assembly space for the school. We put in insulation and drainage around the house and repaired all the molding, replacing windows but leaving all the original trim."

The radiant heating uses a small propane boiler with super-high efficiency that adjusts its firing rate to whatever heat or hot water is needed at the moment. The plumbing contractor for the installation, Bruce Thompson, gave us a tour of the heating system, showing how the bendable pipes circulate hot water through the floors. Zunino explained, "We decided to use radiant heating because we thought it was the most efficient way to heat the space. The ceilings are very high, and this way, we don't have to heat the whole building. And the comfort level is wonderful." The propane heating system has a 96 percent efficiency rating, compared with an oil furnace that is around 80 percent efficient.

The first artist residents have since moved into the village and work in studio spaces in the old Luther Auction Barn in the summer and upstairs at Maxon Mills in the winter. One local resident has suggested that traditional games like marbles and hopscotch be reinstated to make the restoration authentic.

TOURISTS ARRIVE IN THE HARLEM VALLEY

The Harlem Valley was once a major tourist destination. Amenia had five hotels, including a Jewish hotel. Temple Beth David is the only synagogue in the New York Register of Historic Places listed east of the Hudson River and north of New York City. Many tourists rented bungalows along Lake Amenia (now drained). The Dover Stone Church, a waterfall inside a cave with a natural stone "pulpit," drew Victorian ladies in hoop skirts who stayed in a nearby hotel—some were even married in the cave.

LAKE AMENIA: A RESORT RUNS DRY

Millbrook Independent, June 25, 2016

Nestled amongst the high, majestic evergreen mountains of Dutchess County at the gateway to the Berkshires, lies the beautiful and serene Lake Amenia. Come to New York's Vacationland in Amenia, New York, where a glorious time awaits you, boating, bathing, hunting, fishing and dancing!
—*Lake Amenia Resort brochure*

In the Roaring Twenties, you could stay in Amenia at a hotel or a bungalow for twelve dollars a week, with twenty-one meals included. You might have danced in a glass pavilion overlooking Lake Amenia to the crooning of Rudy Vallée and a crescendo of fireworks. Flappers of the era delighted in the place.

At the height of Amenia's resort period, which preceded the Borscht Belt, the town boasted numerous hotels and boardinghouses, and the streets were so crowded that there was not enough room to walk down the sidewalks. There was the Hotel Delavergne, the Pratt House, the Hotel Grand House, Lake Amenia Lodge and a Jewish boardinghouse on Mechanic Street. Tourists frequented restaurants, baseball games, clothing stores and a movie theater. Along the lakeside boardwalk, there were many places to buy refreshments, with rustic gazebos and decorative fencing similar to the outdoor features at the Mohonk Mountain House.

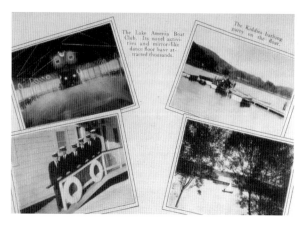

Left: Postcard highlights from the Lake Amenia resort, said in its brochure to "attract thousands." *Amenia Historical Society Digital Collection.*

Opposite, top: Cozy nooks for intimate moments along Lake Amenia. *Amenia Historical Society Digital Collection.*

Opposite, bottom: Lake Amenia, which was compared to a Mediterranean "watering hole." *Amenia Historical Society Digital Collection.*

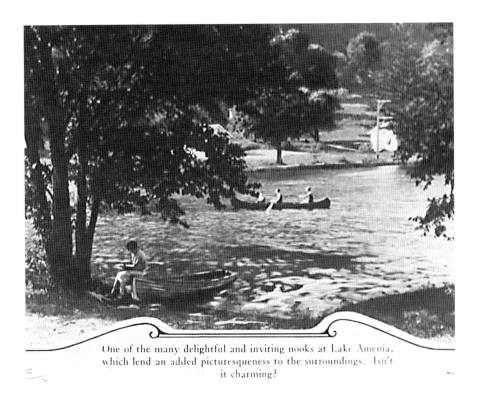

One of the many delightful and inviting nooks at Lake Amenia,
which lend an added picturesqueness to the surroundings. Isn't
it charming?

THE flavor of a fashion-
able Mediterranean water-
ing place is suggested here.
But this picture was taken
from state road No. 21.

In the evening, bands, particularly the Lake Amenia Dunbar Band, played while wearing nautical uniforms with "white trousers and colorful Palm Beach blazers." The pavilion cost $20,000, the equivalent of $250,000 today, to build. Visitors danced on a "mirror-like" dance floor that stretched out over the lake, canoed by moonlight and experienced romantic moments in "lovely, inviting nooks." Tall pine trees shaded larger houses, and bungalow porches overlooked the lake. City folk flocked to the pastoral area in the summers. A steam-operated dredge was brought in to deepen and enlarge the lake in 1928.

And then the crash of 1929 happened, and things came to a standstill.

All of this activity had brought great prosperity to Amenia until the Catskills acquired its resorts and hotels in the 1930s and 1940s and everyone flocked there instead. It only cost two dollars to take the train on a round-trip to Amenia in those days. The old train station was located roughly where the entrance to the Harlem Valley Rail Trail is today on Mechanic Street.

Now, one wonders why the sign says, "Lake Amenia Road," because there is no lake. It is just a marsh with a stream running through it.

Newton Reed's history of Amenia traces the history of the Mill Pond, which preceded Lake Amenia, back to the 1700s. In 1763, Louis Delavergne purchased the one-thousand-acre property, including Delavergne Hill, from the Town of Washington (which now includes the village of Millbrook). In 1863, Thomas Lake Harris, the utopian minister, bought and developed the Amenia flour mill in the hamlet, also establishing his winery and founding the Amenia Bank.

In 1955, Hurricane Diane decimated the East Coast. Rain poured in Amenia for four days. The mill pond dam broke, and Lake Amenia overflowed its dike and flooded the area. The fellow who had the key to the sluice gates was inebriated and lost it. So much water came down that a farmer's cows were washed down what is now Route 22. The streams swelled fourteen and a half feet above their normal height. Fish were flopping on all the roads, and people were picking them up in baskets.

Rudy Eschbach from South Amenia remembered that his family's herd of fifty cows was stranded in the pasture on the other side of the street. His family rounded them up in rowboats, lassoed some of them and jingled pails of feed to entice the rest to swim over so they could be milked. The corn was all knocked down, and it took days to harvest even one field.

By the 1950s, boardinghouses and bungalows were out of style. The dam was never rebuilt. The lakeside community simply vanished. Mr. Beekman,

one of the area's owners and developers, sold land to the town in the mid-seventies for $22,000, and the town constructed the ball field there.

An old-timer named Don Smith commented, "The town could put in a new flood control dam to control the level of the lake and easily restore it. It would be wonderful to have the lake back."

THE VAN AMBURGH CIRCUS AND GREAT GOLDEN MENAGERIE IS SOLD IN AMENIA

The showman and elephant afficionado Hyatt Frost became the proprietor of the Van Amburgh Circus and Great Golden Menagerie after the death of the famed lion-tamer Isaac van Amburgh in 1865. Frost lived in Amenia for twenty-five years. His large property now belongs to the Maplebrook School. He originally came to Amenia for the Eastern Dutchess Agricultural Society Fair, where he exhibited some of his exotic animals. The fair was held on the thirty acres of what is now the Freshtown Plaza. Frost was elected vice-president of the agricultural society in 1871.

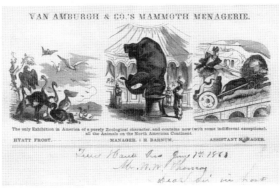

The entire Van Amburgh menagerie was sold by Frost in Amenia in 1881 at a big auction, and the business was discontinued by 1884.

Van Amburgh & Company's great golden menagerie and circus will be sold at public sale on Thursday, November 22, 1881, at Amenia, New York, the present management having grown wealthy in the show business now wish to retire. This show has been successfully managed by Hyatt Frost for thirty-five years.
—Connersville (IN) Examiner, *November 10, 1881*

There was quite a gathering of representative circus men at [Amenia, NY,] *last Tuesday when Van Amburgh* [represented by the owner, Hyatt Frost,] *sold his Great Golden Menagerie and Circus. There were seventy horses offered, with wagons, harnesses and circus paraphernalia, besides menagerie animals. Cole, Coupe, Hutchinson and others were present, but Forepaugh* [a major competitor of P.T. Barnum and the Ringling Brothers] *did most of the bidding and succeeded in securing nearly everything worth buying, including Bolivar, the elephant, for which he paid $7,100. He also bought the double-horned rhinocerous for $2,400.*
—Decatur (IL) Daily Review, *November 28, 1881 (The newspaper mistakenly referred to Amenia, New York, as Armenia, Pennsylvania.)*

Frost, a native of South East in Putnam County, had an early interest in the circus, especially elephants. Hyatt and his brother Eli became enthralled by stories about the first elephant that came to this country, Old Bet. He and his brother Eli worked at Turner's Circus in Danbury and at Howe's Circus in South East as cage cleaners in order to be near the elephants. By 1849, Hyatt was running a one-wagon sideshow for Van Amburgh. Capitalizing on the gold rush, it featured a "big bug of California" that was actually an armadillo. Hyatt and Eli Frost eventually held a variety of jobs with the Van Amburgh show. Van Amburgh himself was from Fishkill, also in Dutchess County, and had also started out as a cage boy.

The spellbinding performances of Van Amburgh, dubbed the original "lion king," featured Van Amburgh in Roman dress going into the cages of his big cats and putting his head into their mouths. His acts brought him great fame and financial success in Europe as well as America. Queen Victoria saw his show seven times in 1839, and she commissioned a painting by Sir Edwin Landseer that shows Van Amburgh laying prone, along with a lamb, with all the big cats in their cage.

Sir Edwin Landseer, *Van Amburgh and the Lions. Steel engraving from* The Works of Edwin Landseer *(London: Virtue & Co., circa 1880).*

Frost had signed on as a young boy with Van Amburgh's Circus, later becoming a manager and publicist, as well as Van Amburgh's business successor. He developed a partnership with P.T. Barnum, forming the Barnum and Van Amburgh Museum and Menagerie in 1866. Frost also owned Herr Driesbach's Menagerie, Indians and Circus and Van Amburgh and Company's Floating Palace on the Mississippi River. Later, he formed a partnership with Reiche and Brother of New York, prompting the *Poughkeepsie News Press*, on March 4, 1885, to declare: "Thus Duchess County contributes three men who are part owners of three of the most successful circuses and menageries in the country—Hutchinson, Ferguson, and Frost—all of whom began their show lives with Van Amburgh."

The Van Amburgh and Company circus tour of October 1875 had "stands" in Pine Plains and, finally, Amenia, where the circus again stopped in April 1877. For many years, the animals wintered on North Street in Amenia. After the Van Amburgh menagerie was sold, Frost leased the Van Amburgh name to the Ringling brothers in 1889.

Frost estimated that during his career, he had traveled over one hundred thousand miles in a buggy. He died in Amenia on September 3, 1895.

THE DAY LADY BIRD JOHNSON CAME TO AMENIA

Millbrook Independent, July 5, 2016

Mary Lasker, a famed philanthropist involved with urban beautification and scientific research, had an estate in Amenia's posh Smithfield hamlet years ago. One day, Lady Bird Johnson announced that she would like to

pay Lasker a visit in tribute to the millions of daffodils and tulips she had donated and planted along the banks of the Potomac River.

Wanting to spruce up the town for the first lady, Lasker arranged to have crab apple trees planted and blooming in front of every house on both sides of Route 22 leading into the village of Amenia as Lady Bird drove through. The crab apple trees were stunning and made a grand impression. A splendid display of the pink and white blossoms festooned the previously drab sidewalks, all to provide a cheery entranceway for the first lady.

The story continued at Mary Lasker's estate, where Lady Bird had a lovely dinner as security guards scurried around to make sure the grounds were properly lit both for her protection and to highlight the thousands of daffodils that Lasker had planted on the hillside, all for Lady Bird's delight. As Lady Bird and Mary Lasker enjoyed a nightcap on the veranda, the entire area was suddenly plunged into darkness by the over-enthusiastic efforts of Lasker's security forces, who overloaded the circuits with the hundreds of outdoor lights. The blackout extended throughout the valley

Mary Lasker, Lady Bird Johnson and legendary heart surgeon Michael DeBakey at the 1983 Lasker Medical Research Awards luncheon. *Mary Lasker Papers, Columbia University Rare Book and Manuscript Library.*

and took days to remediate. Lady Bird graciously enjoyed the rest of the evening by candlelight, not expressing any disappointment about the sudden darkness.

Unfortunately, most of the Amenia crab apple trees have either not been maintained or have been cut down, although a few still remain. But the Amenia Garden Club continues Mary Lasker's tradition of beautifying the town by providing hundreds of tulip and lily bulbs each year, free to all residents who wish to beautify their property. The bulbs are purchased with the proceeds of a garden tour called Hidden Gardens of Amenia, which was started by Diana King, herself a grand dame, whose garden was one of the most splendiferous in the town.

DOVER STONE CHURCH: A CAVERN WATERFALL

Millbrook Independent, July 6, 2010

The Dover Stone Church was so named in the early 1800s, when it was frequently visited and written about. There was even a Stone Church Hotel about one hundred yards from the cavern, where travelers from New York City could stay.

The amazing stone cavern is a cave with a waterfall inside and a protruding "pulpit" that is a fascinating geological phenomenon.

An article in *Family Magazine* 3, titled "A General Abstract of Useful Knowledge," describes the area, saying: "The Stone Church is a singular curiosity worthy of a visit to Dutchess County. From June 1 to December 1, 1832, there were about eleven hundred visitors to this place…which presents relief to the wanderer from the heat and confusion of the city." The Stone Church comprises a fissure in the rock, which creates a cathedral-shaped opening. Inside is a cascading rivulet that creates a waterfall. The huge inner part of the cavern has a massive rock formation that can be climbed via a ladder. The top of the rock formation was referred to as the pulpit.

Literally thousands of visitors came to Dover every year in the 1800s to visit the Dover Stone Church, and many couples got married there, with ladies in hoop skirts climbing up the series of stone steps to the cavern.

In 1847, the Hudson River School painter Asher Durand visited the Dover Stone Church and made sketches of the site. Later, during the Great Depression, Arthur Powell and other landscape artists painted the site

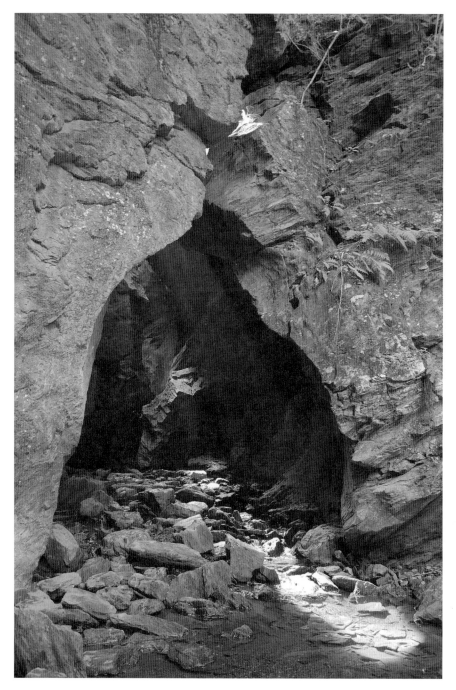

The Stone Church, a cavern where Native people hid out that enticed Victorian visitors.
Mike Adamovic.

Dover Stone Church (1876), brochure by Benson J. Lossing. *The Friends of Dover Stone Church.*

with the support of the WPA (Works Progress Administration), enacted by President Franklin Delano Roosevelt.

Benson Lossing, who edited the *Poughkeepsie Telegraph* and, later, the *Poughkeepsie Casket*, wrote a booklet called *The Dover Stone Church*. He was also an engraver who was renowned for making a sketchbook of the American Revolution and, later, a three-volume set on the Civil War. He was one of the original trustees of Vassar College and described the history and scenery of the Hudson Valley in the *London Art Journal* in the 1860s. The early Native history of the Dover Stone Church that follows is paraphrased and derived from Lossing's writings.

In the early 1800s, a wandering Native basket maker crossed over the mountains from Kent, Connecticut, to sell her wares in the valley of the Tenmile River. Her name was Princess Eunice Mauwee, and she was the granddaughter of Chief Mauwee, who established the Schaghticoke tribe in Kent.

Princess Mauwee spent many nights in the mansion of the family of Benson Lossing on Chestnut Ridge, bordering the towns of Dover and Millbrook, where she was hospitably received after knocking on the door to show the family her baskets. During the long summer evenings, she would recount marvelous stories about the past of her people, and the young people of the family would gather around and listen in rapt attention. She lived until she was 104 years old.

The Schaghticoke tribe comprised direct descendants of the Pequot and numerous other tribes who had been chased off their lands after brutal battles with the British. The Pequot had dominated the entire region of what is now Connecticut and eastern Long Island.

The chief, or sachem, of the Pequot was Sassacus, a feared leader and fierce warrior who consolidated Pequot control over the wampum and fur trade, subjugating other Native peoples of the region and allying with the Dutch against the English. The Pequot tribe was wealthy and powerful. Sassacus's chiefship extended from the Narragansett Bay to the Hudson River. It is said that at the height of his power, no fewer than twenty-six sachems were subordinate to him.

Leaders of the Massachusetts Bay colony found justification for attacking the Pequot, joined by the newly founded colony of Connecticut and Native tribes chafing under Pequot control. The Connecticut militia of English soldiers and their Native allies attacked a Pequot fort on the Mystic River, burning a major wigwam encampment and slaughtering over six hundred men, women and children in retribution for Pequot aggression.

In the aftermath of the massacre, Pequot warriors furiously attacked the withdrawing British. In the frenzy, the Pequot sustained heavy losses, which virtually destroyed them as a military force. Sassacus, finally seeing no possibility for success in battle after a noble fight, fled across the Pequot River (subsequently renamed the Thames River), hotly pursued by the British. A large contingent of Pequot took refuge in a swamp near what is now Fairfield, Connecticut, where the British attacked them over two days. The Fairfield Swamp Fight was the last major action in the Pequot War. The Pequot fought using ruse and ambush strategies. They had to get close enough to the English so their bows could be fired accurately enough to pierce the British armor. But their arrows could not prevail against the British muskets.

Sassacus and his bodyguard of about twenty warriors split off from the larger body of Pequot fighters, fleeing northwest over the mountains into the valley of the Housatonic River and proceeding into the lovely Webutuck Valley near Amenia. Strong local traditions, including Native traditions, hold that the party hid for a time in the watery cavern now known as the Dover Stone Church. There, they would have subsisted on berries and fish, which abounded in the Dover Stone Church Brook, a tributary of the Ten Mile River.

The Dover Stone Church was long thought to be where Sachem Sassacus was attacked and killed by Mohawk warriors. Historians now believe that

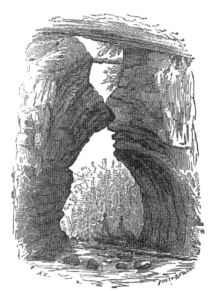

Above: Engraving, English colonists attacking the Pequot fort on the Mystic River in May 1637. *Wikimedia*.

Left: Stone Church interior, *Dover Stone Church* (1876), by Benson J. Lossing. *The Friends of Dover Stone Church*.

View of the Dover Stone Church.
(From the inside looking out.)

he may have fought in a skirmish there but then fled back toward Danbury, Connecticut, where he was captured and killed by the Mohawk, who sent his scalp to the British as a goodwill offering.

Descendants of the Schaghticoke people continue to live in Kent, Connecticut, just over the border from Amenia. The tribe was split over the issue of gambling casinos and has yet to achieve federal recognition.

2

UTOPIAN COMMUNITIES ABOUND
IN UPSTATE NEW YORK

S tarting in the early 1800s, Upstate New York became a crucible for the incubation of an astounding array of utopian communities, most of them religious or inspired by a social or cultural movement. Some promoted free love, and some prohibited sex; some farmed, and others created great furniture crafts or flatware and cutlery. Many espoused the idea of purifying themselves in anticipation of the second coming of Christ, after which they expected there would be a cataclysmic apocalypse. Others believed the second coming had already been accomplished and that they only needed to make themselves worthy for the kingdom of Christ to be realized on Earth. Still, others looked for new kinds of models of group property ownership amid the abuses of the Industrial Revolution. Many simply sought a safe space away from the fray during and after the Civil War. By the mid- to late 1800s, there were scores of such small communities: Shakers, Quakers, Mormons, Adventists, Transcendentalists, Footwashers, Perfectionists, Spiritualists and Anthroposophists, to name a few. John Humphrey Noyes's famed Oneida Community in Central New York state was a Perfectionist group. Some still exist today.

Indeed, New York had a "religiously fecund atmosphere," as proclaimed by Fawn Brodie in her biography of Joseph Smith Jr., who founded the Church of Latter-day Saints in Fayette, New York. Today, all that is left of many of these communities are their buildings and, in some cases, their furniture and crafts.

One of the more renowned communal groups was the Shaker Society, which attracted thousands of converts, building more than twenty settlements. The earliest Shaker community, established in New Lebanon, New York, was located a little over an hour away from Wassaic. In the 1940s, after the few remaining Shakers left, a portion of the site was sold to the Darrow School. Later, in 1975, most of the buildings were acquired by the Sufi Order of Pir Vilayat Khan. The order established a Sufi community there called the Abode of the Message. Pir Vilayat's followers also established the Omega Institute in Rhinebeck, an internationally known New Age teaching center. According to the institute's literature, "Today, the Abode continues as one of the few enduring intentional communities among those that arose by the thousands from North America's new spirituality movement and the 1960s counterculture."

The Bruderhof, which was propelled into existence after the social disintegration of World War II, has four communities in the Western Hudson Valley region. Community members renounce all private property, raise their children in family units with community resources and support and care for the disabled and elderly as a community. They produce wooden playthings and furniture for classrooms.

I also found out that from 1848 to 1880, the Oneida Community practiced a system called complex marriage, in which any member was free to have sex with any other member by consensual appointment. Exclusive relationships were frowned upon. Women over the age of forty were to act as sexual "mentors" to adolescent boys. These women then became religious role models for the young men. Likewise, older men often introduced young women to sex. Oneida silverware and flatware still exist today.

What is it about Upstate New York that has been the draw for these communities? Is it the open space, with plenty of privacy for communal living and acreage for farming? Surely the beauty of the land spoke to the souls of many of these utopians, who may have been attracted at first by the area's practical advantages, such as its relative proximity to the Hudson River and urban areas, such as New York City and Albany, as well as, of course, its access to some of these areas by train.

Historically, was there any formula that enabled some of the groups to survive while others faded away? What was the average length of time that they existed? Was there any unifying aspect common to all of them? Are the many newer foundations—Omega, the World Peace Sanctuary, Tibetan Buddhist monasteries, former Christian monasteries along the Hudson River—part of the same movement?

The people and groups that I have chosen to profile in this book are the ones in or closest to the Harlem Valley: Thomas Lake Harris and his Brotherhood of the New Life; May Peace Prevail on Earth International; the countercultural community in Millbrook started by Timothy Leary; Bill Henry's nonviolent peace activism and his farm refuges in Pine Plains and, subsequently, Wassaic; and ARC 38, a Wassaic community originating in the Occupy Wall Street movement, drawn by Henry's radical hospitality.

Victorian Utopian Group Comes to Wassaic and Sees Fairies

One of the more peculiar episodes in the history of Wassaic entails a community called the Brotherhood of the New Life, or the Use, founded by Thomas Lake Harris, a minister turned poet-prophet. Now a relatively obscure but fascinating figure, Harris was referred to as "America's best-known mystic" by philosopher William James in his celebrated book *The Varieties of Religious Experience* (1902). Harris and his group settled in Wassaic in May 1861, when Harris was thirty-eight years old, at the beginning of the Civil War.

Harris came to Wassaic to start a "Breath House," where his followers could be initiated into seven spiritual levels of what he called the Divine Breath. He claimed to have the power to enable his followers to see fairies and to be united with Queen Lily, a female deity. He spoke to his followers mostly in rhyme through poetry—and some very bad poetry at that. Later in its development, the group made wine that it believed, in Harris's words, "did not get people intoxicated."

Harris was hailed as a Victorian saint by some, including some with a good sum of money. His perceived mystical powers attracted an odd array of followers, including twenty young Japanese samurai, wealthy American southerners who sold their plantations to escape the bloodshed of the Civil War and a British member of Parliament, Sir Laurence Oliphant. Oliphant renounced his brilliant diplomatic career to join the Use, as the commune was called, doing manual labor ("hoeing in the vineyard") and living in a shed that he furnished himself with flimsy vine boxes.

The original Breath House was located on the south side of the Wassaic Creek, across the stream from the extant charcoal kilns, south of Deep Hollow Road off State Route 22. It shows up on some 1867 maps.

At the end of 1863, according to Arthur Cuthbert, Harris's biographer and lifelong devoted follower, the Use moved to Amenia, a few miles to the north, while retaining the Wassaic property for a time. At the end of 1867, Harris moved again to Brocton, a grape-growing region in western New York State on the shores of Lake Erie. A few years later, in 1875, he made a decisive move to Santa Rosa, California, where he established the famed Fountain Grove Winery and where, in the 1890s, the story of the Brotherhood of the New Life came to a scandalous close.

Sir Laurence Oliphant. *Gaye LeBaron Collection, Sonoma State University Library.*

Born in England in 1823, Thomas Lake Harris immigrated to the United States as a child and was brought up in poverty in Utica, New York. His preaching soon attracted attention, and while he was still a young man, he was, for a time, a prominent Universalist minister in New York City. But Harris gradually became "unsectarian." Leaving the Universalists, he pursued his interest in Spiritualism, influenced by the pluralistic theology of Emanuel Swedenborg, and formed the independent Church of the Good Shepherd. Horace Greeley, the crusading founder and editor of the *New-York Herald Tribune*, and his wife were members of Harris's new congregation. Greeley promoted many utopian reforms, such as socialism, agrarianism, feminism and vegetarianism, some of which Harris also espoused, including another "ism," which he called "theo-socialism." Harris was already asserting the reality of unseen spirits, angels and the efficacy of breathing techniques to connect with "divine counterparts" (of the opposite sex), which Harris asserted existed as "spiritual soulmates" in the unseen realms.

After an unsuccessful attempt in the early 1850s to co-lead a Spiritualist community in Virginia, Harris was invited to lecture in London, where he published *The Wisdom of Angels* (1857) and embarked on writing a book about the "coming apocalypse." Sections of this work appeared in his monthly periodical the *Herald of Light*, which he had been publishing in New York since 1857. In its final issue, in May 1861, he said he "was called to return immediately to America...where momentarily a storm of blood and fire could be expected...a reign of blood such as the world has never before seen." This was due, he believed, to the advent of the Civil War.

Arthur Cuthbert wrote that the "horrors of negro slavery...deeply penetrated Harris' heart...as the most monstrous outrage existing on the

planet." Harris said he felt strong sympathy for the abolitionist movement and even with the "fiercer spirit that flamed up in the bosom of John Brown."

Having witnessed the labor abuses of the Industrial Revolution in England, Harris became a champion of a movement he called theo-socialism. His community, he wrote, believed in the "noble and cultivated association of souls for every industrial and human service…living together…making every day a Sunday to set a lively example to others." He rejected communism, nevertheless, concluding, "The Spirit of Liberty is abandoning the social edifice, both in Europe and America….However intelligent, virtuous and well-meaning the electorate may be, they are virtually powerless. Yahoo civilization is doomed…and the final question of the political economy is what is open for discussion, namely the reorganization of the industrial world." These words still resonate 150 years later.

"Socialism," Harris asserted, "must learn its lesson from the capitalists.… It must associate into compact, local groups capable of concerted action." Thus, when Harris first moved up to Wassaic with twelve of his followers, they held all their monies together in a trust.

Harris formed his New Life Community in revolt against church doctrine. His main tenet was that "God's breath," when breathed interiorly, "by inspiration from above to respiration outward," could transform whole communities. He held that God was bisexual, Yessa-Yessus, an idea considered heretical. He also believed himself to be the prophet of a new tradition that celebrated the divine feminine as Queen Lily, his own divine counterpart in the realm of Lilistan. Harris seemingly practiced a form of tantric sexual eroticism with these noncorporeal beings he called divine counterparts.

Harris said he could enable his followers to refine their energies through a form of "open," or pranic, breathing. Those sufficiently initiated into the Divine Breath (after achieving the fourth level) would be able to summon and see "tiny angels and faeries," the "minutest of the minute, tiny innocences who exist in untold multitudes in the vegetable matrices." They would reveal themselves only to the pure of heart, "babies and those whose bosoms throb with the Divine Breath." Thus, "when babies are seen smiling in the cradle and reaching out their little hands to grasp invisible objects, these airy little guests are forming tableaux in the sunlit air that only they can see."

Those who were initiated could experience "fays wafting and rising in a purple mist from banks of violets on a summer's eve, all enveloped in the sea of perfume in which they sport.…The body thrills with fairy life, there are whole families of them abiding in a single rose." Certain members of the commune in Wassaic claimed that they could hear the faeries' little voices.

Talking to the Fairies. Gaye LeBaron Collection, Sonoma State University Library.

Harris selected an "internal" name for each member of the Use whom he initiated into the Divine Breath. The names they were given often corresponded to the flowers they were cultivating when they said they saw fairies, such as Golden Rose, Yellow Blossom, Woodbine (Sir Laurence Oliphant), Seed Corn, Sweet Briar and Tiny Funnyhorns. "Dovie," the heiress Jane Lee Waring, Harris's closest associate and, much later, his third wife, was named after the Holy Spirit (symbolized as a dove). Harris's own internal names were Faithful and Father. The fairies playfully called Harris "Little Yabbit."

Meanwhile, the members of the community in Wassaic were digging, chopping and hauling firewood from the woods for winter use, gathering

the apples from the orchard and doing all their household and out-of-doors work with their own hands. If they did not properly comply with Harris's demands, he would punish them by having them wear rags, sing with a lisp and speak to each other in baby voices.

In Amenia, the Use moved to a flour mill "closer to the larger village," about four miles north of Wassaic. According to Herbert W. Schneider and George Lawton, who wrote the "standard" biography of Harris (1942), they "dressed like the farmers or villagers in Amenia, except they wore their hair long, resembling members of other religious and socialist communities of the day." Jane Lee Waring supervised the community's farming, including the planting of a vineyard, the first foray into what was to become the "chief business of the community," according to Harris.

Harris established the First National Bank of Amenia in 1866 with capital from the pooled funds of the members (particularly from the jewels of Sir Laurence Oliphant's mother and £150,000 from his own inheritance, worth well over $1 million today). Harris was the bank's president, and its cashier was James Augustus Requa (Steadfast), Harris's trusted business manager. At first, the bank was a small, one-room wooden building with a counter and a formidable iron safe. This structure was replaced by a substantial stone building that still anchors the hamlet of Amenia today.

Amenia Bank, Fountain Square. *Gary Thompson Collection, Amenia Historical Society.*

In the late summer of 1866, two samurai students, Naonobu Sameshima and Kiyonari Yoshida, visited the Use with Sir Laurence, whom they had met while attending University College, London. Sameshima and Yoshida and the other samurai students who later came to Harris's utopian community belonged to the most elite clans of the Satsuma Domain.

At the end of 1867, Harris moved his community to a settlement later incorporated as Brocton on the shores of Lake Erie. Harris called the settlement Salem-on-Erie. Before leaving Amenia, he bought a quantity of the newly introduced Salem grape, a coveted hybrid created by Edward Staniford Rogers.

James Requa suggested and then directed this move but died soon afterward in 1868. Harris bought twenty properties, totaling 1,200 acres. With another $100,000 of contributions from members, Harris built an impressive estate for the group—with free labor, mostly from his followers. Vine Cliff, his lavish personal house, had thirty rooms filled with ornate furniture, plush carpets, expensive paintings and a library (however, there were only binding covers without any pages for most of the volumes). The house was surrounded by ornamental plantings, a fish pond, a fountain and even a deer park.

In Brocton, Harris undertook the "manufacture and sale of pure, native wine, made especially for medicinal purposes." The brotherhood's winemaking operation, later using some forty varieties of grapes, produced fifteen thousand gallons of wine each season, which was stored in a huge, one-hundred-foot-deep underground vault. "All the wines of the brotherhood were infused with the divine aura and were therefore absolutely harmless," Harris claimed. He later became a renowned master vintner.

Further investment followed. With the Oliphants' money, Harris purchased eight hundred additional acres and opened a restaurant and a coal-producing operation, financed by the sale of the Amenia Bank and other properties, including those in Wassaic and Amenia. He believed that all the affairs of the brotherhood were divinely blessed, and the group did indeed prosper. Those who knew Harris said he was shrewd in practical matters, with "no trace of the seer or mystic about him when it came to money." The community grew to include over three hundred people, with many newcomers drawn to Harris because of post–Civil War social and political upheavals.

Around the same time as the community's move to Brocton, the samurai students in London found that Satsuma could no longer support their studies, owing to the political and military conflicts culminating in the Boshin War

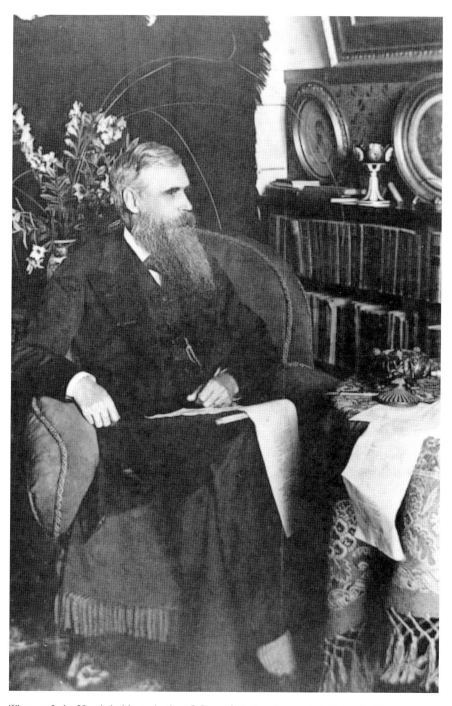

Thomas Lake Harris in his study. *Gaye LeBaron Collection, Sonoma State University Library.*

(1868–1869) preceding the Meiji Restoration. Sir Laurence Oliphant and Thomas Lake Harris were both in London when Harris invited the Japanese students to come to his community to work and study. Most chose to return to Japan, but six of the students, unofficially led by Arinori Mori, accepted Harris's invitation. Every member of this original group subsequently made valuable contributions to their country, either at home or abroad. Other students came later. In all, approximately twenty Japanese students spent time in Harris's brotherhood. Of the original six, only Kanaye Nagasawa—at the age of fifteen, the youngest among them—became a permanent and, in fact, essential member.

Thomas Lake Harris in his sixties. *Sonoma County Library.*

In 1875, Harris moved to Santa Rosa, California, near the Napa Valley, naming his new estate Fountain Grove and quickly establishing vineyards there. He left many of his most loyal followers—including Laurence Oliphant and his mother—behind in Brocton, saying they were not spiritually evolved enough to come with him. Oliphant was not permitted by Harris to be united with his wife, Alice le Strange, for over ten years.

Soon after arriving in what became Fountain Grove, Harris received an apocalyptic message that he was to write a book for the public declaring that the end of the world had arrived and that the second coming of Jesus was now resident in Harris's body. He believed that he was the deity himself. *The Lord: The Two-in-One; Declared, Manifested and Glorified,* the book announcing this momentous event, was printed in Brocton by the Brotherhood Press in 1876. To the dismay and chagrin of Harris and his followers, the publication was basically ignored outside their own community.

In 1881, Sir Laurence Oliphant arrived at Fountain Grove with his mother, who was dying of cancer. When he confronted Harris, he noticed that his father's watch had been given to Mrs. Requa (Golden Rose), who shared Harris's bed in order to be united with her counterpart, her late husband. Oliphant saw that another woman follower was wearing his mother's ring. Appalled by the opulence with which Harris surrounded himself, Oliphant threatened to sue Harris for the funds he and his mother had given him. Sir Laurence later wrote in his diary, "I had reason to believe that he had entirely abandoned the early purpose of his life and was selling gold for his own private ends, the gifts with which God entrusted him for

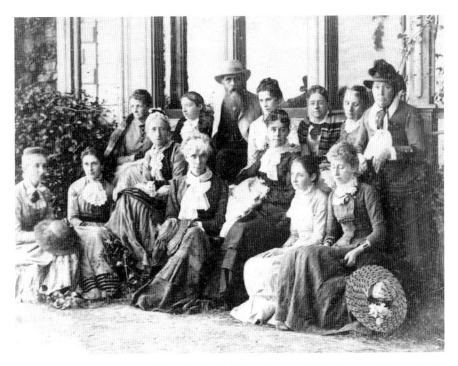

Thomas Lake Harris surrounded by female disciples, circa the 1880s. *Museum of Sonoma County.*

the service of humanity, thus converting him from a religious reformer to a religious imposter."

To forestall the lawsuit, Harris returned to Brocton and sold all the properties there to pay Oliphant and the other disgruntled members, who likewise were shocked by what they had heard about the sexual goings-on at Fountain Grove and had tired of Harris's constant demands for money. One Brocton family, the Emersons, went on to purchase a winery in Washingtonville, New York, which they named the Brotherhood Wine Company. It still exists and is credited with launching Hudson Valley wine tourism in the 1960s.

In June 1891, a young woman named Alzire Chevaillier, a suffragist magazine writer and feminist reformer, visited the colony with her mother. They remained for six months. Upon leaving, Chevaillier wrote a series of letters to San Francisco newspapers and the local *Sonoma Democrat*, exposing the "licentious" activities at Fountain Grove.

The townspeople of Santa Rosa heard about members in large bathrooms rubbing each other while nude to "de-magnetize" and remove "negative

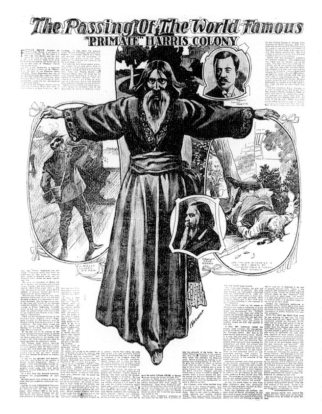

Harris depicted as a menacing black magician: "For Thomas Lake Harris, spiritual prophet, seer, reformer or what not, is no ordinary man." *From the* San Francisco Call, *May 19, 1901.*

influences and entities." They learned of the practice of spiritual sexual "counterparts" and were scandalized by the inference that the celestial counterparts could sometimes be found in the natural bodies of members of the opposite sex to whom a member was not married. Coupled with the fact that Harris was always surrounded by a large circle of women, these revelations caused no end of speculation.

According to the Santa Rosa History website, Chevaillier gave lectures in San Francisco and Santa Rosa, where she "melodramatically demanded that either she or Harris should be sent to state prison." She charged that Harris was a "vampire," a lecherous fiend" and a "horrible sensualist." He was the "greatest black magician today," who had "boasted to her that he had psychically murdered Laurence Oliphant."

Although Harris stated that spiritual counterparts would only "reveal themselves as fays, voices or visions," a certain naïve Miss X was taken aback, according to Schneider and Lawton, when she discovered the method of getting "consolation from the Lily Queen," Harris's counterpart: "The troubled soul was to go to Mr. Harris's room and get into bed with the Lily

EXPERIENCES OF A SISTER IN THE NEW LIFE

The following account is from an anonymous young lady from San Francisco who stayed with the Brotherhood of the New Life in Santa Rosa:

Mr. H. put his hand upon me and told me to cry just as much as I wished, that it was my Mother's house, and in it I must feel perfect freedom to do as I pleased....He gave me a lovely white lily. We went outside. I told him I was not married. He said "Oh, yes, you are, as much as I am. Yes, your counterpart died when he was four years old."

I occupied the room that Mr. H. usually does. I slept tolerably well only, but...kept feeling sensations in my arms. Well, since I have felt them quite often, and they seem to be gradually extending over my body. This morning for the first time, I felt it enter my head and also pass into my thighs. The first time that it came into my body, that is the trunk, it seemed to enter through the generative organs, and with it came the thought, "This is like sexual intercourse, only infinitely more so, in that every atom of your frame enters into union with another atom to the furthest extremity of your body." I am sure I never had such a thought before, nor supposed that anything could be of such infinite gratitude. I felt infinitely calm and peaceful, nothing turbulent and passionate about it, and my only desire was to constantly pray in thankfulness. If it were indeed...my counterpart, I can only imagine in some slight degree what might be in store for us all.

Queen." Miss X asked what became of Mr. Harris. "Oh, the Lily Queen is inside of the Father, and consequently, he stays in the bed, and by getting into his arms, we get into her arms."

Harris could not withstand the public uproar instigated by Alzire Chevaillier. In early 1892, he hurriedly married Jane Lee Waring and fled to New York City. Long before, he had put the Fountain Grove winemaking operation in the very capable hands of Kanaye Nagasawa, whom he had named Phoenix. For decades afterward, the winemaking operation flourished. Kanaye Nagasawa renamed the winery Fountaingrove in 1933 and planned for a post-Prohibition expansion, but he died in 1934, and the winery was sold and converted to a cattle ranch.

Harris and Dovie also built a retreat in Florida, where Harris passed away in 1906, after making several unsuccessful attempts to form a new

community. Only after two months did the true believers at Fountain Grove accept the fact of Harris's death.

Arthur Versluis, an authority on American esotericism, wrote in a paper about sexual mysticisms of the nineteenth century, stating that Thomas Lake Harris was one of the most influential leaders of an American utopian community in the post–Civil War period. According to Versluis, Harris "saw heterosexual union as part of an esoteric Christian mysticism aimed at realization of an angelic androgynic unity and ultimately at union with God."

JAPANESE SAMURAI COME TO WASSAIC TO THE BROTHERHOOD OF THE NEW LIFE

So, how and why did some of the most promising young Japanese men from the most influential and prestigious samurai families end up coming to the small hamlet of Wassaic in Upstate New York starting in 1866? The reason was quite curious: they were actually impressed by Harris and his strange religious ideas. They also hoped that he would sponsor their continuing education in America.

There were six original samurai students of "good lineage and social standing" who came to participate in the Brotherhood of the New Life and the "Breath House" that Thomas Lake Harris was establishing in this small agricultural community in Dutchess County. The young men, all in their early twenties, were from the Satsuma Domain (now called the Kagoshima Prefecture), which was one of the most powerful and wealthy domains in Japan during the shogun Edo period. They had to change their names before they left Japan to study in England, because their travel abroad was in violation of their country's national seclusion policy at the time. They cut off their topknots, renounced their swords and donned western attire.

Sir Laurence Oliphant, then a member of Parliament (MP), had helped educate these students about international affairs when they were in college at the University of London, taking them under his wing and supporting them financially when they lost their financial support in the turbulent period prior to the Japanese civil war (the Boshin War), which toppled the feudalistic Edo era of Japan. Sir Laurence retained a love for Japan, despite having been badly injured there in a sword attack by a xenophobic ronin (rogue samurai).

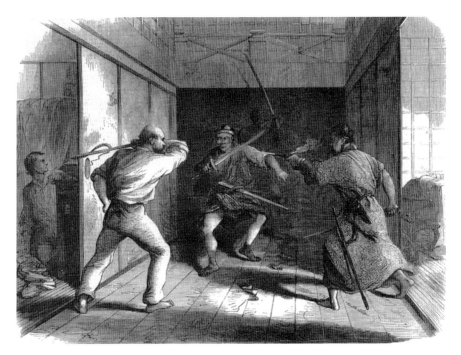

The Outrage on the British Embassy at Jeddo, Japan: Attack on Messrs. Oliphant and Morrison. From the London Illustrated News, *October 12, 1861.*

The young students asked Oliphant for his advice about where they could go to continue their education. Oliphant suggested that they make the journey to New York State to visit the Harris colony. Oliphant offered to pay for their travel, room and board to come and live in the utopian community that was starting up in Wassaic in the town of Amenia. Oliphant, already a follower of Harris, knew that the "prophet" was interested in attracting Japanese followers. Harris thought that the Japanese were more spiritually advanced than westerners and hence would be more open to his teachings.

Harris's closest follower, Arthur Cuthbert, wrote that though Harris thought that "aristocrats were generally poor material for the religious ideas and discipline that he represented, he had, nevertheless, a strong conviction that the royal family of Japan and the descendants of the old princely nobility would prove an exception." He believed this because "in the old Shinto religion, as in his own system, the Divine Feminine was the central and most inspiring influence who ruled supreme over the hearts of all Japanese people from her high altar Fujimyama, as in Harris's theology, where the Lily Queen was sovereign from her home in Lilistan."

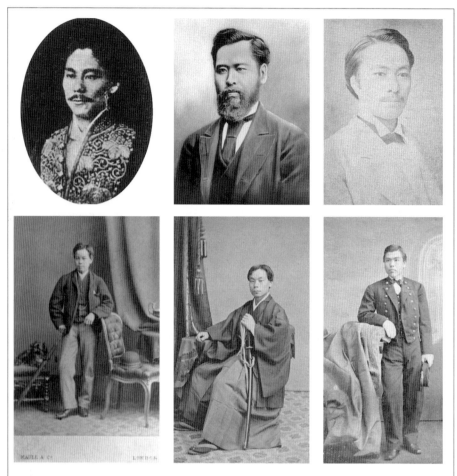

Top row, left to right: Naonobu Sameshima, Arinori Mori, Kiyonari Yoshida.
Bottom row, left to right: Kanaye Nagasawa, Yoshinari Hatakeyama, Junzō Matsumura.

Naonobu Sameshima (1845–1880) was Japan's first resident envoy to Europe starting in 1870. He was also awarded France's coveted Légion d'Honneur (1874). *Wikimedia.*

Arinori Mori (1847–1889) At age twenty-three, he became the first Japanese ambassador to the United States from 1871 to 1873. When he returned to Japan he was appointed as Minister of Education by the Meiji government and helped establish modern secular co-education. *National Diet Library, Japan.*

Kiyonari Yoshida (1845–1891), succeeded Mori (1874) as Japanese ambassador to the United States. He was designated a viscount when he returned to Japan in 1887. *Wikimedia.*

Kanaye Nagasawa (1852–1934) was an internationally renowned horticulturalist called the "grape king of California." He was also Thomas Lake Harris's personal secretary and managed the Fountain Grove Winery until his death in 1934. *Gaye LeBaron Collection, Sonoma State University Library.*

Yoshinari Hatakeyama (1842–1876) graduated from Rutgers College (1871). He became the president of the future University of Tokyo as well as the director of the National Diet Library and the Tokyo National Museum. *Dr. Clark; William Elliot Griffis Collection, Special Collections and University Archives, Rutgers University Libraries.*

Junzō Matsumura (1842–1919) was the first Japanese student to graduate (1873) from the U.S. Naval Academy. He later became admiral of the Imperial Navy and Naval Academy. *N. Bowdish, U.S. Naval Academy; William Elliot Griffis Collection, Special Collections and University Archives, Rutgers University Libraries.*

Below: Retinue of the Satsuma student envoy to the Exposition Universelle de Paris, 1867.
Front row, from left: Junzō Matsumura, Naonobu Sameshima, Kiyonari Yoshida and Hakuai Nakamura. *Back row, from left*: Shipei Minoda, Arinori Mori, Ichiki Masakiyo and Yoshinari Hatakeyama. *Kagoshima City Historical Museum.*

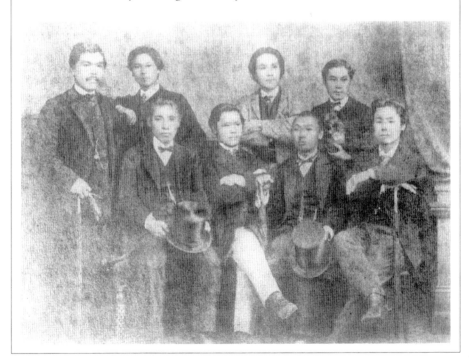

The original group of six students were later valued for their knowledge of the West and were given important assignments both in Japan and abroad, making invaluable contributions during the early Meiji period. A few of them went on to study at Rutgers and other universities in the United States. Some of them left the community after a year because they could not go along with Harris's increasingly eccentric religious ideas. Others from the group, including Mori, stayed longer and later attributed much of their inspiration to the philosophy of Harris. The utopian and apocalyptic ideas of Harris apparently had a significant influence on some of these impressionable young men.

During the time they spent at the Brotherhood of the New Life, they were required to do menial work, working in the fields and kitchen, to prove their worthiness to receive the mystical Divine Breath.

Wassaic: "Most Holy Place on Earth"

I found it more than a little coincidental that more than one hundred years after Japanese samurai students from Satsuma appeared at the Brotherhood of the New Life in Wassaic, another Japanese group came to Wassaic to build a peace sanctuary. There were some interesting historical parallels between the two groups. The parent organization of the modern group was called Byakko Shinko Kai, or the White Light Society, and Thomas Lake Harris had called his journal the *Herald of Light*. Harris espoused divine breathing techniques, and Masami Saionji, the spiritual leader of the World Peace Prayer movement, wrote a book titled *Essentials of Divine Breathing* (2017). Even more striking, Mrs. Saionji is descended from the Ryukyu royal family; the Ryukyu Kingdom was a vassal state of the Satsuma Domain from the fifteenth century until it was formally annexed and dissolved by Japan in 1879 to form the Okinawa Prefecture.

When I sent my daughter to preschool at the Maplebrook School in Amenia, I befriended a young Japanese woman from Hiroshima who was an exchange teacher there named Sonoe Takigawa Okino. She was folding origami paper cranes at the time. She said to me, "Wassaic is most holy place on earth!" I laughed and said, "You have got to be kidding!" She responded, "No, really. People from all over the world will come here to pray for peace. You will see—I'll show you!"

Sonoe took me over hill and dale to the 150 acres of land that the Society of Prayer for World Peace (now May Peace Prevail on Earth, International)

Masami Saionji, author and chairperson, World Peace Prayer Society, the Goi Peace Foundation. *World Peace Prayer Society.*

had just purchased as the location for a peace sanctuary and festival. It had been an old farm that once belonged to the Bentons, the same family who owned Troutbeck. It had a beautiful grove of very tall black walnut trees and a spectacular field with views of the mountains. Sonoe told me that Masami Saionji, the daughter of the founder of the peace movement, Masahisa Goi, was from the royal Ryukyu of Okinawa and had married into the imperial Saionji family. Her husband is Hiroo Saionji, whose great-grandfather Kinmochi Saionoji was a dedicated pacifist who served under three emperors, starting with the Meiji. His dying words were: "There is no reason for Japan to become a military power."

Ms. Masami Saionji, who is referred to as Masami Sensei, and her husband bought the land after looking in six states, as the view of the mountain from the high field reminded them of Mount Fuji. "Coming together of earth and sky energy," she said.

Sonoe folded one thousand tiny paper cranes that summer, each of which had the message "May Peace Prevail on Earth" in tiny writing inside. She gave them away at a local environmental festival supporting the Oblong Valley's fight against gravel mining. Sonoe introduced me to the president of the Society of Prayer for World Peace in New York City, Mr. Tanaka, who liked to be called Mr. T. He hired me on the spot to edit their newsletter and cover an event called Peace Prayer Day at the United Nations. That was during the first Gulf War. Ambassadors in the general assembly participated

in a moving flag presentation, where peace was affirmed for each country. Pretty soon, I was the society's local spokesperson and began helping organize their first peace festival in Wassaic, which drew more than four thousand people. That was in 1991.

It was truly an extravaganza. The Hudson Valley Philharmonic played Beethoven's Ninth Symphony, with four hundred voices from churches around the region in the choir. The World Peace Flag Ceremony was performed, and speeches about peace were given by Bishop Paul Moore of the Cathedral of St. John the Divine in New York City and Vasiliy Safronchuk, undersecretary general for Political and Security Council Affairs. He was Ukrainian, and the Soviet Union had collapsed that year. Ukrainian children in full folk costume sang and danced at the ceremony. Many other people appeared in their native garb to pray for peace. Sonoe's prediction came true: people from around the world did indeed come to the tiny hamlet of Wassaic to pray for peace.

I was suddenly enveloped in an international community that believed in peace. They had already been planting poles for peace for years, especially in sacred spots and war-torn areas. That summer, in the middle of one of the fields, they constructed a giant peace pole that read, "May Peace Prevail on Earth," in eight languages. My husband called it the peace pencil because it came to a sharp point.

I was working with the producer of the event, Mark Duffy, who had produced shows for the Village People. (Remember the song "YMCA"?) He told me, "We're on a mission from God, babe!" I became coproducer of the event, which we created from scratch and had only a couple of months to set up. Mark brought in rock-and-roll roadies with names like Razor and Conan to set up the scaffolding for the stage area and the sound systems; they were stark contrasts to the gentle New Age women in cascading skirts praying for peace. He hired someone called Billy

Local elementary school children singing at the First Amenia World Peace Festival, September 28, 1991. *Video (VHS) cover, New York: World Peace Prayer Society, 1991.*

Sparks to bring in the Native presence, including Lakota pipe holder Arvol Looking Horse, Mohawk chiefs Jake Swamp and Tom Porter and Onandaga clan mother Audrey Shenandoah, all distinguished leaders and spokespeople for their nations.

We set up a meeting with Leon Botstein, the president of Bard College, to ask him to conduct a song composed by New Age composer Richard Shulman, with Amy Fradon and Leslie Ritter singing "May Peace Prevail on Earth." But Botstein declined to conduct the New Age composer's music, saying, "I only conduct dead composers!" Shulman simulated falling dead to the ground, hari-kari style, holding an imaginary knife to his chest. This did not change Botstein's pronouncement, however, so we had to get Joe Eggers, the conductor of the Symphony for the United Nations, to conduct that piece. Leigh Taylor Young, an actress of *Peyton Place* fame, was the mistress of ceremonies.

Over the years, a strange array of celebrities came to sing for peace in Wassaic. Julie Gold sang her famous song "From a Distance, God Is Watching Us"; Natalie Merchant sang; Pete Seeger appeared, apologizing for his waning voice; Paul Winter came—the list goes on. It was heady stuff for a former cornfield in middle-of-nowhere Wassaic.

I had already been part of a global link on New Year's Eve to pray for peace at the stroke of midnight. This movement affirmed the power of group thoughts for peace to create a dynamic energetic field "strong enough to empower the course of planetary destiny," in the words of the May Peace Prevail on Earth International's mission statement—a tall order indeed. Thus, we all felt that we were helping save the world.

It seemed more than a coincidence that the staff working on the first peace festival were from most of the countries involved in World War II: the United States, Japan, Germany, France, Russia, Italy and the United Kingdom. We were all children and grandchildren of those who had experienced the horrors of war, and we felt like we were somehow helping absolve the war karma of the past by praying for peace.

The group of twenty-six Ukrainian children who came and sang at the peace festival that first year were subsequently invited to come live with host families and attend the high school in Amenia.

Some local families, who had never met people from other countries and who had previously been xenophobic and isolated in the Harlem Valley, suddenly found their horizons and hearts broadened by the beautiful Ukrainian young people, many of whom were musically talented. These Ukrainian children and American children worked together on a

Left: Ukrainian children from Kiev were invited to the World Peace Festival in Amenia and stayed with host families, later attending school in Amenia for three months. *World Peace Prayer Society.*

Below: Young people from the Harlem Valley practicing as flagbearers for the World Peace Flag Ceremony, during which the flags of all 193 member states of the United Nations were presented while the audience affirmed peace in those nations. *World Peace Prayer Society.*

play called *The Magic Daisy*, a show about the danger of nuclear power destroying nature. At first, all the animals and trees and other plants come together to put humans on trial, deciding that humanity must die for what the Chernobyl disaster had done to nature. The "Red Chernobyl Pine" sings a poignant plea for all life, describing how her needles had all turned red from radiation and that she was about to die. Other creatures are more forgiving. A Japanese chrysanthemum danced with a paper umbrella, saying that to heal the Earth, they must not only forgive but find it in their hearts to affirm kindness and pray that all nations find peace. "May peace prevail on earth," they sang.

Some of the children from Amenia later went to Ukraine and were forever changed by their experiences there. One young man, who played the embodiment of the nuclear disaster at Chernobyl, draped in a red cape, went on to study theater. Olga Lisovska is a trained pianist who went on to Middlebury College and is now an opera singer in Boston. We hosted a third-grader, Ira from Kiev, in our home; she went to school with our daughter for several months. Her work habits were superb, and she used to come home and proudly announce to our daughter, "Zoë, it's a home vork!" Ira was a full year ahead of our third-graders in math. She lit a little fire under our nine-year-old to do her best. A bond was made that lasted for many years, with Americans and Ukrainians going back and forth, writing and visiting each other. This was real peace work in action that changed young people's lives and transformed how they viewed the world and each other.

MISSION STATEMENT OF THE MAY PEACE PREVAIL ON EARTH MOVEMENT

The Power of "May Peace Prevail on Earth": "May Peace Prevail on Earth" is an all-inclusive message. It is a meeting place of the heart, bringing together people of all faiths, backgrounds and cultures to embrace the Oneness of our planetary family.

Our mission is simple: to spread the Universal Message of Peace, "May Peace Prevail on Earth," far and wide to embrace the lands and people of this Earth.

The following are memories of the Peace Festival by American and Ukrainian students who attended:

> *As to my impressions of our trip to the peace festival, it was one of the most influential and amazing experiences of my life! It remains in my heart and memory as a bright spot, with some memories so sharp as if they were formed yesterday. It brings me pleasure thinking about all those beautiful times and people.*
> —*Olga Lisovska*

> *The Amenia Peace Festival was a place where individuals from all over the world gathered with a common greater good—peace. The experience of meeting new people, singing and dancing with them and enjoying the day was experience unlike any other.*
>
> *The Ukrainian students who stayed with host families in our district were kind, smart and so eager to learn. They brought a living experience of diversity to the classroom and the community. They had a true appreciation for America, always smiling.*
> —*Dawn Marie Klingner, Town Clerk, Town of Amenia*

HORSEY MILLBROOK BECOMES THE UNLIKELY CENTER OF THE COUNTERCULTURE

Youths coming of age and rejecting their parents' values in the wake of the involvement of the United States in the Vietnam War led to protests and unrest in the 1960s. People were susceptible to many different quasi-religious cults as they searched for meaning, alternative communities, utopian freedoms and peace. Buddhism, Sufism, Hinduism and Hare Krishna appealed to many who felt alienated from the mainstream "establishment" religious traditions. When Dr. Timothy Leary arrived in Millbrook on the hilltop above the Harlem Valley to do research on psychedelics with his Harvard colleagues, his message "Turn On, Tune In and Drop Out" resonated with an entire generation.

The 2,500-acre estate where Leary and his fellow researchers landed and remained from 1963 until 1968 was owned by the siblings William "Billy" Mellon Hitchcock and "Tommy" Hitchcock III, the grandchildren of William Larimer Mellon Sr., the founder of Gulf Oil from the prominent

Tribute to Charles Dieterich's Daheim in Millbrook. *From the* New York Tribune, *November 16, 1902.*

Mellon family. Their far-out sister "Peggy" Hitchcock had introduced Leary to her brothers.

In his autobiography, Timothy Leary wrote:

> *Peggy Hitchcock was an international jet-setter, renowned as the colorful patroness of the livelier arts and confidante of jazz musicians, race car drivers, writers, movie stars. Stylish, with a wry sense of humor, Peggy was considered the most innovative and artistic of the Andrew Mellon family. Peggy was easily bored, intellectually ambitious, and looking for a project capable of absorbing her whirlwind energy. And that was us.*

The sixty-room mansion featured stunning stonework, turrets, columned wrap-around verandas, a gatehouse, a carriage house and other outbuildings. The estate was built by Union Carbide cofounder Charles F. Dieterich, who named it *Daheim*, German for "at home." The Hitchcocks had purchased it from Walter C. Teagle, the president of Standard Oil.

My grandmother Elizabeth Shoumatoff painted a portrait of the Mellon-Hitchcock boys when they were young, as well as portraits of other members of the Scaife and Mellon families in Pittsburgh. Thus, when the Millbrook Historical Society sponsored a lecture about the Leary

commune given by Devin Lander, the New York State historian, in March 2018, I eagerly attended.

Lander, who had been researching Leary's Millbrook commune for more than twenty years, demonstrated how the group belonged to the tradition of utopian societies in Upstate New York:

> *Really, as I look at this project, I see the Leary commune as falling into the tradition of the other nontraditional utopian communities throughout New York state, including the Oneida Community, the Shakers, the Fourierists and other new-thought colonies. What happened at the commune in Millbrook is part of that tradition.*

Lander explained that Timothy Leary, who had been a respected lecturer in psychology at Harvard University starting in 1959, had experimented with psilocybin during a vacation in Mexico. This changed the course of his career. Originally a traditional academic psychologist, he became a psychedelic research scientist.

He and his colleague Richard Alpert (later known as Ram Dass) initiated a project called the Harvard Psilocybin Project. Unfortunately for them, they ran afoul of the Harvard administration for not adhering to scientific norms and methods: they experimented with psychedelic substances outside of the laboratory.

The most influential mentor for Leary and his group was Aldous Huxley, the British author of *Brave New World* (1932) and *The Doors of Perception* (1954), among many other works. *The Doors of Perception* documents Huxley's own experiments with mescaline. Huxley was then a visiting scholar at the Massachusetts Institute of Technology (MIT). The two regularly met to discuss their ideas about psychedelic research.

Other key characters who played a role during this period included the famous Beat poet Allen Ginsberg, who took part in the Psilocybin Project as a subject and traveled to Harvard in 1961. Both Huxley and Ginsberg helped Leary formulate the idea of bringing psychedelics out of the laboratory and into society at large. They firmly believed that the beneficial aspects of psychedelics outweighed the potential negatives. Psychedelics were not illegal at that time.

Aldous Huxley, 1930. *Henri Manuel.*

A postcard of Lake Amenia near Delavergne Farms hotel. *Amenia Historical Society Digital Collection.*

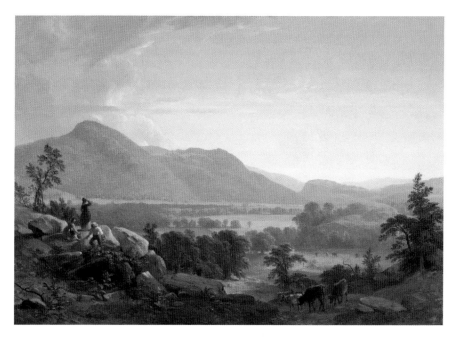

Asher B. Durand, *Dover Plains, Dutchess County, New York*, 1848 (oil on canvas). *Smithsonian American Art Museum.*

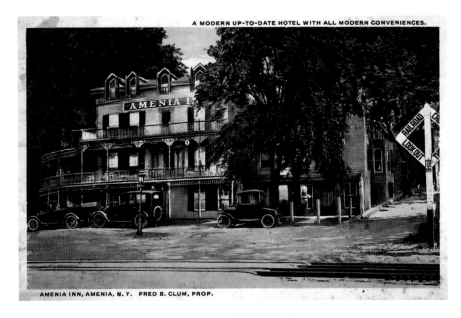

Postcard, Amenia Inn. *Amenia Historical Society Digital Collection.*

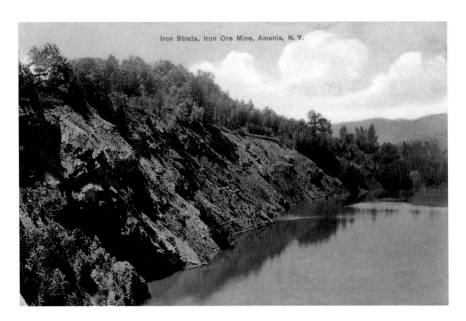

Postcard, Amenia Iron Ore Mine. *Amenia Historical Society Digital Collection.*

Postcard, State Road, Wassaic. *Amenia Historical Society Digital Collection.*

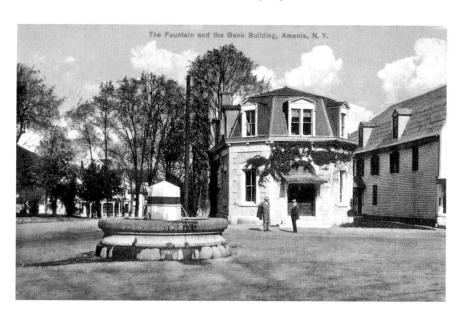

Postcard, First National Bank of Amenia. *Amenia Historical Society Digital Collection.*

Caroline Clowes, *Two Cows at Wappinger Creek*, 1882. Clowes is now associated with the Hudson River School painters. *Dutchess County Historical Society.*

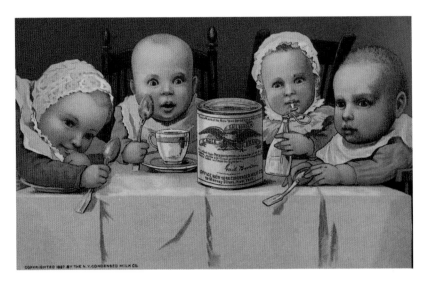

Babies clamor for more milk, Borden's Condensed Milk advertisement, 1887. *Amenia Historical Society Digital Collection.*

Two of the Luther girls, Ketorah and Tabitha, in one of Betty Jo Luther's many productions. *Luther family.*

Betty Jo Luther performing as Miss Carla in a production of the musical *Annie Get Your Gun* at the Tri-Arts Theater. *Luther family.*

Left: Little Zoë, cowgirl, in a Betty Jo Luther production. *Tonia Shoumatoff.*

Below: Sir Edwin Landseer, *Isaac van Amburgh and His Animals*, 1839, commissioned by Queen Victoria. *Royal Collection, Windsor.*

LAKE AMENIA AMENIA, N. Y.

Postcard, Lake Amenia. *Amenia Historical Society Digital Collection.*

High School, Amenia, N. Y

Amenia High School, 1910. *Amenia Historical Society Digital Collection.*

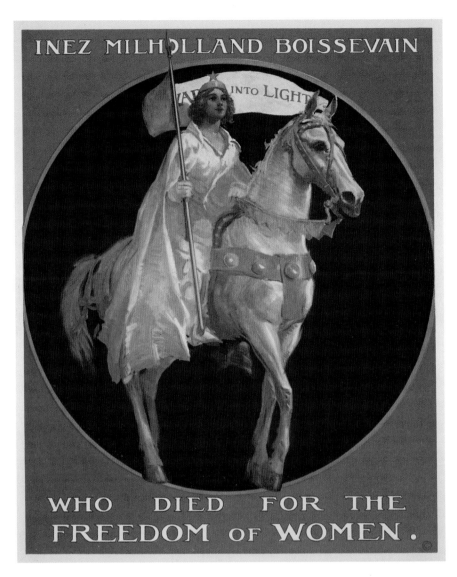

INEZ MILHOLLAND BOISSEVAIN

INTO LIGHT

WHO DIED FOR THE FREEDOM OF WOMEN.

Poster commemorating suffragist heroine Inez Milholland Boissevain, who led the March 3, 1913 Women's Suffrage Procession in Washington, D.C. *Schlesinger Library, Harvard University, Harvard Radcliffe Institute.*

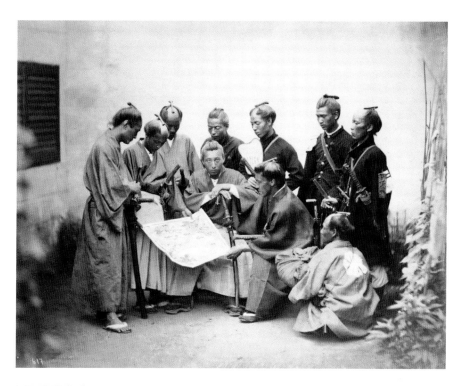

Above: Samurai of the Satsuma Clan, Boshin War period (1868–69). *Felice Beato.*

Left: First Amenia World Peace Festival poster by Seymour Chwast, Pushpin Studios. *World Peace Prayer Society.*

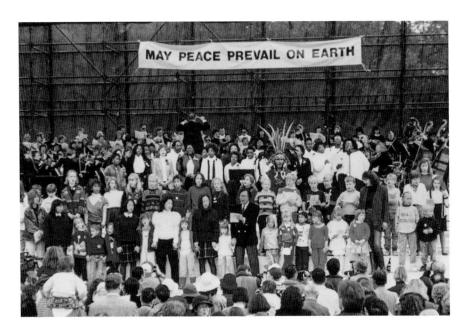

First Amenia World Peace Festival, Hudson Valley Philharmonic and choirs. *World Peace Prayer Society.*

Natasha Zaika from Kiev holds the Ukrainian flag aloft during the World Peace Prayer Ceremony, 1991. *World Peace Prayer Society.*

Above: Timothy Leary, psychedelic collage, author unknown. *Public domain.*

Left: José Mediavilla arrives from Occupy Wall Street at the Luther Barn. *Lauren Hermele.*

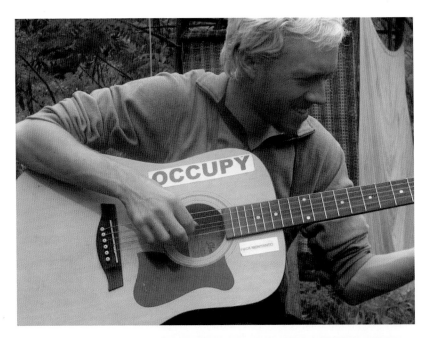

Above: Walter Nolan-
Schmidt from Alabama
joined the Wassaic
Occupy Wall Street
group. *Devin Irby.*

Right: DeCost Smith,
Onondaga Woman
(watercolor). *DeCost Smith
Collection, 1880–1943,
Cornell University, Division
of Rare and Manuscript
Collections.*

DeCost Smith, *Driven Back*, 1892 (oil on canvas). *Birmingham Museum of Art.*

Lewis Mumford, *Sketch of Amenia Hills. Lewis Mumford Collection, Guggenheim Memorial Library, Monmouth University.*

Left: Alexander Shundi, *Wheel of Destiny*, 2013 (oil on canvas). *Tonia Shoumatoff.*

Below: Eve Biddle, Wassaic Project codirector, in front of the Luther auction barns. *Verónica González Mayoral.*

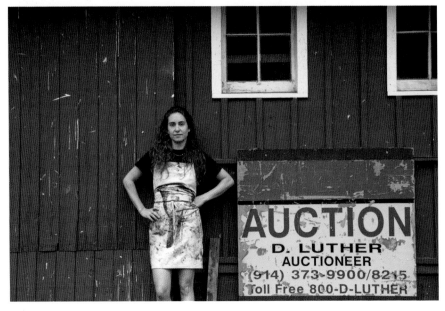

Avery Danziger, *Harlem Valley Power Plant*, interior. *Avery Danziger*.

Ghost of a Dream in their studio in Wassaic working on *Yesterday Is Here* (2020–23), their installation for Boston's MassArt Art Museum (MAAM). *Ghost of a Dream*.

MassArt Art Museum (MAAM) lobby, featuring collages from more than thirty years of MassArt Museum exhibition catalogs. *Ghost of a Dream.*

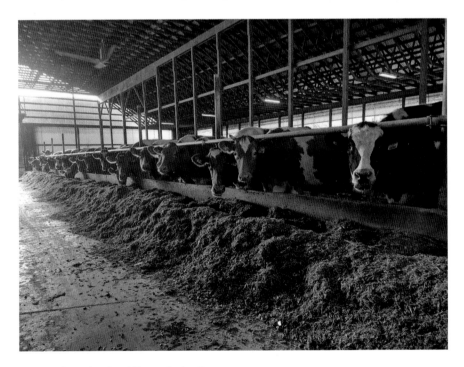

Cows at Coon Brothers' Farm. *Jessica Coon.*

Researchers in the field of psychedelic research internationally thought that the drugs had potentially provable medical and psychological benefits that needed to be studied scientifically. But most researchers were not talking about giving psychedelics to the general population. Leary's group was among those talking about using them only as part of psychotherapeutic research under strict guidelines.

Because of the problems they encountered at Harvard, Leary and Alpert, in early 1963, created a nonprofit organization called the International Foundation for Internal Freedom (IFIF). The IFIF's November 1962 statement of purpose asserted the organization's roots in Leary's and Alpert's Harvard research:

> For the past two and a half years, a group of Harvard University research psychologists have been studying and directly experiencing these issues. Five research projects on the effects and applications of consciousness-expanding drugs have been completed. Over four hundred subjects have participated without serious negative physical or psychological consequences. Over sixty percent of our subjects have reported enduring life changes for the better.

Later, in 1963, the IFIF was renamed the Castalia Foundation, after the futuristic utopian province that was the setting of Hermann Hesse's last novel, *The Glass Bead Game*. Leary's Castalia Foundation later declared itself the "only independent center for psychedelic research." The foundation was subsequently restructured as a religious organization called the League of Spiritual Discovery (LSD), which regarded the drug LSD as its "sacrament."

Since Leary's contract was not renewed at Harvard in the spring of 1963 and Richard Alpert was fired for giving psychedelics to an undergraduate student, the two of them came up with the idea of continuing their research in a community. Luckily for them, one of the people they knew through Allen Ginsberg and Aldous Huxley was Peggy Hitchcock, the most experimental member of the Mellon family. Peggy Hitchcock mentioned that her brothers had purchased some property in Millbrook, in Dutchess County, and that perhaps they would be willing to rent out the large unused building to Leary and his group. Richard Alpert flew in on a Cessna plane with Peggy to meet the Hitchcock brothers, who agreed to rent the ramshackle mansion to Leary and Alpert for one dollar per year.

Now, Leary and Alpert had a location from which they could begin to flesh out their idea of communal living while experimenting with psychedelics,

Left: Timothy Leary in front of Daheim. *Alvis Upitis, used with permission.*

Below: Daheim with a painting of the Buddha as Salvador Dalí, artist unknown. *Millbrook Historical Society.*

namely LSD, in an effort to determine and document the drug's benefits, possibilities and effects.

"What was that like for the people in the village who lived near the commune?" queried Lander. According to press at the time, the community's reaction was surprisingly neutral. There was no confrontation; the group was accepted by the townspeople, even though they had previously gained notoriety as a result of coverage in the *New York Times*.

"The group was very small. They were not flamboyant at that time," explained Lander. "There was a general understanding by the people in Millbrook that although they were eccentric on some level, they were all also highly educated, since they were almost all doctors and professors, and they were respected by people in the local area. And besides, Billy and Tommy Hitchcock, who were Mellons after all, had given the group their blessing."

The researchers moved into the Daheim estate in November 1963. Right after they moved in, on November 22, Aldous Huxley died—the same day President John Fitzgerald Kennedy was assassinated.

The commune attracted jazz greats, such as Charles Mingus and John Coltrane, and writers, including Jack Kerouac, William Burroughs, Allen Ginsberg, Alan Watts and Ken Kesey.

Exotic women also appeared at the commune during those early years. Its rooms were decorated with Hindu symbols and tantric mandalas. Mattresses covered with Indian bedspreads and pillows were on the floor. Incense burned while residents twisted themselves into various yoga poses. The exterior of the building was famously painted with a huge mural of the Buddha with a pointy black mustache that was supposed evoke the Spanish surrealist artist Salvador Dalí.

What started as the headquarters of a foundation for serious drug research turned out to be "more like a hippie commune suffused in eastern religion.

Left to right: Timothy Leary, Allen Ginsberg, Alan Watts and Gary Snyder. *Wikimedia*.

Guests meditated and took drugs. The neighbors were horrified," stated the *Washington Post* in a Leary obituary.

The scene was described by writer Nina Graboi as a "cross between a country club, a madhouse, a research institute, a monastery, and a Fellini movie set." Graboi ran Leary's nonprofit LSD-based meditation center in New York City. The organization was designed by Leary to disseminate information about the use and misuse of psychedelics in order to inform the public and minimize worry about the drugs' ill effects.

Unorthodox doctors and psychologists, including British psychiatrist Humphry Osmond, who invented the word *psychedelic*, and R.D. Laing, a psychiatrist who eschewed mainstream psychiatry and viewed schizophrenia as a theory instead of a scientific diagnosis, were also visitors to the Millbrook compound. Scholars of religious studies and psychology, such as Alan Watts, Huston Smith and Walter Houston Clark, visited because they were interested in studying hallucinogenic mystical experiences.

It did not take long, however, for the "research" colony to become a party scene.

One of the more controversial visitors to the Leary compound was Ken Kesey, who arrived in his psychedelically painted school bus with his "merry pranksters" in 1964. The story is immortalized in Tom Wolfe's *Electric Kool-Aid Acid Test* (1968), which devotes a whole chapter to it.

Leary's "League of Spiritual Discovery," as he named it when it was incorporated, needed to raise money. The group decided to cash in on the fad and put on psychedelic light shows at the Village Theater and, later, at the Fillmore East. They opened their house to visiting guests on the weekends. You could come to Millbrook and have a firsthand sensory experience with psychedelics without taking LSD—for a fee.

To demonstrate the effects of psychedelics, the group would do things to distort a person's perception. For example, they would change the colors of foods—like turning milk blue—or change the color of objects with black lights. They also did yoga and tantric breathing, which was extremely uncommon at that time. Visitors were fed a macrobiotic diet and encouraged to read the *Tibetan Book of the Dead*.

The overall effect was meant to not only increase the number of paying visitors to the commune but also spread its notoriety. The group started getting written up in national and international publications. "Every time Leary was mentioned, Millbrook was mentioned as well. Millbrook became known as the East Coast mecca of psychedelics," explained Lander—not necessarily the sort of notoriety that Millbrook people who valued their privacy wanted.

Art Kleps, a former school psychologist who wrote *Millbrook: A Narrative of the Early Years of American Psychedelianism* (1968 in newspaper format and 1975) observed, "It didn't take long before the invocation of the name 'Millbrook,' which had previously sounded no more exciting than 'Maple Street' or 'Riverdale,' began to ring in the ears of…people as 'Mecca' or 'Lhasa.'…I noticed that a flicker of reverence frequently accompanied the pronunciation of those two syllables."

Things changed abruptly in December 1965, when Leary took his two children, Jack and Susan, and his girlfriend (and later wife), Rosemary Woodruff, to Laredo, Texas, intending to cross the border into Mexico and spend the Christmas break there. Less than half an ounce of marijuana was found on Susan Leary by border agents. In March 1966, Leary was convicted of transporting marijuana and sentenced to thirty years in prison and a fine of $30,000, which made front-page news across the country and created more negative publicity for the group—and for Millbrook.

Instead of returning to Millbrook and becoming more low-key, Leary went on the attack against what he viewed as the "establishment." His name was flashed across the media, and there were more and more articles about LSD in general, most of them negative. Paranoia about the drug mounted, particularly during the early Nixon administration.

Pressure grew within Dutchess County and the Millbrook community to start looking into what Leary was up to. An investigation was launched, led by G. Gordon Liddy, a former FBI agent who was then the assistant district attorney of Dutchess County, and Sheriff Larry Quinlan. The two of them went on the offensive in 1966, thinking that they were going to find all manner of nefarious drugs on site. Instead, after they searched the large building, all they found was some peat moss and a science kit that belonged to Leary's son, Jack. By that time, the roadblocks they had set up for all cars going into the commune had become a real issue for the local community.

Liddy, an employee of the county prosecutor's office, channeled the community's anger into action: he got a search warrant and organized a raid on the Millbrook estate. Leary recalled scenes from the raid in *Return Engagement*, a 1983 documentary he made with Liddy when the two of them teamed up on a college lecture tour. Leary said he woke one morning to find a throng of policemen and Liddy (sporting a trench coat and his signature mustache) standing outside his bedroom, repeatedly banging on the door.

Leary finally appeared, wearing just an Indian kurta shirt, and asked Liddy, "Is this Peter Sellars posing as Inspector Clouseau?" Liddy, who later botched the first attempt to break into the Democratic National Committee offices

G. Gordon Liddy. *Wikimedia.*

in Washington, D.C.'s Watergate complex, also botched his attempt to bust the Leary group. He had been hiding in the bushes that morning with other members of law enforcement and loudly dropped a set of binoculars while ogling a nude female member of the commune, which alerted the group to his presence. Other officers wanted to have their turn at the binoculars, because the women who were just waking up were half naked.

Bob Trotta, a local attorney in Millerton, New York, who handled public defender cases in Dutchess County at the time, represented Art Kleps, the only member of the group who was found with marijuana—a very small amount. Trotta privately asked Liddy to get off their backs and issue an adjournment in contemplation of dismissal for both Kleps and Leary, whose lawyer was Noel Tepper. Both cases were dismissed. There were no drugs or evidence substantial enough to justify prosecution.

After that, however, the Hitchcock brothers, who did not want to be sued, gave Leary and company their walking papers, since, by this time, the commune had changed. Once the commune was open to paying visitors on the weekends, partially because of the publicity it garnered, it grew in size. More and more nontraditional-looking young people were wandering around the estate. Art Kleps described the new arrivals: "Many were uninvited guests who crept in like lizards; they were Jesus freaks, Scientologists, Meher

Babaists, Macrobioticoids, transcendental meditators, Hare Krishnas and so forth, all intending to show us the 'True Path.'"

After Tommy Hitchcock sent the group a legal document requiring everyone to vacate the premises, Leary left for California, where he ran for governor against Ronald Reagan in 1969. Of course, he did not win, but he had a famous campaign song written specifically for him: "Come Together," by John Lennon of the Beatles.

The lecture for the Millbrook Historical Society was illustrated with a newspaper cartoon that queried: "Why wouldn't Millbrook be happy to be the psychedelic center of the world?"

Lander was asked by a member of the public at the historical society lecture in Millbrook what he thought the legacy of the group was. He responded:

"I think the organization itself was important because it was a precursor to many of the things that ended up happening later in mainstream culture," *he replied. "The weekend spiritual retreats they started, with transcendental meditation and yoga, were precursors for what later became mainstream.*

The Astronauts of Inner Space and the League of Spiritual Discovery existed way before the Esalen and Omega institutes. The Human Potential Movement that later emerged, humanistic psychology, the interest in eastern religions, were all things that Leary and Alpert pioneered. I would argue that the counterculture started here in Millbrook and not in San Francisco. And that, to me, is fascinating."

Because of the negative publicity given to Leary's personal actions, LSD became a schedule 1 narcotic, and all use and scientific and medical research on psychedelics were suppressed for more than sixty years. Legitimization of the field, profoundly stigmatized by decades of social and political disapproval, has begun emerging only in recent years. In 2006, Johns Hopkins University launched the Center for Psychedelic and Consciousness Research, the first dedicated psychedelic research center in the United States.

Timothy Leary, trippy. *Wikimedia.*

The research that has come out of Johns Hopkins since then has actually confirmed much of the research that Leary did at Harvard. Psychedelics are starting to be used in psychotherapy in the way that Leary and Alpert

originally envisioned. Psilocybin, in particular, is now being researched for its therapeutic value when used under medical supervision for patients with intractable depression, anorexia, PTSD, migraines, alcoholism and terminal cancer and for smoking cessation, with good results. Timothy Leary's last words, according to his son, Zachary Leary, were: "Why not?"

BILL HENRY: 1960S NONVIOLENT PEACE ACTIVIST BUYS THE LUTHER HOMESTEAD

The Committee for Nonviolent Action is a group of private American citizens who have joined together for the purpose of exploring ways in which nonviolent action can be used to prevent the outbreak of war. Drawing much of its inspiration from the life and work of Mohandas Gandhi, it recognizes no creed, class or race distinctions, operates openly in all its affairs and believes that human conflicts must find their resolution not in violence but through imagination, dynamic expression, truth and love.
—credo of the Committee for Nonviolent Action

There are many kinds of peacemakers: some are activists, and some work for peace in a more spiritual way. The early history of World War II and postwar peace activism is being reconsidered, and people who were once seen as self-centered "draft dodgers" are now being re-envisioned as sincere people of conviction who resisted war and the specter of a nuclear holocaust during the Cold War era. Many of these people were inspired by the writings of Mohandas Gandhi about nonviolence. Among them was Bill Henry, a lifelong nonviolent activist for peace and justice. His commitment to nonviolent activism inspired a number of Occupy Wall Street protesters to come to Wassaic to recover and regroup after they were evicted in late 2011 from New York City's Zuccotti Park. Henry supported their intention to farm, allowing them to use his land.

Bill Henry lived in the old farmhouse in Wassaic that once belonged to the auctioneer Dave Luther. He has lived in this area for almost fifty years. He bought the Luther farmhouse and property because he loved the big green barns. He knew Wassaic from working at the state school years ago. He is now in his nineties.

As one of the founding members of the nonviolent peace movement of the early sixties, he knew and worked with Dorothy Day of the Catholic

Left: Bill Henry. *ARC 38 Archives.*

Below: Bill Henry being arrested. *From the* New Haven Register, *November 23, 1960.*

6 NEW HAVEN EVENING REGISTER, WEDNESDAY, NOV. 23, 1960

Pacifists Who Disrupted Sub Launching Taken

Members of the Committee for Non-Violent Action are shown being brought into U.S. District Court Tuesday after their arrests in Groton during the launching of the nuclear submarine Ethan Allen. In the left photo, four of them walk into the hearing room escorted by police officers; at the extreme right in the picture is William Henry, 28, of Lodi, Wis., one of the two men who were successful in boarding the sub. In the middle photo, two Marines carry Victor Richman, 20, of New York City, into the Federal building. At the right is the only female member of the group, Miss Madeline Gins, 19, of New York City.

Worker movement and David Dellinger, an organizer of massive antiwar demonstrations in the 1960s and one of the Chicago Seven. Henry was arrested many times. His most dramatic peace action was climbing aboard the nuclear submarine the USS *Ethan Allen* at its launching in November 1960 in order to protest the proliferation of nuclear weapons. For that action, he was featured on the front pages of the *New York Times* and the *New Haven Register.*

Bill Henry grew up as a farm boy in Baraboo, Wisconsin, during the Great Depression. His family of four lived on two dollars a week from their creamery receipt for ten head of cattle and grew sweet corn, hay, oats and vegetables. He attended North Central College, an evangelical college in Naperville, Illinois, where some of his professors were supporters of the pacifist movement.

Henry, who majored in philosophy and sociology, avidly read Gandhi's *The Story of My Experiments with Truth* (1925–29; published in the United States in 1948). In 1952, he was in his second year of college, and he thought the two most important things were justice for Black people and resistance to war, since he had heard of the horrors of World War II and Hitler when he was very young, only ten years old.

"As soon as I started being a pacifist, my mind was busy figuring out how I could fit into this movement. I wanted to say 'no' to the military system and do so by direct nonviolent action," Henry told me when I interviewed him at his home in Wassaic in 2012 for a story that appeared in the *Millbrook Independent.*

When Bill Henry became an avowed pacifist in 1952, Senator Joseph McCarthy's witch hunt for "communists" and the hearings and investigations of the U.S. House Committee on Un-American Activities were in full force. Henry was prepared to be accused of being a communist at every juncture. There were spies listening in at many of the meetings he attended in support of nonviolent actions, and after a while, he could recognize them. The philosophy of the resistance and civil disobedience movement, however, was to "do your action in openness and truth," and the known spies were treated with respect.

At a Quaker meeting in the South Side of Chicago, he read in a brochure about Bradford Lyttle, a fervent pacifist and, later, a prominent organizer with Committee for Non-Violent Action (CNVA) who had refused the draft. In 1956, at the age of twenty-four, Henry was drafted but refused military service, becoming a conscientious objector (CO). He stated, "I refused to go because I thought it was morally improper to participate in servitude of an involuntary action of violence." He was sentenced to two years in prison for his draft refusal and served eight months in the Springfield, Missouri federal penitentiary, now known as the United States Medical Center for Federal Prisoners, where he helped keep the prison hospital functioning. He worked on the prison farm for several months and kept records for the kitchen. At the prison, there were other conscientious objectors from around the United States, including Amish and Quaker

COs. While incarcerated, Henry heard about the nonviolent work of the Fellowship of Reconciliation, started by A.J. Muste.

Some of Henry's earliest peace actions were organized by the Quakers' American Friends Service Committee and World War II war resisters, as well as a group called the Peacemakers, many of whom had served in World War II and were involved in war tax refusal. When he was paroled from prison in Missouri for good behavior in 1958, Henry went to work in a Quaker school in Iowa. He supported—but, because of his parole, could not participate in—a major CNVA protest called the Omaha Project Action against intercontinental ballistic missiles (ICBMs) at the Offutt Air Force Military Base, south of Omaha. It was (and is) the headquarters of the Strategic Air Command, which controls all American nuclear missile forces. A team of activists climbed the fence every week and were promptly arrested. This made national news, and soon, sympathetic peace groups from around the country joined them.

After his parole was up, Bill Henry immediately went to Fort Detrick in Frederick, Maryland, and protested during the fall and winter of 1959–60 against the new U.S. biological weapons program that was housed there. It was a Quaker protest, with demonstrators holding signs outside the gates for months.

Henry visited two important people in the movement at the Sandstone, Minnesota federal prison: Arthur Harvey, who was a founder of the Committee for Non-Violent Action (CNVA), and Ammon Hennacy, a cofounder with Dorothy Day of the Catholic Worker movement. Inspired by them, Henry became an important member of CNVA. He was also inspired by the Quaker and Catholic Worker philosophy of helping the poor. Henry helped many poor inner-city residents fix up their apartments over the years.

In January 1960, the first Polaris submarines were tested in Cape Canaveral, Florida. The Polaris missile was a solid-fueled, nuclear-armed, submarine-launched ballistic missile (SLBM) built during the Cold War by the Lockheed Corporation for the U.S. Navy. Each submarine cost $100 million, could carry an H-bomb and stay underwater for up to two months and had a missile range of 1,500 miles. Henry called them "vengeance machines."

Henry arrived at 58 Grand Street in New York City in April 1960, ready to participate in the Polaris Action Project. The group distributed mimeographed flyers to the growing list of supporters from the CNVA's Omaha Project Action, proclaiming, "Polaris is immoral and dishonorable. No nation under any circumstances has the right to threaten, burn, blast and radiate tens of millions of people to death." Anti-red, or anti-Soviet, feeling

was rampant in the country: "Better dead than red" was the slogan. The peace movement turned the phrase around to say, "Better red than dead."

To protest against the Polaris submarines, the CNVA decided to organize a peace walk in June 1960 from New York City to New London, Connecticut, where the submarines were based. (Only two shipyards build submarines for the U.S. Navy: the Electric Boat Division of General Dynamics, with principal production facilities in Groton, Connecticut, and Newport News Shipbuilding, a Tenneco subsidiary in Newport News, Virginia.)

A friend of Bill Henry, Harry Purvis, a World Federalist who owned a machine shop in Brooklyn and had run for Congress, had a rowboat, which he and Henry dubbed the *World Citizen*. They decked it out with a United Nations flag and a twelve-foot-tall weather balloon. Putting in off the FDR Drive on the east side of New York City, they dropped off flyers at the Soviet Mission at the UN and then rowed all the way to New London on Long Island Sound, dropping off leaflets at towns along the way. Meanwhile, more than one hundred people walked along the highways to New London from New York City, protesting the SBLM submarines.

"We started really demonstrating from Groton to New London, handing out flyers to ten thousand workers," said Henry. Pete Seeger supported the effort. After Seeger sang "If I Had a Hammer" at the Newport Folk Festival that summer, the song became the anthem of the peace movement. Demonstrations were held from June to November, gaining national attention.

On November 22, the USS *Ethan Allen*, the big new Polaris submarine, was to be launched in New London. The peace groups announced to the press that they would try to block the submarine by swimming in front of it.

Bill Henry and Don Martin, an MIT student from Wellesley, Massachusetts, were the activists who did it. The temperature was in the thirties. Henry recounted his experience in *CNVA Polaris Action Bulletin*, no. 16:

> *Into the calm, dark, icy water we strode. The cold pierced us and we gasped for air. The numbness…was forgotten as whistles blew.…We pushed off in the direction of the sub, situated in the center of the river with its colorfully draped bow pointing toward us about 250 yards away. A number of [coast guard] launches were in the area.…Another boat blocked us.… Don headed for the bow and went around it.…I was blocked.…I swam in close to the launch in order to try to pull myself up around the bow by holding onto the projections from the hull even while the launch moved… then made a lunge and several quick strokes to pull myself in front of the boat.…It moved in position ahead of me again. Don had disappeared.…*

Someone [in the coast guard boat] *said, "You'll never make it." Just then another guardsman said, "Look, his buddy is there already."...I reached up and grabbed the horizontal edge of the deck and by swinging hand over hand I was able to move around the bow to open water. I could see Don clinging to the drapery halfway up the sub's bow 150 feet away.*

The launch blocked me again. I was wearying and numb....After several minutes I was able to swim around to the stern. Maybe I was permitted to do so....

As I moved closer to the sub a huge section of wooden launching cradle bobbed to the surface. A man amidships yelled, 'You'll be killed if you stay there." I moved toward the bow and the ship seemed to start moving ahead. I grabbed the red, white, and blue streamers and pulled myself up....The slope of the hull was about 45 degrees. I pulled my stiff body up to the rope guards around the deck....The outside of my body was frozen like the exoskeleton of a bug.

Barely conscious, Henry was directed to climb down into a waiting navy boat, where Don Martin was already being held. The two were brought to a coast guard station, where their fellow "civil disobedients" were in custody. And then, under state police escort, they were taken to the federal courthouse in New Haven. The next day, November 23, 1960, Bill Henry was on the front page of the *New York Times* for his act of civil disobedience.

Henry told me, "We were in Whalley Avenue Jail in New Haven, me and Don Martin, who swam with the ice in the water. All the other people were in boats. The others were released after the hearing." Don Martin got a long sentence: three years. Bill Henry got out on bond, which was posted by the CNVA. In January 1961, while he was out on bond, he got arrested again with Don Martin. Bill Henry said:

The first submarine that had missiles in it—it was a submarine tender—was called George Washington *and came in from Charleston, South Carolina....Don and I got a boat and rode over there and sat on the submarine with sixteen missiles on it. A couple of weeks after the second arrest, I was given two one-year sentences. The nice judge, who had been in World War II, in New Haven asked me all sorts of questions, and he recognized that he could not let me go, and he said, "I am sentencing you to one year for your first offence and a second year for the second offense." In 1961, around March, I started serving in Danbury Prison.*

At Danbury, Bill and his fellow activists preached nonviolent resistance to the other prisoners. In protest, Henry decided to stop working at the prison as well, and he was sent to solitary confinement. He had a single cell high up in the prison. That is when he started his hunger strike at the end of September. He did not eat for fifty days. His weight went from 185 to 147 pounds. They force-fed him liquids twice a week with a quart of liquid. After ten days, he got out of solitary, and after another ten days, he was force-fed with a tube. Because his health was failing, they said they should send him to the hospital prison in New Jersey. He was told, "We'll let you out if you start eating after ninety days." Then they sent him to the hospital. He ended the hunger strike after ninety days and was released from prison on December 10, 1961, after ten months, for good behavior—and because they wanted to get rid of him. He stayed in the prison hospital until he was strong enough to leave.

After his release, Henry finished college at Goddard College in Vermont. In 1967, he married civil rights activist Deborah Rib, who had registered many Black voters in rural Fayette County, Tennessee, approximately fifty miles east of Memphis, in the mid-1960s. Henry taught young children in Harlem, heading up a New York State daycare center in East Harlem called the East Harlem Block School, and continued to help the poor.

In New York City, Henry met up with Jerry Lehmann, a fellow CNVA activist who lived on Spring Street. Lehmann suggested that they find a place to get away from the city, somewhere nonviolent peace sympathizers could go on weekends for a respite. At first, they found a place (now the Town of Stanford's garbage dump) next to actor Jimmy Cagney's property in Stanfordville. But there was no toilet there, which was important to Lehmann's girlfriend. So, they then decided on a property in Pine Plains, a ninety-seven-acre former dairy farm with two houses about one hundred miles from New York City. They paid $24,000 for the farm in 1963.

At first, their place was called Ammon Hennacy Farm, named after Hennacy, the nonviolent activist who was the editor of the *Catholic Worker*. Later, they changed the name to *Satya Graha*, meaning in Sanskrit "grasping reality" or "grabbing onto truth," which was used to express Gandhian nonviolence. About ten or twelve people came up every weekend, mostly Catholic Worker movement people. In 1964, Dorothy Day bought a farm in nearby Tivoli, New York, where free lunches were served. (The Tivoli farm lasted until 1978; Day died in 1980.) From 1966 to 1968, Henry and Lehmann put up tent platforms and invited Black and Puerto Rican families to come up for a rest. After the Vietnam War, they invited refugee families

The Farm, Voluntown, purchased by Marjorie and Bob Swann in 1962 to house and train CNVA volunteers, 2018. photo: Michael Centore

A Legacy of Nonviolence in
VOLUNTOWN
By Michael Centore

Las Vegas Sun, August 26, 1968.

Pacifist Site Guarded By State Police

New York Daily News, August 25, 1968.

Rightists Raid Pacifists, Fight Cops; Six Shot

Collage of a photograph of the farm Marjorie and Bob Swann bought in 1962 as a "community house" for CNVA volunteers with images of newspaper clips recounting the August 1968 attack. *Michael Centore; from* Connecticut Explored *17, no. 3 (Summer 2019).*

from South Vietnam to come live at the farm. People bought shares in the property. In 2006, Henry bought the Luther farm, but the farm in Pine Plains is still owned by a nonprofit called Satya Graha.

Over the weekend of June 11–13, 2010, in Voluntown, Connecticut, at the New England Center for Non-Violence (now known as the Voluntown Peace Trust), there was a reunion of sixty people who had been involved

in the Polaris Action and many other peace actions of the CNVA. Many, by this time in their late seventies, eighties and even nineties, came from all over the country, and it was very emotional for all of them to come together after fifty years. They had a memorial chart that honored fifty of the nonviolent activists who had died since they last saw each other. Bill wiped a tear from his eye when he remembered some of his friends who were wounded during the August 24, 1968 minutemen vigilante attack on the New England CNVA center in Voluntown. He was not there during the attack, but Bradford Lyttle and others he knew were. At their reunion, Lyttle, the lead organizer of the CNVA movement, showed slides of all their activities over the years, including the walk from San Francisco to Moscow (1960–61). He wrote about the action that Bill Henry participated in, saying: "The Polaris Action was attempting to convince Americans that nonviolent resistance is a practical as well as a moral means for coping with aggressive totalitarianism."

OCCUPY WALL STREET COMES TO WASSAIC AND BECOMES ARC 38

After Occupy Wall Street was evicted from Zuccotti Park in lower Manhattan in late 2011, a group of young people arrived in Wassaic, hoping to build community. Their stay was made possible by Bill Henry, a longtime nonviolent peace activist who was sympathetic to their cause and gave them access to his 188-acre property, along with permission to live in his big green barn, formerly the home and farm of Wassaic auctioneer Dave Luther.

Even though the barn had no heat, running water or plumbing, the group toughed it out for the first winter, staying in a "warm room" with electric heaters and other rooms that were "ill-equipped, with no plumbing and other facilities suitable to house groups of unrelated people," as the *Millbrook Independent* would later report in its July 1, 2012 edition.

The call to come up to the Luther farm was made by a barefoot youth named Eco (who was actually a Bard College graduate). He sounded a conch shell at Zuccotti Park, inviting the movement to become "more solutions-focused" and for those in New York City to come up to the last stop on Metro-North Railroad's Harlem Train Line to join the mission to "empower people." Those who answered the call wanted to rebuild, having witnessed the entire microcosm of community that existed at the Zuccotti

The view from inside the Luther barn during the Occupy Wall Street residency, 2011–2013. *ARC 38 Archives.*

encampment destroyed overnight: a kitchen, a medics' station, hundreds of tents and a "people's library" with hundreds of volumes.

Members of various Occupy Wall Street working groups arrived in Wassaic—primarily those from the Alternative Currencies, Occupy Farms and Sanitation working groups. Occupy Farms had purchased a large number of military tents, some of which were sent up to Wassaic. In November 2012, Occupiers brought their tents to contribute to the Occupy Sandy hurricane relief efforts in coastal Queens, Staten Island and other parts of New York City, where many Occupy activists, including some from Wassaic, worked full time for months.

Eco, who looked like a cross between Peter Pan and the Artful Dodger, wore an array of tie-dyed outfits, harem pants, a Turkish bathrobe and multicolored scarves to cover his head and his mono-dreadlock. Others followed suit, wrapping themselves up in bedspreads, sleeping bags and blankets to stay warm. Many of the Occupiers used alternative names: Truth, Casper, Tesla, Venus, Catbird, Blue, Shine, Lola, Leprechaun, Prince and many others.

Some Occupiers came to Wassaic on November 25, 2011, the fateful evening of the raid on Zuccotti Park. Kiril Ravensong (formerly Jason Blum,

the son of two Scarsdale doctors) recalled, "We were spent, having given all of our will, all of our passion, all of our effort into sustaining the movement and insisting that the public's voice be heard in relation to the banking crisis and the resulting unprecedented, publicly funded federal bailouts." Ravensong recounted:

> *Eco invited myself and a small group of exhausted doers to drive up to the land, and take our ease at last. We accepted, gathered what we could of the warm tents, sleeping bags, and loose gear that the movement could spare, and made our way north, out of the city…a silent caravan in the night, as police raided the last stand of activists who were not yet ready for the experiment to come to an end.…Over the following weeks, leading up to the first winter snows, many individuals came to the farm in Wassaic, each seeking something different, all bound together in the desire to be the change we wanted to see in the world, to see how universal land access, ownership, and stewardship could become the solution for millions of activists worldwide. It was the spirit of fellowship that ran like a red thread throughout all of the preparations, dreams, victories, and dramas that ensued.*

That winter, a small but steady flow of organizers heard and responded to the invitation to use the space to plan events in the city and to partake in the wintry wonders of the pristine wilderness behind the Luther farmhouse, which became the encampment for a small village.

The first formal use of the space, for several days in February 2012, was a training retreat hosted by the Occupy Wall Street medics. They demonstrated natural and practical first-aid techniques and practiced triage in unpredictable protest situations, re-enacting in the courtyard between the barns scenes that many had personally experienced over the previous months, including police violence and encounters with agents provocateurs. They investigated what role peaceful protesters might play in the interactions that tend to take place in escalated situations. The small crew on site also hosted the "99% Spring" in an effort to bridge the Occupy movement's presence in the downtowns of over two thousand cities worldwide and to train for actions in more rural and suburban settings.

"It's hard to summarize the energy of that formative time in the aftermath of the Occupy Movement—everyone was fully engaged in exploring how the dreams we'd just shared might take root," remembered Eco. The Occupy Wall Street social media feed "was primarily a shared set of communication

tools. We'd learned new ways to share collective experience, to communicate honestly, to survive on the streets, to share time and focus in respectful nonviolent ways."

He continued:

> *Those of us who were there together carried that over into how we shared space outside of the park at the Luther farm....I remember we were all sharing our inspirations all the time, reading out loud from James Redfield's* The Celestine Prophecy *and Hermann Hesse's* Glass Bead Game *and noting our synchronicities. We were immersed in a living mythology of apocalypse and rebirth, with prophecies about the end of the Mayan calendar in 2012.*

The Occupiers hoped to create a community for like-minded activists who were choosing to opt out of what they saw as a corrupt and failed system. Many of them had not succeeded in finding jobs after the stock market crash of 2008, despite being college graduates. They were frustrated, unable to find a purpose or meaning for themselves in mainstream society. They wanted to create a "container," as Eco called it, for new ideas, a place where "healing, learning and unlearning" could take place in a semi-retreat setting in nature, where people could redefine themselves and the community could evolve, it was hoped, into a functioning farm with mountain camping.

An "evening naming ceremony [for the new community] took place around the fire on the hill," recalled Jon Connors, an MBA from Boston who has since completed a cross-country bike tour and other actions to bring attention to regenerative environmental projects. "I was wearing a Red Sox pitcher's jersey, number 38. We had been reading the *I-Ching* for the last few days, and the verse that came up was number 38."

"The ARC was my sanctuary, even if we were still sleeping outside up there, because it was safe and I was among friends," wrote Connors. "I remember the smell of the wood, how we shared everything, and how we lived with nothing, and it was glorious. I remember bathing in the creek with Dr. Bronner's soap, envisioning ARCs around the world and reveling in the fresh water and air."

"I remember Eco talking about this farm in Wassaic, near the train station in the town of Amenia, where we could all go up and build another world," wrote author Stacey Hessler, also known as Shine, of the People's Movement (a nonprofit that connects people with land projects through a yearly caravan of buses).

The courtyard between the barns became a site for impromptu meetings and workshops. *ARC 38 Archives.*

Pretty soon, dozens of young people trudged over from the train station to the green barns. Youth from as far afield as Alabama, Nevada, North Dakota and even Ukraine all came to Wassaic, looking for the "cry of the wild and the call of the future," as Eco put it, in the woods and fields of the former Luther farm.

Lauren DiGioia remembered:

Feeling oversaturated and burned out, I was now compelled to participate in the solution, and I wanted to participate in that just as fully and passionately as I had in lifting the veil.

I didn't have to look far. Less than three hours away from the city was an unanswered invitation to participate in a land project in Wassaic, near the train station. The concept was simple: help transform this beautiful mountain-lined acreage into a sustainable eco community, accessible by train. So, in May 2012, I ventured up there.

That piece of land would become my summer home, and it was there that I attempted to apply solutions I had only dreamed of. Through that

primitive experience I was granted a blank canvas on which to paint that world I claimed was so possible....We held meetings, made schedules, delegated tasks and formed working groups. We took organizational cues from Occupy, but with so many of us unaccustomed to "roughing it" in the countryside, many days our noble efforts devolved into disagreements and stalemates. We were like patients trying to build our own hospital.

Indeed, some of the people who landed at ARC 38 were homeless or mentally ill but were nevertheless embraced and accepted as part of the group, which sometimes caused problems.

José Mediavilla was a U.S. Marine Corps veteran who had a degree in film. He left an apartment and lucrative job working for Milk Studios, doing shoots for *Vogue* and other popular magazines in Manhattan.

Those were some of the best times of my life. I remember feeling at home, with my tribe. People who cared about the Earth, cared about people, and were eager for beneficial change to emerge from our efforts. We were out to

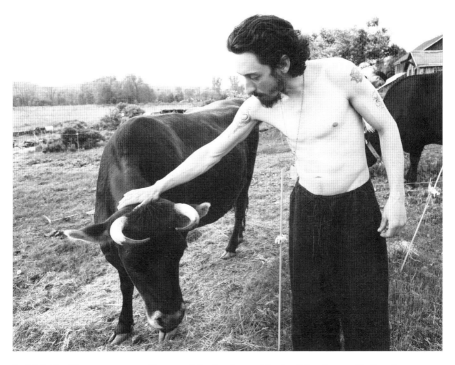

José Mediavilla communes with one of the bovine residents at the former Luther farm. *Lauren Hermele.*

save the world, and it felt like we were making a difference just by making a stand and sharing what we learned with others. I never met or talked with so many different people in my whole life.

I became a herald in the streets, preaching about the errors of mankind and our possible journey to a new promised land of sustainable and harmonious living....Eventually I networked with Occupy Farms. After the raid it became very clear that the movement needed safe space to reorganize, as well as grow food to feed people. Many of the young people needed to heal.

When I first arrived in Wassaic, it was like leaving Babylon to become a part of a small tribe living in nature. The land had everything from a flowing stream and a gorgeous valley to a mountainous forest of with paths and magical places. I fell in love with Gaia, our Earth mother. People at the farm taught me about natural herbs growing on the land that could be harvested for food and medicine. I felt secure, knowing that the abundance of nature could nurture us back to health. I also learned about permaculture, a design science that mimics the patterns of nature to build functional systems for humanity to live in harmony with both the environment and the local community.

My mind has gone through many evolutionary shifts since I participated in the Occupy Wall Street protest at Zuccotti Park. I went from being a hardcore Republican, Roman Catholic jar head to a nature-loving kind of guy...awakened to the great spirit of life. I felt a duty to sustain the natural systems that support our lives on this planet.

José was the hardest-working gardener and worked at the Wassaic Community Farm in the hamlet as well as putting in a garden on Bill Henry's land. Some of the other ARC 38 participants tried to plant, hoe and weed, but they were better trained for dialogue and spent most of their time on

ARC 38 community members begin planting. *ARC 38 Archives.*

their laptops. The few who actually got their hands into the soil were OK at planting, but they were not so good at weeding or harvesting.

The group seemed to spend endless hours brainstorming ideas. More often than not, many of them were hungry. They dumpster dived and lived on overripe bananas, stale bread, old veggies that were still somewhat usable and peanut butter. Food was scarce, and they could not afford to pay for it. Attempts to practice economics without financial corruption or any money remained a focus and struggle for the group. The church food kitchens were kind to them.

Stacey admitted:

> We came up to Wassaic to build an alternative life, but most of us had never lived outside and were out of our comfort zone. The whole scene was out of our comfort zone, since most of us were suburban or city kids. Everything we were doing was the first time, and we made mistakes but still kept moving forward. It started out with one vision, which was to figure out how to dismantle the entire system. To start over and build a new foundation, an example of a sustainable and just world run by the people.

ARC 38 did win allies as well as raise eyebrows in the community. Some of the local people, even a few town officials, including the building inspector, were sympathetic to the group and their cause and seemed intrigued by their eccentricity. He enjoyed driving slowly by the property ogling the young women who sunbathed topless on the silo in the spring. One noteworthy visitor was the executive director of a major environmental defense nonprofit who later wrote to the town board in defense of the community when attempts were made to shut down the project. One local young woman joined the community and helped with the planting.

Three years into the organic process of gathering the community and stewarding the space, the group enlisted a lawyer to help formulate an application for federally recognized status as a nonprofit organization. The project finally earned tax-exempt status by 2017.

In the fall of 2017, after the bank foreclosed on Bill Henry, the entity known as ARC 38 succeeded in purchasing the house and surrounding land at auction for $238,000 at 1:38 p.m.—one of those strange coincidences that made them believe that truth really is stranger than fiction.

Almost all of the core members of the early group had scattered by 2017. Squatters moved in who did not know or care about the original cause, and the site deteriorated. Eco was the last to leave, in 2019. The farmhouse has

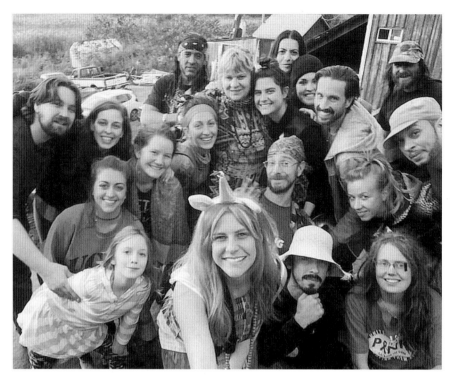

Youth from Brooklyn get a curated adult playdate with ARC 38 community members. *ARC 38 Archives.*

been condemned due to code violations. A new group using the ARC name is living on the property and growing mushrooms in the forest, but their cottage industry does not appear to be catching on.

Some of the community's founding members have gone on to participate in community building elsewhere. Shine alias Stacey wrote, "I now travel with my two children, homeschooling and facilitating Non-Violent Communication (NVC) workshops, the people's library, free schools, education, building infrastructure (such as outdoor kitchens, water systems, planting trees and seeds, composting outhouses) and carrying the message of Occupy. I still believe that another world is possible, and peace is the way."

Norman Rodriguez said, "Without Occupy Wall Street, Occupy Poughkeepsie and the ARC, I would have just stayed in Dutchess County and never branched out. After leaving the ARC, I seized the opportunity to challenge my potential by striking out on my own and building a company and family. I'm forever grateful for that experience."

ARTISTS, WRITERS AND ARCHITECTS ABOUND

A panoply of artists and writers have traditionally moved to the Harlem Valley area in search of privacy and seclusion away from the hubbub of the city. Photographers, too, have been fascinated by the hamlet of Wassaic, frozen in time, and have documented the last existing farms and their owners in Amenia. Some also documented the crumbling remains of the now-closed institutions of the Harlem Valley and have taken photographs of local people who have lived here for years.

Two of the most renowned—and now older—artists in the area are Frank Stella in Amenia and Jasper Johns in nearby Sharon, Connecticut. Among the famous authors who have lived in Wassaic are Simon Winchester, the author of *The Professor and the Madman, A Tale of Murder, Insanity and the Making of the Oxford Dictionary* who still owns land here, and John Rockwell, a former music critic for the *New York Times*. Rockwell bought a piece of property that used to be a hunting lodge next to a small lake on the top of Rattlesnake Mountain, overlooking the hamlet. He had a beautiful view of the water with a dock off his kitchen. He said he did not like the Hamptons and preferred Upstate New York because it is a place to relax and read books. He told me that he likes being isolated up on the mountain, away from the fray. He is exemplary of many of the area's writers.

Another major author who lives in Amenia is the elusively private Maxine Paetro, who is a cowriter with top-selling mystery writer James Patterson. She pens the Women's Murder Club series, among others, which is now up to its twenty-sixth book. She sometimes uses the names of local people in

her stories (with their permission); my moniker was "Tonia Shoumatoff, the firebrand reporter for the *Millbrook Independent*" in her book *Woman of God*. Her magnificent garden is open only twice a year and is a featured stop on the elite Dutchess County Garden Conservancy tour. Inspired by English gardens, her garden has many winding paths with rustic gates leading to enchanting "garden rooms," a koi pond and a woodland area featuring a bear picnic. She is a respected koi breeder.

An interesting array of architects have also been drawn to the area, restoring its old churches, mills and schoolhouses. In Wassaic, Tony Zunino restored many historic buildings, starting with the seven-story grain elevator that dominates the tiny hamlet. The architect Allan Shope built a "carbon-neutral house" that has been featured in *Architectural Digest* on the grounds of the former Wassaic Developmental Center, recycling and repurposing hardware from the state school for the disabled in intriguing ways. Architect Leo Blackman, known for his church restorations in New York City, restored the Gridley Chapel to its original glory with its multicolored slate roof.

The new jewel in the crown of the arts in the area is the Wassaic Project, which was started as a lark by several art school graduates who initially just wanted to have fun, produce a festival and exhibit the work of their artist friends who struggle to find a place in the New York City art scene. Many of the historic buildings in the hamlet have been restored as exhibition and living spaces with the help of Anthony Zunino, who was part of the restoration of the South Street Seaport area. Now, twenty-five of the artists have purchased houses and permanently settled here. It is amusing to see Brooklyn hipsters sipping beer alongside old-timey locals.

But as always, we start with the most historic figures.

EDNA ST. VINCENT MILLAY'S STEEPLETOP

Millbrook Independent, July 13, 2011

Everyone knows that the hills of the Hudson Valley are filled with hideaways for celebrated authors, musicians, actors and artists. But few know how many of those artists were actually celebrities in the 1920s. The poet Edna St. Vincent Millay lived at Steepletop in Austerlitz, just up the road from Amenia, producing some of her most profound nature poetry there.

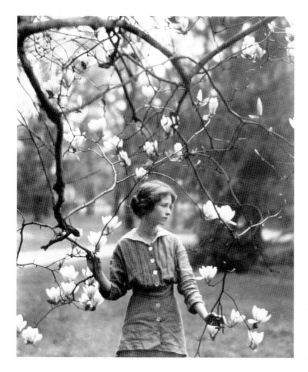

Edna St. Vincent Millay at Vassar, 1914. *Arnold Genthe; Genthe Photograph Collection, Library of Congress, Prints and Photographs Division.*

Millay's 625-acre estate houses the Millay Colony for the Arts, an artists' residency program that hosts fifty-three artists per season. A tour of the house and gardens includes stops in Millay's writing study, bedroom and library. Many of her poems were written about specific plants, trees and animals in her garden. Being there elucidates the poems and brings them alive.

The poet moved to the Hudson Valley begrudgingly, because she had wanted to move back to her beloved Maine after becoming successful. She had been living at 75½ Bedford Street in Greenwich Village, the skinniest building in New York City at just nine and a half feet wide. Subsequently, John Barrymore lived there while performing at the Cherry Lane Theater, and later, Margaret Mead, the anthropologist, lived in the same building. Millay's husband, the Dutch importer Eugen Jan Boissevain, recognized the need for Millay to be near her publisher, Harper & Brothers in New York City. In 1924, she already had four books on the bestseller list and a Pulitzer Prize under her belt.

Millay was familiar with the area, having attended Vassar College. She had lived in Cold Spring on the Hudson River in a summer writers' colony that included bohemian writers and such radical intellectuals as Max Eastman and John Reed. The first performance of her play *Aria da Capo* was held at

Bennett College in Millbrook. She embraced the ethos of free love, which was practiced by many of the bohemians, and had both male and female lovers.

Edna and Eugen found the historic Bailey family farm off Route 22 in Austerlitz through an advertisement in the *New York Times* and bought the house with five barns and several outbuildings for $8,000. They moved there in May 1925. Edna added another building from a Sears Roebuck kit so she could house her guests. The deeds to the property were in her name.

The house looks rather Victorian. She planted a large, slightly creepy-looking dragon willow that now looms over the driveway. She also cultivated purple and white foxgloves and scores of pheasant's eye and poetica narcissus, which added a decadent perfume to the already Beardsleyesque atmosphere near the pool area.

Even though it was not Maine, the land began to grab her attention, and she played with the idea of making her place look like Maine. There were already low-bush blueberry plants on the property, and she added apple and cherry orchards. Since she missed the ocean, she planted fields of blue lupins outside her bedroom window that would undulate like the waves of the sea. Near her writer's cabin, she created piney woods from thirty-one white pine trees that she transported from Maine.

She named her house Steepletop after the steeplebush that still blooms on her property. She said she "commuted to work" to her tiny writer's cabin, a wooden structure amid the grove of transplanted balsam firs from Maine. Her commute took her past the charming wildflower rock gardens she had installed. She always wrote in pencil and set her alarm clock for three and a half hours of writing, starting at 2:00 p.m. Her cabin was unadorned and spartan. She once wrote:

> *Through the green forest softly without a sound,*
> *Wrapped in a still mood,*
> *As in a cloak and hood I went,*
> *and cast no shadow in the shadow of the wood.*

Millay, who called herself Vincent, had just written her acclaimed volume of poetry *A Few Figs from Thistles*. The first "fig" was the poem:

> *My candle burns at both ends;*
> *It will not last the night;*
> *But ah, my foes, and oh, my friends—*
> *It gives a lovely light!*

Millay, Eugen and friends poolside. *Rockland Historical Society.*

Although "Vincent" had been one of the bohemians in Greenwich Village—her former lover Floyd Dell, an editor, described her as "a frivolous young woman, with brand-new dancing slippers and a mouth like a valentine"—the thirty-two-year-old poet was ready to morph from starving poet into lady of the manor. She posted a letter to her servants that said, "Do not speak to your mistress or guests unless you are spoken to. Say nothing, not even 'Good morning' to me when I come down the stairs and say nothing to you." She installed three bidets in the house, vestiges of her time in Paris.

For someone with size 3 boots who described herself as "ephemeral but far from frail," she came across to the neighbors as both daring and daunting. She hunted ducks with a tiny .22 rifle, had a small crop made to order and strode into town in jodhpurs. The daughter of a society lady in neighboring Spencertown remembered her mother telling her never to go near her "because she wore pants and smoked."

Edna and Eugen had tall wooden gates put up around their pool area to conceal the illegal drinking parties (since Prohibition was in effect) that took place under a pergola adorned with bittersweet. The bartender was bare-

Top: Millay's library office, Steepletop. *Tonia Shoumatoff.*

Bottom: Millay at Ragged Island, Maine. *Rockland Historical Society.*

chested, and guests were instructed to take off all their clothes before they entered the pool. There is a photograph of Millay cavorting while nude in the pool with her Vassar Latin teacher.

She continued the tradition of nude-only swimming on her beloved Ragged Island in Maine (which Eugen had purchased for her for $750), exclaiming, "We think bathing dress of any sort is indecent, and so do the waves and so do the seagulls and so does the wind!"

There is a hashish hookah in her study on the long table where she would divide her galleys. She wrote everything longhand before typing it up. Her library has a print of Sappho with a stylus in her mouth and, over the light switch, a little portrait of Shelley, whom she referred to as "the illuminator of the sonnet." She worked on a translation of Baudelaire's *Fleurs du mal*, which is in the library. Early issues of the banned magazine the *Masses* are on the table. Aside from a voluminous collection of poetry, she collected early feminist treatises with titles such as "Motherhood in Bondage" and antiwar books, such as Bertrand Russell's *Why Men Fight*.

Millay was working on a translation of Catullus for Harper when she accidentally fell down her stairs and died. She was buried next to Eugen in her beloved woods on the property. "I do believe the most of me floats underwater," she once said.

DeCost Smith:
Artist and Advocate for Native Americans

DeCost Smith (1864–1939) was a painter and author renowned for his paintings of Native subjects. From 1921 until his passing in 1939, Smith lived in Amenia in an elegant columned house on Perrys Corners Road, built on land that belonged to his family. The Greek Revival–style elements were designed by the architect Nathaniel Lockwood. The home was later owned by Donald R. Lomb, a descendant of one of the two founders of the Bausch + Lomb optical company.

Smith was a frequent visitor to the neighboring English-style manor house owned by his sister Celestia Sawtell, which was reputed to have been the home of film stars John Barrymore and Dolores Costello, Barrymore's third wife whom he dubbed the "goddess of the silver screen." Smith enjoyed painting the sweeping views of the valley from Morse Hill at that location. Two small paintings of his from that period were donated to the Amenia Library.

The DeCost Smith/Lomb house entrance with new columns after restoration. *John Kinnear Architects.*

Having grown up in the Finger Lakes region in Skaneateles ("long lake" in the Iroquois language) in Onondaga County, Smith spent time on the nearby Onondaga Reservation. He was later initiated as a member of the tribe. He had been impressed as a boy when an Onondaga woman with a papoose on her back came to the door of his family's house. He was later known for his advocacy for Natives.

The house DeCost Smith grew up in, the renowned Reuel E. Smith house, also known as Cobweb Cottage or the Gingerbread House in the Cove,

Sitting Bull holding a peace pipe, 1884. *Library of Congress, Prints and Photographs Division.*

was designed by the architect Alexander Jackson Davis and built in 1852 for Smith's grandfather. It is considered one of the finest examples of American Gothic Revival architecture. Smith's father, E. Reuel Smith, who inherited Cobweb Cottage, was a renowned illustrator.

Smith's sensitivity to Native perspectives is described on the book jacket of his *Martyrs of the Oblong and the Little Nine*, which was published posthumously in 1948. (The title refers to the early land patents of the area.) DeCost Smith had, it states, "an understanding of the American Indian's mind and nature that few white men have....His explanations of their conduct and the perplexing causes of their persecution is sane and objective."

Smith traveled extensively throughout the West with his older brother, Leslie, a photographer. He met with and sometimes sketched and painted powerful tribal leaders, including Sitting Bull, who united the Sioux against the white settlers encroaching on their lands, Rain-in-the-Face of the Lakota and the Shoshone chief Tendoy.

Smith also worked for the federal Bureau of Indian Affairs under several presidents, including President Theodore Roosevelt. He felt strongly about the travesties taking place against the great Sioux peoples as they were gradually stripped of their lands by the federal government, and he wrote about their brave fight in his autobiographical book *Indian Experiences* (1943).

In that book, Smith explains:

> *I was twenty when I first saw the Far West in 1884. The buffalo herds had dwindled to almost nothing, and the Indian was at his last stand....I had the privilege of knowing most of the noted men of the Northern Sioux...and hearing from them the Indian side of much that happened in the Big Horn campaign. The next twenty years saw the passing of nearly all that had made the frontier what it was.....Now the bands of wild horses are being slaughtered as a pest. Wolves, coyotes, eagles, foxes, bears, prairie dogs, bobcats and mountain lions are officially being trapped and poisoned. The antelope and buffalo are all but gone, and the open spaces are void of interest.*

Above: DeCost Smith standing with family and friends, all in Western outfits. *Left to right, standing*: Celestia Smith (the artist's sister) and DeCost Smith. *Seated*: Elizabeth Maitland Mills (later DeCost Smith's wife) and Burnett Smith (the artist's younger brother). *Reclining*: Leslie Smith (the artist's oldest brother). *Family collection, courtesy of William Sawtell.*

Right: DeCost Smith, a portrait accompanying his article "An Upper Missouri Trip, III, In the Ice." *From* Sportsman Tourist, *n.d.*

Smith studied painting in Paris in 1885, and in 1889, he exhibited his painting *Conflicting Faiths* (1888) there. That painting is now on permanent exhibit at the Skaneateles Library. He collaborated with fellow artists Edwin Deming and Frederic Remington, both of whom painted Native and cowboy subjects in the Wild West. DeCost Smith's paintings are noticeably more sympathetic to the Native perspective.

The plight of the Sioux people became a frequent subject of Smith's work, including his painting *Driven Back*, which was included in the art exhibition at the 1893 World's Columbian Exposition in Chicago. In his description of the works on display in the Fine Arts Building, Western historian Hubert Howe Bancroft wrote, "One of the smallest and best [paintings] among them is *Driven Back*, painted in 1892 by De Cost Smith, whose time has been largely devoted to the study of Indian life. It represents a party of Sioux warriors emerging from a river by which they are separated from a pursuing squadron of cavalry." This painting was inherited by DeCost Smith's grandnephew William Drake Sawtell and is now in the collection of the Birmingham Museum of Art in Birmingham, Alabama.

It was while Smith lived in Amenia that he became interested in the fate of the last longhouse settlements of the Mohicans (Mahicans), who had a settlement in Shekomeko (located near Pine Plains), and other woodland Native peoples of Algonquian descent, such as the Lenape, who lived in the Hudson and Harlem Valley Watershed.

Smith researched and photographed many of the areas where the Mohicans lived, including two sites where they lived alongside the Moravians: in the Shekomeko settlement, as well as encampments along what is now Indian Lake in Lakeville, Connecticut. His book is considered one of the most historic and detailed accounts of the persecution of both the Mohicans and the Moravians. The Moravians tried to help the Mohicans hold onto their lands but were expelled from New York by the New York General Assembly in 1745, which led to the last bands of Mohicans fleeing along with them to Pennsylvania.

Smith describes the sad demise of the Native peoples who inhabited the Harlem and Oblong Valleys:

> *From that day* [in 1746] *the fate of the Mohicans of the Oblong and the Little Nine was sealed. No gift of prophecy was needed to see that sooner or later they would be driven from Dutchess County and the province of New York. Unlike the more war-like Iroquois west of Albany, they* [the Mohicans] *were much too harmless to be allowed to remain.*

131

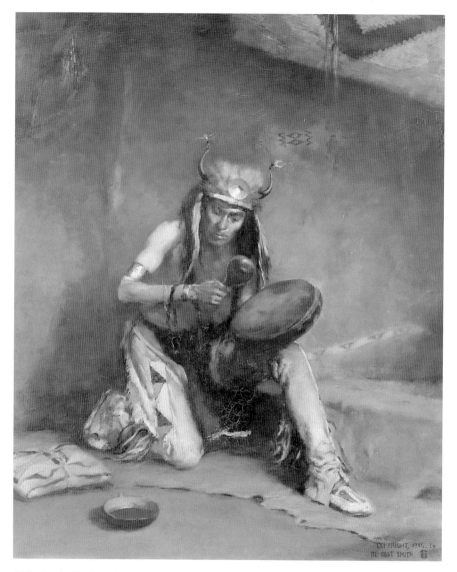

Divination, by DeCost Smith, 1906. *Museum of Fine Arts, Boston.*

The ragtag group of the last Mohicans to depart along with their Moravian missionary friends were described as "a bevy of forlorn men, women and children, in the raw catchy weather of early March, as they crossed the Hudson River and were halted by a mob and arrested as 'traitors to the king.'" By 1749, the Mohicans had vacated all their villages and missions due to persecution.

One of the great leaders of the Shekomeko Mohican village whom Smith wrote about was Tschoop (Wassamapah), who, late in his life, embraced the theology of the Moravians. He is believed to be the prototype for the character Chingachgook in James Fenimore Cooper's classic novel *The Last of the Mohicans* (1826). In Cooper's book, Tschoop's dying prayer is:

> *Great Spirit, Maker of All Life. A warrior goes home to you swift and straight as an arrow shot into the sun. Welcome him and let him take his place at the council fire of my people…for they are all there but one—I, Chingachgook—Last of the Mohicans.*

The Moravians were embraced by the Mohicans because they differed from other missionaries. They learned the Mohican language, lived with them, intermarried, dressed like them and valued the idea of "unitas," or community. But they still viewed the Mohicans as heathens who needed to be converted to Christianity.

DeCost Smith was an active member of the Dutchess County Historical Society, the Moravian Historical Society and the American Ethnological Society. His literary archives, photographs, paintings and sketches are held in the Rare Manuscript Collection at Cornell University. The artifacts that he collected from his trips are kept in the American Museum of Natural History, the National Museum of the American Indian and the Smithsonian. DeCost Smith was buried in Amenia.

AMY EINSTEIN SPINGARN: PAINTER, PHOTOGRAPHER AND POET

Known mostly as the wife of Joel Spingarn, Amy Einstein Spingarn was so self-effacing that she is referred to by historian Camille Roccanova as "one of the many women that those who create history often choose to overlook—the ones that made history but did so behind the scenes."

Yet Amy Spingarn was an accomplished painter, a published poet and a skilled photographer who took well-known (but uncredited) photographs of the NAACP's historic Amenia Conferences, held at Troutbeck in Amenia, the Spingarns' country estate. She is rarely acknowledged for serving on the NAACP board for many years after her husband passed away in 1939. Amy Spingarn deserves to be better recognized. Her small archive is buried within

the vast archives of her husband and others of the period. As Roccanova observes, she does not even have a Wikipedia page of her own.

Amy Spingarn studied painting with the well-known painter and teacher Hans Hofmann in Europe, traveled to Switzerland in 1928 to undergo analysis with Carl Jung, corresponded with Harlem Renaissance writer Langston Hughes, hosted suffrage and civil rights leaders and was a close friend of both W.E.B. Du Bois and Lewis Mumford. Dorsha Hayes, a fellow member of the Analytical Psychology Club of New York, said of her, "Amy was one of the few persons on this continent to know the work of Jung in the early part of this century; she was a Jungian before any Jungian societies had been formed." Amy attended Jung's seminars in both England and Maine.

Amy Spingarn. *Joel E. and Amy E. Spingarn Papers, New York Public Library, Manuscripts and Archives Division.*

Despite her reticence, Amy Spingarn was a passionate advocate for women's rights, particularly the right to vote. She was a leader of the Dutchess County Women's Suffrage Association, giving speeches, raising money and attending meetings, activities she documented in a detailed notebook called *Suffrage Campaign Notebook 1915–1917*. She was the co-organizer of an impressive suffrage parade and pageant presented at Troutbeck as part of the 1914 Amenia Field Day. Camille Roccanova wrote of the event in vivid terms in her fascinating and well-researched essay "Amy Spingarn: Humility and Pride," in *Women of Dutchess County, New York*, the 2020 Dutchess County Historical Society Yearbook:

> It is mid-August 1914, in Amenia, New York. Women in headbands and long white Grecian dresses parade across the lawn of the Troutbeck, the Spingarns' country estate. The line of women—members of the Dutchess County Women's Suffrage Association—squint in the sun, smile and talk among themselves. A crowd looks on, men in boater hats, women with parasols and crisp summer dresses.
>
> The crowd watches as a pageant unfolds: A young girl kneels, hands bound, at the feet of a woman wearing a crown and a dress covered in stars. The crowned woman holds a shield that bears the name "New York" with

Carl Jung and Amy Spingarn, Bailey Island, Maine, 1936. *Joel E. Spingarn Papers, New York Public Library, Manuscripts and Archives Division.*

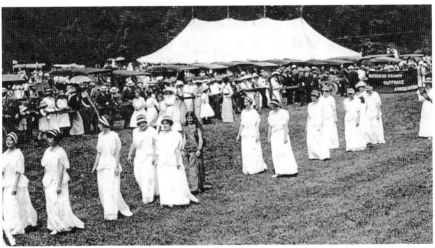

Suffrage parade, Amenia Field Day, Troutbeck, August 16, 1913. *Photograph published in Collier's Weekly 52, no. 1, September 20, 1913, Dutchess County Historical Society.*

an oversized question mark, effectively demanding to know when the state will honor women's right to vote. Somewhere in the watching crowd is Amy Spingarn, Mistress of Troutbeck.

The Amenia Field Day concept, described as "a rural experiment in co-operative recreation" in its 1913 brochure, became widely influential. Amy and Joel Spingarn hosted the annual event from 1910 to 1914.

In her *Suffrage Campaign* journal, Amy Spingarn refutes the argument that women are "too emotional" to vote, sarcastically observing, "Men, of course, have never been swayed by emotion." New York State finally ratified the Nineteenth Amendment three years later, in 1917. In the failed 1916 referendum, town by town in the Harlem Valley, including Pawling, Dover and North East, most voted in favor of women's suffrage—ironically, except for Amenia, which surprisingly chose instead to vote "wet," a stance of many antisuffragists.

In attendance at the 1916 Amenia Conference was Inez Milholland Boissevain, along with major leaders of the NAACP, such as her father, John Milholland, its treasurer. Milholland, a Vassar graduate, was a

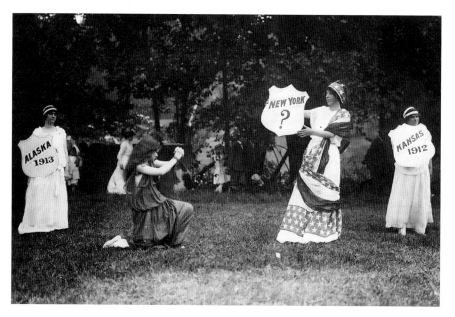

Women's suffrage pageant, Amenia Field Day, Troutbeck, 1914. A shackled young woman kneels before a woman dressed in stars, beseeching her for women's right to vote in New York State. *Amy Spingarn Collection, Amenia Historical Society.*

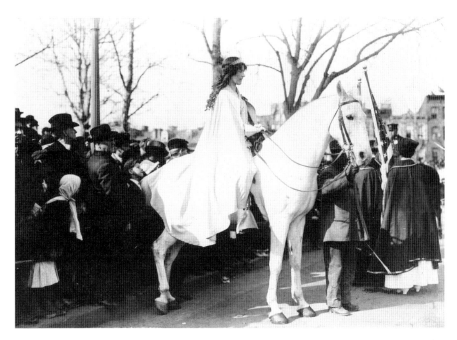

Inez Milholland Boissevain leads the suffrage parade on a white horse in Washington, D.C., March 13, 1913. *Library of Congress, Prints and Photographs Division. Item 97510669.*

renowned young suffragist who, in March 1913, famously rode a white horse down Pennsylvania Avenue in Washington, D.C., at the head of the massive Women's Suffrage Procession. In July 1913, she married Eugen Boissevain, a Dutch coffee importer. After her early death in October 1916, just months after the Amenia Conference, Boissevain married poet Edna St. Vincent Millay.

Amy Spingarn was also close friends with members of the Heterodoxy Club, which supported bisexual and lesbian women as members and hosted Margaret Sanger as a speaker. She was particularly interested in birth control, having given birth to four children in quick succession over five years early on in her marriage. She wrote that being a mother did not come easily to her. As Roccanova recounts, Amy's daughter Hope remembers her mother bringing back "exotic contraceptives" from a trip to Europe and enthusiastically giving them to her.

Amy seemed to have been conflicted about reconciling her unassuming nature with her inner passions. In the introductory poem published in her poetry collection *Humility and Pride* (1926), titled "The Parlor Car," she wrote:

Without I am cool and impassive,
And my behavior is suited to a parlor car,
But within I feel whirling gusts of passion and tumult;
I want to run through the streets naked,
With hair and clothes streaming behind me;
I want to drink and dance with lustful Alexanders…

But all the time I remain wistfully in the parlor-car,
And while I am quietly looking out the window,.
Deep down within my feverish depths I listen
To voices shrieking IO BACCHE, IO BACCHE.

THE LEGACY OF LEWIS MUMFORD IN AMENIA

Millbrook Independent, December 11, 2013

There is a saying in the New Testament: "No prophet is recognized in his own town." Lewis Mumford lived in Amenia for sixty-one years and yet is barely remembered by the townspeople. He bought a house near Troutbeck for $2,500 in 1929. He was part of the Spingarn crowd and a close friend of the family. Few people in the vicinity remember him or know he was one of the seminal thinkers of the twentieth century. He was among the first to emphasize the importance of considering human scale when designing towns and cities. He warned against allowing "technics," or machines, to replace spiritual values in the face of the commercialization of modern culture.

He was a strong spokesperson for the life of the village. His concepts still have relevance for little hamlets and villages today. Perhaps, as the Hudson Valley faces increasing suburbanization, it is time to get our copies of Mumford's books out of the closet and dust them off.

Mumford was perennially concerned about the effects of what he saw as a national addiction to automobiles and the building of highways to accommodate them. He wrote about how unwise transportation to suburban and urban areas would decimate the culture of villages, cities and communities.

In *The Highway and the City* (1963), Mumford wrote, "For the current way of life is founded not just on motorcar transportation but on the religion of the motorcar, and the sacrifices that people are prepared to make for

this religion stand outside the realm of rational explanation....Perhaps the only thing that could bring Americans to their senses would be a clear demonstration that their highways will, eventually, wipe out the very area of freedom that the private motorcar promised to retain for them."

And he later added, "The planners of the New Towns seem to me to have over-reacted against nineteenth-century congestion and to have produced a sprawl that is not only wasteful but—what is more important—obstructive to social life."

From the late 1920s, Mumford was a big proponent of regional planning and understanding what the concept of a "region" comprised. He was influenced by the British "garden city," which included interior areas with gardens, walkways and agriculture around the towns that would supply food locally. He outlined how to incorporate residential, cultural and industrial components that were supportive of each other.

He became the spokesperson for the Regional Planning Association of America, a group of planners and architects who helped plan sustainable green communities, such as Sunnyside Gardens in Queens. One of the group's crowning achievements was the design of the Appalachian Trail along the ridgelines of the Northeast.

The only time Lewis Mumford spoke up at a meeting in the town of Amenia—an incident that is still recounted and remembered by some today—was to disapprove, in the 1970s, of the placing of a shopping center, the Ames (now Freshtown) Plaza, outside of the village. He carefully explained that this would lead to the death of the village as a business center. And indeed, that is what occurred. No sidewalk was created to make it safe

Lewis Mumford in his thirties.
Lewis Mumford Collection, Monmouth University, Guggenheim Memorial Library.

and convenient to walk to the new plaza from the village, and slowly, all the small businesses in the village—the hardware store, the small supermarket, the clothing store—went belly-up and out of business. What remains are a panoply of under-visited antique stores and tiny shops that seem to have gone out of business one after the other, since the town is now just a drive-by town. The architect Bert Brosmith, who worked with Paul Rudolph of the Yale School of Architecture, came to Amenia to review the hamlet and famously remarked (quoting Gertrude Stein), "There is no there there, is there?"

In Mumford's view, it was a mistake to allow huge residential and commercial developments to dictate where other kinds of creative planning could take place. He was a firm believer that planning needed to be ecologically, sociologically and commercially sound. These were fairly radical thoughts in his heyday of the 1930s through the 1950s, when suburban sprawl was at its height.

If Amenia's citizens had listened to Mumford's advice, they might have, at the very least, insisted on having a sidewalk from the village to the shopping plaza. And perhaps they would have put brick walkways behind the main streets and hiking trails around the lovely pond behind the Immaculate Conception Church when the pond was offered to the town for purchase for a pittance of $10,000 a number of years ago.

And now, as the town is facing the prospect of a large residential gated development and probable changes in zoning to accommodate that complex, along with newly elected officials who are in favor of more development along Route 22 and Route 44, some of Lewis Mumford's ideas might bear revisiting.

A visit to the Amenia Library found the small collection of Mumford's published books stuffed unceremoniously in a little closet. The librarian Miriam Devine said there is no room to put them out on the shelves, even though there are only about twelve books in the collection. A drive past Mumford's former residence revealed a house that is peeling. A new park is being named after an American Patriot who never lived in Amenia, Thomas Young. Perhaps these are still more signs that, as the Bible said, a prophet is not recognized in his own town. (The new library in the town of Amenia has a glassed-in bookcase that will house Mumford's books.)

THE LAST DAYS OF LEWIS MUMFORD IN AMENIA

New York Times (purchased in 1994)
Lapis, no. 3 (1996)

In the fall of 1989, I was casting about for some ways to augment my meager income as an independent filmmaker. I came across this advertisement in the *Moonlite Trader*, a quaint handout of classifieds printed in Amenia: "Wanted: weekend companion for aging writer."

I had run across the same advertisement the year before, when we first moved to Dutchess County, and intuitively thought it might be for Lewis

Mumford. My filmmaker friend Roger Phenix had told me he had been to Amenia a few years before, filming a series of interviews with Mumford for PBS.

I drove the few miles through the rapidly suburbanizing dairy farm country of northeastern Dutchess County until I came to the Mumfords' unprepossessing, white-clapboard farmhouse, right on the road, to which little had been done since it was built in the early 1800s. When I arrived, I asked Sophia Mumford about those interviews, and she complained about the burn marks the production lights had left on the wooden beams in the study. Apparently, according to Roger, the film crew had gotten so cozy in front of the roaring fire, listening to Mumford's hypnotic intonations, that they had all fallen asleep.

As I walked through the kitchen with Mrs. Mumford to discuss what she needed in the way of a companion for Lewis, I passed Mr. Mumford sitting on a gray, hard-backed chair, staring out the window at his once-luxurious garden, now filled with brown stalks. It was a bleak November day. I went up to the old man and timidly pressed his hand while blurting out: "It's such a privilege to meet you—you've given so much to the world!" There was a nod and a flicker of acknowledgment, but my general impression was that, at the age of ninety-four, Lewis Mumford's great mind was flickering as well.

Sophia and Lewis Mumford at home in Amenia. *Roger Phenix.*

He had a *National Geographic* in front of him and was looking at pictures of architecture. He would vigorously protest when an ornate building was not to his liking. "Too rococo?" I asked. "Yes," he agreed.

Lewis Mumford: of course, I had heard of him and knew that he was famous for his writing about city planning, but I must confess I had never really read his work. When I did dip into his writings, I realized he was the father of everything we had espoused in the sixties: finding ecological balance amid the lopsided dominance of technology and materialism, creating a worldview that restores kindness and dignity to social structures, returning architecture and life to a more "human scale." I also learned that he had helped organize the country's first nuclear disarmament program, that he had actively opposed our government's involvement in Vietnam and that his writings had presaged the environmental movement and advocated for green spaces in urban areas.

In fact, one of my favorite magazines, the *Utne Reader*, was peppered with quotes from Mumford in stories with headings like, "Don't Just Say 'Yes' to Technology."

As I stepped into his austere but cozy Danish-modern book-lined study with Sophia, I realized that although her celebrated Greek stride in flowing skirts had been diminished to delicate paces behind a walker, she still emanated a progressive yet distinguished air. I realized that the Mumfords were serious people—what Donald Miller referred to in his biography of Lewis Mumford as the "extinct species that we call the public intellectual."

Lewis Mumford. *Lewis Mumford Collection, Monmouth University, Guggenheim Memorial Library.*

I asked Sophia if she knew the poet Edna St. Vincent Millay, and she started reciting Millay's most famous poem, "Renascence": "All I could see from where I stood, was three long mountains and a wood." Sophia had met and published Millay when she was an editor at the *Dial*, the journal that had published many other renowned poets and writers, including E.E. Cummings, Marianne Moore, T.S. Eliot and William Carlos Williams. It was there that she met Lewis and left her promising career to marry him.

Getting down to business, Sophia Mumford explained that what she needed was someone who could gently guide Lewis from the chair in the kitchen to the bed at bedtime, since "Lewis can't stand to be handled." She said she would call me if

she needed me to substitute for the nighttime companion. "Lewis is a sketch of his former self, but the essence of his being, his courteousness and sense of humor, are still there. He can read people and sense who they are."

Two weeks later, I had almost forgotten about my encounter with the nonagenarian twosome when Sophia called me at suppertime on a Saturday, asking in an urgent tone whether I could come over immediately, since she could not manage Lewis alone. I went over right away, even though I had dinner guests.

I found them as I had left them, in the kitchen. Sophia was trying to get Lewis to bed. Leaning over her walker and peering into his face, she said, "Come on, darling. you must get up. On the count of three, look into my eyes and stand up." Mumford grinned at her and thumbed his nose but stubbornly refused to try to rise from his chair. I realized how difficult it must have been for her to witness the degeneration of her brilliant husband of nearly seventy years into a mischievous prankster. I coaxed him into cooperating by reciting an anonymous poem that I had heard at the Hayden Planetarium:

> *For Age is Opportunity*
> *No less than Youth itself*
> *And as the evening Twilight*
> *Fades away*
> *The Sky is filled with stars*
> *Invisible by Day.*

Mumford's eyes twinkled with what seemed to be appreciation. He lifted himself up on the next count of three and shuffled along on his walker behind Sophia on hers—the bedtime train, I called it. Lewis counted the exact number of steps from the kitchen to the bedroom and knew by heart each rise and dip of the uneven country farmhouse floor.

After we got Lewis to bed, Sophia and I stayed up and talked about her impressions of the *New York Times* book review of Donald Miller's recently published biography of Mumford. Sophia (as she insisted I call her) was disturbed by the fact that Miller—a "cold academic," as Lewis had described him—had not shown her the personal sections of the biography as he had promised. She seemed less disturbed by the lurid detail with which he recounted sexual episodes in the Mumfords' personal lives than by the interpretations he ascribed to them, portraying Sophia as a put-upon and patient Griselda, when, in fact, theirs had been a free, open and honest

relationship in which every decision, event or idea was admitted, discussed and, if perhaps agonized over, finally accepted.

There were no secrets or constraints. Sophia told me that at one point, while writing his autobiography and discussing the role of the other women in his life, Mumford had offered to throw the whole thing into the fire, an offer she rejected. Her creed (as quoted in the "Amor Threatening" chapter of *My Works and Days*, one of Lewis's three autobiographical volumes) was: "Looking back on our life, I'd have nothing changed, if I could live it over again.…I could accept you having been in love with other women. I don't believe a blameless life is a good life."

She told me how it had been easier to accept the affairs, since she actually liked the other women, particularly Catherine Bauer, and respected their minds and thought them worthy of Mumford's interest. ("Except for Alice, who was a nuisance and threw herself at Lewis when I was pregnant and made it difficult for all of us.")

In spite of Mumford's active extracurricular love life—which resulted in his declaration, at one point, that he was intellectually in love with Catherine, spiritually in love with Josephine and domestically in love with Sophia—he proclaimed that Sophia was the "Winged Victory who proudly stands above them all" in the "Westminster Abbey" of his love and that his marriage with her exerted "a gravitational pull that no passing comet could overcome."

During my first night in their home, I could palpably feel the warmth and love that had held them together all those years. I was intrigued by the simplicity and functionality of their space, particularly Sophia's organization of the old-fashioned pantry, with scores of jars, all meticulously labeled, from oatmeal to orzo—and unusual items, such as orris and arrowroot. "Lewis was meticulous about having a tidy space to work in," she said.

After dinner, one of us would put the children to bed, and the other would do the dishes, and then we would both dry the dishes together and discuss the issues of the day. Lewis saw through communism early, although he was, at heart, a socialist. I was more sympathetic and said, "Give them time." Lewis always believed it was important to resist evil and that, in fighting World War II, we had emerged not cleansed but infected by the same virus, the quest for power and money.

A few days later, Sophia asked me to come sit with her husband five nights a week. I was to sit up and keep vigil near Lewis's bed while he slept. As he lay sleeping under an orange and brown afghan, I noticed that his ancient

The Mumfords in their Amenia garden near Troutbeck. *Lewis Mumford Center, State University of New York at Albany.*

profile had an air of nobility and clarity about it. There was a faded Tibetan *thangka* (sacred painting) of Chenrezig, the Bodhisattva of compassion, at the head of his bed and another of Shakyamuni Buddha on the wall at his feet. Sophia called them "reassuring presences."

Three of the bedroom walls were lined with books. The one closest to where I sat contained his life's work: various editions of the thirty-odd books he had written. As I continued to keep vigil by his side, I delved into his writings. He had a precise and stylish way with words. He seemed to be a philosopher, sociologist, architectural planner, artist and scientist all rolled into one. His interest in the interplay of good and evil particularly interested me.

At that moment, I realized that Mumford was like the lone prophet in the wilderness, warning of the incipient dangers of the commerciality of American culture and ethos. As I copied his words into my notebook, my silent presence seemed to affect him as imperceptibly as wafting smoke. He murmured, "Who's there? A cigarette?"

A few nights later, the moon was full, and Sophia warned me that her husband often became very talkative at that time. As I sat with him, he started talking almost feverishly, questing after new ideas and insights about what his new work should be. "Have you any ideas about the work?" he asked. I was amazed by the intensity of his words. "I don't think what I have written has given us all we need to make the transition to a higher place. I feel weak." He spoke animatedly about "the people, the workers," and kept referring to the importance of "small groups working together and creating help for us all. We need smaller groups now. That is all I can speak of, and it is not nearly enough…hope, a new class of people who will know what is necessary for us to survive. It is these small groups who will lead the way in the eventual help. These are the people who will be able to make the change to a higher place.…Their small risks will become a new law."

He seemed to be passing into a place where his concern for others and the future were more vivid to him than his waning physical existence. The next evening, I showed Sophia his ramblings, which I had written down. She said

he had spoken of these small groups before. Their daughter Alison told me that some months earlier, Mumford had kept asking Sophia to take him out to these "small groups."

Perhaps these words were nothing more than senile babble, or perhaps, as Lao-tzu has written, when an extremely old man starts to fade away, he comes into contact "with life in its highest form….At that age a man may free himself from his body and become a holy being." The possibility of such liberation was something that intrigued Albert Einstein as well:

> A human being is part of a whole, called by us "universe," a part limited in time and space. He experiences himself, his thoughts and feelings, as something separate from the rest, a kind of optical delusion of consciousness….Our task must be to free ourselves from this prison by widening our circle of compassion to embrace all living creatures and the whole of nature.

As he dropped off to sleep, I whispered an ancient Celtic incantation: "Deep peace of the running way to you, deep peace of the silent stars, deep peace of the flowing air to you, deep peace of the quiet Earth. May peace, may peace, may peace fill your soul. Let peace, let peace, let peace make you whole."

On Christmas Eve, I could not get to the Mumfords' until after ten. Mumford was restless again. His right hand was making broad strokes in the air, as if he were painting or sketching. He had been quite an accomplished watercolorist, and his self-portraits, cityscapes and landscapes of the lush green vistas and rolling fields around Amenia were hanging throughout the house.

"Can I leave now?" he kept asking, trying to get out of bed as if leaving. It reminded me of something Sophia had said about wishing she could just take him through a "door" out of this life and into the next.

The strange twilight relationship that I shared with Mumford in his final days seemed to affect him, too, even though I was sure he did not really know who I was. But as I sat with him, night after night, jotting down his final mumbled phrases, I felt in tune with his soul changes.

The night before my last with him, five days before he died, there was a huge snowstorm, and it was late morning before his day companion could get there. I stayed and made breakfast for Sophia, and we chatted while her husband slept.

That night, I picked up another of Mumford's lesser-known books, *Interpretations and Forecasts* (1972), and read the following commentary, which he had underlined, about Henry Adams's address to the Virgin:

> *Henry Adams, who sensed so many important transformations that he could not prove, was wise enough to seek, as a corrective to the large-scale perversion of life that was already taking place* [in America] *the help of a woman. He saw that we needed not more information, more statistical data…more exact knowledge; our society was already overburdened with larger qualities of power, under these heads, than we could ever make use of, without a profound change in our whole attitude toward human existence.*
>
> *Adams saw that we needed more feeling…feeling that has been poured into a thousand cultural forms, pictorial, musical, architectural and expressed itself in every sustaining mode of embrace…from the kiss of greeting to the hot tears with which we take our leave from the dead.*
>
> *The overgrowth of the instruments of intelligence had anaesthetized feeling, and thereby paralyzed our capacity to respond as whole human beings to life's many-sided demands. To restore the human balance upset by our pathologically dehumanizing technology…we must unite our higher capacity for feeling with our higher capacity for thought in order to produce acts that will be worthy progeny of both parents.*

Was Mumford, in his urgent references, pointing to the need to heal the more compassionate side of our nature?

In the last couple of evenings I sat with Lewis, he became weaker and weaker, refusing to eat or drink. On the last night I was his attendant, the only phrases I jotted down were "bands of light," "essence of being" and something about spring. His daytime attendant Robin said he kept telling her to start small—"This applies to cities, too," he said. In Stephen Levine's book *Who Dies?*, he wrote that to the degree that a person's life has been an investigation of truth, those insights will come alive at the time of their death.

When Dick Coons, Lewis's most beloved and constant companion, called to tell me about his death—quietly during his nap—I did not feel immediately sad. I felt that in his final moments, Mumford had embodied his own words about Ralph Waldo Emerson:

> *No one could have met the disturbance of senescence with more smiling resignation.…Like a winter apple, still ruddy, though mealy-ripe, he clung to the tree, safe from the worms and the wasps. When his thoughts*

no longer made sense, he had the sense to remain silent. But the halo remained gay and bright: and today, against the addled counsels, the insensate threats, the artful self-induced psychoses of our age, that halo has become gayer and brighter than ever, for it radiated from a poised and finely balanced personality.

ALEX SHUNDI: SURREALISTIC SHAMAN IN AMENIA UNION

Dutchess, April–May 1989

Over the portico of the old farmer's Grange Hall in Amenia Union is a sign that says "Webutuck Grange 1888–1931." A more perplexing sign stands in relief over the front door, "SHUNDI." Driving by the salmon pink, Greek Revival–style building, one wonders what those letters might stand for.

A peek into the driveway reveals a beat-up, finned, fifties vintage Cadillac, some welded metal sculptures and several station wagons with bumper stickers saying, "Indians discovered Columbus," and "Chu-chu's Pizzeria." Perhaps the stickers should say, "Italians are discovering Indians," since the station wagons belong to half-Italian, half-Albanian artist Alex Shundi, a man who, over the years, has been obsessed with capturing Hopi imagery in his paintings. Chu-chu's Pizzeria is located on a Zuni reservation in New Mexico, a place that has become part of Shundi's artistic stomping grounds, along with Wassaic.

A closer look at the outside of the Grange Hall, which was once a church, reveals Italianate cornices adorning the side and a west wing featuring a stained-glass Tiffany window in an addition that Shundi built for his mother. The man who opens the door of this converted Grange Hall generates intense positive energy and comes across more like a stevedore than a Yale- and Beaux Arts–educated fine artist. Alexander Shundi has also come to resemble the Natives whose symbols are so much a part of his work, and he is often asked if he is Native. "No, I'm actually a Wopaho," he ceremoniously announces, with a characteristically jovial and candid flair.

Shundi grew up in Parma, Italy, home of Verdi and Correggio, until his parents moved to Bridgeport, Connecticut, when he was thirteen. His father came from generations of pharmacists who made medicines for the Albanian royal family. His mother owned an art store and had the young

boy copy the Impressionists Van Gogh, Rembrandt and Rubens when he was just a tyke.

"Moving to America was like going from a truffle to a hot dog," he said, remembering the Bridgeport street toughs in leather and chains and how the family went from living in a villa to living in a third-floor walk-up with creaky stairwells, windows that wouldn't open and small rooms with low ceilings. Alex couldn't speak a word of English and was put in a class for second-graders who were behind in their education. In Italy, he had been so bright that he had started kindergarten at the age of four and then skipped a grade. But as he put it, "The kids in Bridgeport didn't go for my short pants or my tsi-tsi manners."

Coming into the Grange Hall is a phantasmagorical experience that combines elements from Native, Eastern and European cultures. In a mixture of simultaneous contrasts of the mundane and the sublime, Shundi has placed masks of Kachina dancers (Hopi representations of the forces of nature) amid Florentine cornices and columns with insets of Italianate tiles and Nepalese *thangka* paintings.

The tablita-style headdresses of the Hopi butterfly maiden social dances, called *kotpatsis*, flutter over the living room chairs, which are draped with Navaho blankets and rugs. Mirrors and stained-glass windows separate the rooms and reflect shelves of Kachina dolls, drums and other sacred objects.

An old-fashioned woodstove stands in front of a painting of an Etruscan stone lion, with two baby bears nursing, Romulus and Remus–style, from the sculpture. A mural of the Hopi lightning symbol adorns the bathroom door. The overall effect is both rococo and Felliniesque. In fact, Fellini is one of Shundi's collectors—quite fittingly.

After graduating from the experimental Silvermine Art School in New Canaan, Connecticut, Shundi went back to Italy to the renowned Brera Academy in Milan, where he studied under sculptors Mario Marini and Giacomo Manzù. Then he attended the Beaux Arts in Paris during the turbulent student rebellions of the late sixties. It was an exciting time to be on the art scene in Europe, and Shundi raced off-road vehicles through the Alps and attended some of Dalí's wild parties and be-ins. He then drove with his half-Algonquin, half-Russian first wife throughout Turkey, Afghanistan, Iran and India before settling back into his post-graduate work of studying and teaching at Yale.

"I love to embellish my environment," says Shundi, who has designed and painted murals for a half-dozen restaurants and pizzerias in the area. He painted sports cut-outs of Marilyn Monroe, Superman, Napoleon and

Tutankhmen, all eating delicious-looking slices of pizza, for a pizzeria in Wassaic. (The Mona Lisa, however, is gracefully twirling a spoonful of pasta.) Allen's in Millbrook and the Maharajah Room in Millerton were among the other restaurants that featured Shundi's handsome "embellishments" that made him a permanently welcome member of these establishments. He said, "Making images should be like breathing and eating, a part of everyday life. Some artists might not stoop to doing the kind of work that I do, but I have a feeling for public works."

Like the farmers who once swapped tools in the Grange Hall and like the Native people Shundi has befriended, he liked to exchange goods for services. Over the years, Shundi has bartered for medical, plumbing and heating services—not to mention food and entertainment—in exchange for much of the work he has done for local businesses.

How did he come to live in Amenia? He said:

Back in 1977, I was going to get a loft in Soho, but when my friend Murray Zimilies, who lives in Millerton, mentioned that there was an old Grange Hall for sale in Amenia, I went to go look at it and bought it for $12,000. Of course, at that point, it was just a grungy gray shell of a space. Basically, I don't like American cities; I prefer the countryside. Around here, wherever you drive, the view is magnificent. I'd never lived in the country before. It definitely makes you more selective and peaceful. The city is too distracting for an artist. If you know something is going on, you are almost under pressure to participate. Up here, you can be more introspective and get more work done.

On the wall is an example of this work: the leering little black face of a Mexican mask, with a beard and seed pod eyebrows and a snake coming out of the nose.

Shundi teaches a painting class at the Grange Hall on Mondays. He has also taught at Yale; Silvermine Art Center in New Canaan, Connecticut; SUNY Purchase; and an arts school that he ran for four years in Millerton, New York.

Some of his larger projects include animated films for IBM in Japan, a series of films on the Hopi and computer animation. He developed designs for blue jean jackets with some of his shamanic motifs.

Two of the influences Shundi mentions as salient to his work are Giorgio de Chirico and Hieronymous Bosch. Shundi's work emanates the same dream landscape quality as the square in de Chirico's *Enigma of a Day* in the

Surrealistic shaman

Amenia artist Alexander Shundi combines a love of DeChirico, a fascination with native American culture and a sense of wonder to create unique artworks

by Tonia Shoumatoff

photos on pages 27, 34 and 36 by DannyDelaney

all other photos by Robert Kalman

Alex Shundi, *Snake Priests* (detail), 1991; article opener illustration, *Surrealistic Shaman*, by Tonia Shoumatoff. *Robert Kalman, from Dutchess, April–May 1989.*

Museum of Modern Art. He superimposes disembodied symbolic images from the Native landscape that almost leap off the canvas, creating a surreal and almost three-dimensional effect. Feathers, birds, snakes, cactuses and drums interweave with each other in bizarre and uncanny ways that are disturbingly vivid.

The male-female juxtaposition comes up a lot in Shundi's work. In one painting, a male Native is emerging out of a hand-painted, earthen pot, the symbol of the eternal mother, the earth, the womb, and is inseminating the universe by blowing seeds through a thin reed pipe into a gourd-god, through whom they swirl into the quintessential spiral of life. He said:

I have heard that there is some kind of psychic plane out there that I don't follow, think, read or study about, but somehow in my work, I seem to tap into it. I put out my antennae, open myself up and these things just come through and appear in my art. There is a tremendous amount of coincidence in my life, and after I started visiting the Indian ruins in Santa Fe and reading about the Anasazi Indians, I loved their symbols and noticed a similarity to things I had come up with in my paintings independently without knowing about them. I don't know if I was plugging into what Carl Jung called the collective unconscious, but I felt a real connection, and I went back again and again and bought more and more Kachina dolls and tried to fathom the essence of this incredible mythology through my paintings.

Shundi described how he used to watch a lot of "cowboy and Indian" movies as a kid and how his love of the West was born when he went out to Arizona and the Grand Canyon as a visiting professor at Arizona State. Later, he married one of his Connecticut students, Elizabeth Hill, whose family was from Amarillo, Texas. Her family went to Santa Fe, New Mexico, all the time for weekend retreats. "Liz was the one who took me to Santa Fe to the Indian ruins, and I found real magic there," he said.

Shundi also found similarities between the pueblo architecture and the small towns of the Mediterranean. Building the towns around a plaza and a

church is similar to the way the pueblos were built around a town square and a kiva, he said. "Take a city like Siena and compare it to a pueblo like Walpi, and on the exterior level, they seem different, but on an inner level, the same elements come into play—a love of stone, strong family ties, heraldic symbols steeped in ancient mythological tradition."

Upstairs at the Grange Hall is Shundi's studio, where he gives classes on Mondays to a small group of area students. His wife, Liz, paints at the far end of the studio and is a fine young painter who also trained as a concert pianist. Her paintings abound with Native imagery as well.

Composition and form are extremely important in Shundi's world. He actually cuts out and stretches his canvases into bizarre shapes to capture and enhance the meaning of the symbols he is depicting. The most extreme example is the thin cut-out body of a snake hanging from the teeth of a snake dancer. In another piece, the jagged edges of the canvas are designed to echo the pounding bear of dancers' feet, adding the dimension of movement to the work.

Alex Shundi, *Snake Priests*, 1991. Hopi priests perform sacred snake dance to invoke rain. *Lazlo Gyorsok.*

Shundi becomes passionate when he talks about his unique approach to the form of the canvas: "I begin with an idea and develop that and draw a tremendous number of sketches. Why, when shape is limitless, should I limit myself to painting within a rectangle and having to fill up negative space that has nothing to do with the paintings? It's like forcing a musician to compose only within the range of C and F."

When Shundi composes a mural, however, the shape is dictated by the space. He was commissioned to paint a sixteen-by-seven-foot mural at the prestigious Chappaqua Library in Westchester, which is designed to be a ceremonial experience of the daily life in the longhouse—an essential part of Northeastern Native heritage. The piece features artifacts from the Iroquois, Algonquin and Mohawk traditions.

It is evident from Shundi's work that he feels a commitment to preserve and document a dying way of life among the Hopi. "There is a company that is trying to strip the coal from the Black Mesa for mining. They ship the coal 280 miles by water, which is lowering the water table of Hopiland, and this coal is being used to run the rotten wheels of Las Vegas. So, it is quite possible that Las Vegas will be the death of Hopiland," he said.

The word *Hopi* means "peaceful," but the young people are restless and do not want to continue in the Native ways. Shundi said, "The priests realize how precious this tradition is and are now willing to open up to the camera for the documentary film I am consulting on. Next time, I'll be invited into the kiva." The kiva is the most sacred ceremonial chamber, and for a white man to be admitted is a great honor.

Walking out of the Grange Hall, which itself looks like a sacred ceremonial space, Shundi explains a little about the various Kachina dolls.

This is Hemis, one of the rain Kachinas. There are 150 rain Kachinas, and the Hopi dance all year round for rain, because if there's no rain, there's big trouble. This one is Koyemsi, the Mud Head. He was the first one to come out of the "sipapu," or the belly button, of the Earth, and he is like the idiot child or the fool.

Each Kachina represents a different energy in nature. By honoring these energies that are all around us, by recognizing and depicting them, the Hopi were able to understand and live in balance with the flow of the elements in daily life. In modern life, we have lost touch with understanding the nature of these energies, and that is why we are such victims of our negative emotions and create so many problems in our environment.

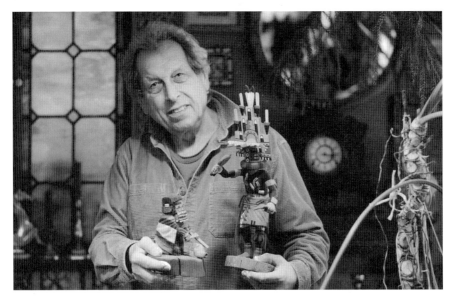

Shundi with Hopi Kachinas, who are prayed to for rain and a good harvest. *Lazlo Gyorsok.*

Shundi helps support a number of Hopi artists by buying their art. He also took care of his mother, who was partially paralyzed by a stroke but was still able to paint fanciful paintings remininscent of Chagall. So, art runs in his veins.

Recently, one of the great masters of Surrealism, Dalí, died. But his spirit of the surreal lives on in Shundi's work. The form of Shundi's work is surrealistic, but the content is uniquely American.

ALLAN SHOPE PIONEERS A CARBON-NEUTRAL HOUSE IN WASSAIC

Millbrook Independent, April 27, 2013

During the course of my career, the world changed profoundly, with the need for renewable energy and sustainable architecture becoming increasingly apparent. I left [my firm] *in 2006 to start a new architectural office dedicated to carbon neutral architecture....We must figure out how to build buildings that produce more energy than they use.*
—Allan Shope

Allan Shope seems to have enough energy to heat three renewable energy houses just with his presence. He is also one of the first architects to innovate and implement a design for a carbon-neutral house that produces more energy than it uses. He and his wife, Julie, lived, for several years, in one of the first carbon-neutral houses Shope built on the property of the former Taconic DDSO dairy farm.

It is an amazingly simple yet harmonious earth-buffered structure that demonstrates how a home can be constructed in a way that requires no fossil fuels to heat, light or cool it and has no carbon footprint.

He began with some basic priorities: using recycled materials, keeping labor local and reducing or eliminating the carbon footprint during the construction, operation and maintenance of the building. He said, "We all know that it's a bad idea to burn things…so we decided we would start by looking at what we did before fossil fuels were used in 1850 and set out to build a modern house to accomplish the same thing.…The discussion did not involve what we wanted but what we needed, trying to make the house as compact as possible to reduce the energy requirements."

Shope was inspired by some of the design aspects of eighteenth-century barns that were dug into southern-facing hills to create buffering effects for three sides of the lower level of the barn, with the sun warming the southern side that was not earth buffered. He realized that the uphill level, where hay was stored, provided an insulation mat for the lower level, which was also heated by the animals' body heat, the solar gain from the sun on the southern façade, the geothermal heat from the earth and the composting of the hay mat on the floor combined with animal feces and urine. This was his formula for building his carbon-neutral house.

Taking this practical and simple approach from a pre–fossil fuel era and applying it to a modern house, Shope built his carbon-neutral dwelling into the side of a hill, with a southern slope for geothermal gain through the earth buffering and floor-to-ceiling windows for meaningful solar gain from the southern exposure. He replaced the hayloft area with high-tech, sixteen-inch-thick insulation. He replaced the warming achieved with animal excrement with a human septic system placed outside the house that is fitted with a pressurized heat exchanger and aerator to convert human waste into heat via controlled composting in the house, which is enhanced by aerobic amoeba.

Shope took the building a step further than the available technology of the eighteenth century by adding photovoltaic electricity through solar panels on the "roof," which is actually just the top of the hill, and he

enhanced the aesthetic look of the building by adding copper flashing and using stones from the surrounding area, including the old buildings on the north side of the old Wassaic Developmental Center (now Taconic DDSO) that he purchased, tore down and recycled. He put some mushroom-shaped copper roof ventilators from the old buildings that were weathered into a lovely green on the roof and reused all the hardware from the 1920s buildings, including hinges, door hardware, casing and sinks, all refurbished and recycled.

The total effect is somewhat like a modern hobbit house with much more light, due to the sliding glass doors and full-length windows on the southern side. There is also a sleek elegance to the verdigris oxidized copper flashing that he used for the exterior. Shope added a unique artistic touch with his use of interesting hardware scavenged from the old Wassaic Developmental Center buildings. The interior of the building utilizes primarily local cherry wood that was grown on the property where the house was built. It has a warm feeling, with an interesting color and textural contrasts, enhancing the feeling of light.

Because the house is dug into the hillside, it is not exposed the way a normal house is, and the fifty-four-degree temperature of the earth buffers the cold in the winter and enhances the coolness in the summer. All the

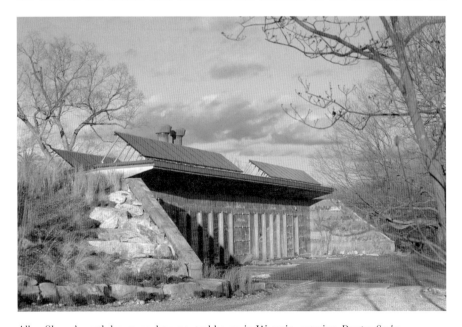

Allan Shope's earth berm, carbon-neutral house in Wassaic, exterior. *Durston Saylor.*

electricity is produced from the sun via the photovoltaic solar panels, which are designed to produce twice as much of the fifteen kilowatts per year of electricity that Shope calculated they would need. The heat is not dependent on combustion of any kind, and although the Shopes do have the luxury of a fireplace, they do not need it for heat. The passive solar energy is stored in the two-foot-thick concrete floor that absorbs and stores the heat and then gives it off after the sun goes down.

The occupants of the house, two humans and two cats, also give off meaningful energy, approximately 15 percent of its requirements, according to Shope. The house also gains energy from the carbon waste chain. Every time we flush, Shope says, we are throwing away energy: "We are recycling the human waste chain through a radiant loop that captures the heat from the septic system and distributes it through the house geothermally by radiant lines of piping in the concrete floor. Collectively, all these systems produce far more energy than we use or need."

There is no long-term maintenance required for this house, other than washing the windows once a year. The house offers a solution to the world by giving more than it takes, both to the world and to its occupants, who feel good about living this way. Shope said, "One of the dumbest ideas is to make a two-story wooden house sticking out of the ground and paint it white, which gives off heat all winter long. And yet this is the American dream."

The Shopes have found their house to be a great empty nester but say that it could be expanded to have two to four bedrooms. They have made a committed lifestyle change and put their possessions away in boxes. Julie said she loves the warmth, light and coziness of the space.

Allan said he would recommend this kind of house for anyone:

> *The time has come for houses that produce their own energy; the time is now, but I do not think that the world realizes that. We need "carbon-neutral" buildings now.…We need cars that do not require combustion now.…We need lifestyles that respect our children and grandchildren's futures, now. Society is "green washing" the most important conversation we need to have in this century. We live on a planet that is capable of sustaining about 1.5 billion people without fossil fuels. Fossil fuels have allowed humanity to grow currently to a population of 7 billion people. There is a general agreement that we will be victims of climate change and may run out of fossil fuels during this century, creating a very big mess on Earth that will look like survival of the strongest. We need to plan and innovate today for that event to mitigate its disastrous implications.*

It is amazing that a building that reflects the common sense and wisdom of an eighteenth-century barn also addresses concerns of energy efficiency for the future and provides a model for that.

PETER WING'S ECCENTRIC CASTLE

Millbrook Independent, September 18, 2009

When Peter Wing came back from Vietnam in 1969 to the dairy farm his father owned in Amenia (which was later sold to John Dyson of the Millbrook Winery), he proposed to his high school sweetheart, Toni Simoncelli, on a grassy knoll overlooking the Hudson Valley and promised he would build her a castle someday.

He had always loved the corner pasture of the family farm that was too rocky and rough for tilling but perfect as a "maternity ward" for the dry cows (his father milked 120 a day). The pasture, which is off Bangall Road, between Millbrook and Stanfordville, also has some of the most spectacular views in the area, spanning across the Hudson River into the Catskills.

Wing originally intended to build a barn with two silos for his new bride, but the silhouettes of the silos reminded him of turrets. Thus began his phantasmagorical journey to create what is now, forty years later, one of the strangest but most fascinating structures in the area, drawing hundreds of tourists from near and far to experience its magic every year.

Peter Wing is a consummate artist, with no formal training as either an artist or an architect, whose unique visual approach to life permeates every nook and cranny of the place. His father, a dairy farmer, was also an artist (as are his two children) and would draw pictures on napkins to amuse his children. "He would draw teams of horses working in the field, and you could see every muscle," Wing reminisced. "In those days, you could not count the cows, haybales and farms in our area."

Walking up to Wing's Castle, appropriately on a Halloween afternoon, one is struck by the sheer bravado of stonework that erupts into odd arches, rock buttresses, vaults, steps, windows and turrets, placed seemingly without rhyme or reason and yet somehow fitting harmoniously into the autumn landscape with the same jutting shapes as the untrimmed orange and red sumacs that stick out from every direction.

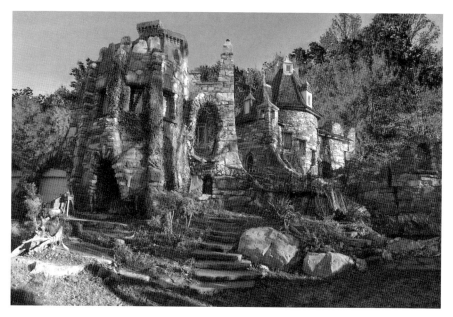

Wing's Castle. *Charles Wing.*

Approaching the castle, one notices frightening faces with gaping eyes and mouths made out of wood that appear above the windows and a bevy of heraldic turrets adorned with peculiar looking weathervanes. The mask motif is carried on throughout the castle and reminded this author of a dark valley in Switzerland called the Löchenthal, where residents carved terrifying masks to keep away evil spirits.

"I like to think I can deflect the bad spirits by depicting them," said Peter Wing, and indeed, even his front-end loader has a dragon with fangs painted on its jaws. One also sees Iroquois masks on the kitchen walls (Toni is part Schaghticoke); scores of World War I and World War II helmets, gas masks and goggles adorning the heads of mannequins; dragon shapes; creepy locks; crypts beneath the building; a gigantic copper cauldron for a bathtub; and niches with intriguing creatures throughout—a magical mystery tour par excellence.

"My approach to the bizarre and the frightening is to make it very Fellini-esque," he said, in reference to his other major oeuvre, the Frankenstein's Fortress theme park in Stanfordville. Martha Stewart said it was the creepiest haunted house she had ever seen when she featured it on her TV show.

Wing said he never tried to imitate a specific genre, but there are some elements of Antoni Gaudí, the Spanish architect, in his work. It's a mix of

Gaudí and English Tudor on the outside, with a touch of Salvation Army and late house wrecking on the inside. The entire building is actually a giant sculpture that Wing and his wife live in.

The materials Wing used to create the building come from a demolished stone bridge in Salt Point, beams and remnants from eleven old barns throughout the Hudson Valley and bricks from Poughkeepsie's urban renewal of Main Street in the 1970s.

Wing said, "For a living, I paint murals, buy and sell antiques, repair stuff and do commissions for restaurants and decorators. Ninety percent of my collections of odd memorabilia are from garage and tag sales. You have to get there before everyone else." He painted the Grecian murals at the Four Brothers restaurant in Amenia that presides where a hotel used to be.

Wing has an existentialist attitude toward his work and says that it is meaningless within the larger scheme of things, but he likes the ethic of hard work. He becomes grumpy when asked how he was able to lift all those heavy stones. "You have to realize that this has taken over forty years of my life to build," he said. The poured concrete leading to the guesthouse he is currently building took two years alone. His wife, Toni, a physical therapist, is a good choice for a partner and has a quietly wise demeanor.

"You might call me obsessive compulsive, but Mrs. Wing will not let me clutter the place to the point of no return," said Wing. He confessed to having many more boxes of stuff stashed away in corners:

> *I like to think that there might be strains of collectors from the hunting and gathering period who have survived into today, but you have to be obsessional to find the best "fruits and nuts" in my trade. But I don't believe in having any plans or goals for the future. Buddhism says you have to be accepting of the now.*

But Wing ended the tour by displaying the future bed-and-breakfast he was in the process of building, which is attached to the main house through a vaulted tunnel reminiscent of the catacombs.

The courtyard of the future bed-and-breakfast features a mosaic of Sisyphus pushing a rock up a hill. Perhaps that is the best metaphor for Peter Wing's life experience.

Wing's Castle is definitely a unique expression of Wing's mad genius and fantastical mind that is a must-see. He said that fifty Russians would be arriving the day after our interview for a tour.

I walked back to my car past scores of pig-scalding cauldrons that adorn the edge of the driveway. "They used to put the pigs in the cauldrons to get their hair off. Last summer, I took Shakespeare's sonnets and rearranged them into the story of Frankenstein for the Annandale Children's Theatre. A London theatre director is now interested in the piece," said Wing. He then left to attend to his Frankenstein's Fortress, where dozens of local trick or treaters were waiting for him.

Peter Wing passed away, sadly, in a freak accident with his three-wheeled car on September 28, 2014.

SHOOTING METAMORPHOSIS INSIDE THE HARLEM VALLEY PSYCHIATRIC CENTER

Millbrook Independent, November 9, 2012

I love the stillness and quiet of the place. All I can hear is my breath through the respirator and hazmat suit I have to wear. I feel like an underwater sea diver.
—*Avery Danziger*

It took Avery Danziger a year and half to get permission to shoot photographs inside the deteriorating Harlem Valley Psychiatric Center. He had to put up a $1 million bond, sign an indemnification waiver, buy a special hazmat suit and respirator and hire an employee from Dover Knolls to accompany him on over thirty trips into the site's eighty-one buildings, where he shot 3,500 photographs to get 100 usable images. He started in February 2010, and he is the last photographer who will ever be allowed to film inside the facility.

When asked why Danziger was selected to be the last photographer, Kathy Schibanoff, the local project coordinator for site (which then belonged to Dover Knolls), said:

We were impressed with Avery's reputation. He has been exhibited around the country and at the Museum of Modern Art. He jumped through all the hoops, held us harmless and even bought and paid for all the hazmat gear himself. But we will not entertain anymore photographers. It is just too dangerous. You never know when a roof or floor is going to collapse. He is the last artist who will be allowed access into the inside of the buildings.

Harlem Valley Psychiatric Center's interior, 2012. *Avery Danziger.*

It is a photographer's dream to be able to shoot in such a location. Dover Knolls accommodated many photographers after it acquired the property in 1994, allowing a *New York Times* fashion shoot with actress Selma Blair; an indie movie called *Toxic Avengers*; photographs for a book called *Asylum*, by Christopher Blair; and even several music videos.

And indeed, a ceiling-mounted propane heater came crashing down in one of the rooms where Danziger was shooting. Danziger could work for only four hours a day because he wanted to use natural lighting. "It was so toxic in there due to all the old asbestos, lead paint and mold, I had to be aware of my surroundings at all times. You lose all sense of where you are....I had to drop pieces of colored tiles like Hansel and Gretel to find my way out."

The way Danziger discovered the power of the place was by sticking his head through a broken window of the power plant near the Harlem Valley–Wingdale train station. He then put a camera on a monopod (single-armed) camera mount and took a photograph using a remote trigger. He was very excited by the "random chaotic beauty" that was revealed in the space.

Danziger decided to approach the experience as pure art and was able to capture abstract images. He would walk through the spaces first without a camera and just allow the images to unfold as he took notes or quick shots with a cellphone. He said:

It was not scary, because I was going there as an artist and was not allowing myself to be weighed down by the history of the place. I was only seeking to capture the slow transformation from man-made order into the beauty of natural chaos. The buildings at Harlem Valley have been abandoned since its closing in 1994. All the buildings are in a very deteriorated state; most have been vandalized and covered with graffiti. It is only our perception of the change that makes it scary.

Danziger actually said that he came to respect the "dignity" of the place and found many of the spaces inspiring. The only creepy area was the morgue in building 85, where, he said, he could not work for more than half an hour without the hair standing up on the back of his neck.

At its peak in 1956, the facility housed up to 5,800 patients. In 1936, it was the first mental hospital to introduce and teach the practice of electroconvulsive therapy, and physicians from institutions around the United States and Canada came to Wingdale to learn the practice. Until 1960, the institution was a self-sufficient community with farmland that held a piggery, up to three thousand chickens in a poultry house, a dairy barn and a root cellar.

The institution introduced state-of-the-art renovations to create a more comfortable, personalized setting in the mid-1980s, with new lighting and furnishings that resulted in an uplifted morale for both patients and staff. There was even group therapy and a patient-run advocacy council.

But all that fell by the wayside when the institution succumbed to the public policy of closing state mental health facilities and reintroducing patients into the community, which resulted in the big influx of homeless people in New York City.

"This place speaks to me viscerally," said Danziger. "It is disintegrating every day, and this helps me understand something about my life and the nature of impermanence. It's not about anything other than letting go."

WASSAIC PROJECT ARTISTS TRANSFORM THE HAMLET OF WASSAIC

The Wassaic Project, a nonprofit artists' collective that arrived in Wassaic in 2008, epitomizes how artists can reinvigorate an entire community. It started with the rehabilitation of the Maxon Mills grain elevator building

by Anthony (Tony) Zunino and Richard (Dick) Berry (Zuberry Associates) in the middle of the village. Zuberry was renowned for its restoration of historical buildings in the Front Street area of the South Street Seaport Historic District in New York City.

Once the tallest building in Dutchess County, Maxon Mills was a looming hulk in danger of being torn down by the town of Amenia. Its aluminum siding had come loose and was flapping in the wind. A tree was growing out of the very top of the building. Hundreds of feral cats frequented the property, still seeking the mice that ate the grain.

Sharon Kroeger, the owner of Calsi's General Store in the hamlet and a major voice for preserving the mill when the town wanted to tear it down, had bought the building for one dollar from the feed company. She worked to get it designated as a historic site by the state. She started a nonprofit called the Wassaic Historic Agricultural Crossroads, hiring local Latino workers to remove the dangerous siding. But the maintenance became more than she could handle.

Kroeger then brought in Zunino and Berry, who seized the opportunity to buy and restore the historic old grain elevator building. They sank over $400,000 into stabilizing it, saving the grain elevator from being demolished.

Little did anyone know that the Zuninos' daughter Bowie (named after David Bowie), her college friend Eve Biddle and Elan Bogarin (joined shortly afterward by Jeff Barnett-Winsby) had a vision of creating an art festival, a residency and an exhibition venue for emerging artists. They found an opportunity in Wassaic.

In the summer of 2008, the little hamlet was indeed transformed. Hundreds of young people came to party, camp, exhibit and see art on the many floors of the restored mill. Bowie and her friends worked night and day, scrubbing the old Luther Auction Barn, turning the auction ring into a film venue for avant-garde films and bringing hay bales onto the outdoor performance platform built by Zunino and company. A regular hootenany lovefest took place among an odd combination of local rednecks and Brooklyn hipsters.

The Wassaic Project only grew from that first summer festival. Almost every historic building in the hamlet of Wassaic has now been creatively restored and repurposed for use by the Wassaic Project artists. The former cow stalls in the auction barn have been repurposed as summer studio spaces, and the small hotel rooms attached to Maxon Mills have been renovated as winter studios. The Wassaic Project's website expresses the relationships these artists have built in the hamlet: "We're of and for Wassaic, not just in it. Our artists-in-residence live right here in town. We work out of refurbished

historic buildings. And our festivals and exhibitions are free and open to the public. Wassaic is our home, and that informs everything we do."

One of the mascots for the Wassaic Project was a white goat called Pantyhose that belonged to young Dave Luther, who looked after the Luther family auction property and, years later, still pitches in. Pantyhose even made it into a July 2009 preview in the *New York Times* of the Wassaic Project's second summer festival.

The Wassaic Project is now a year-round destination, featuring a summer-long exhibition at the mill and a winter exhibition, as well as family-friendly outdoor and indoor dining at the historic Lantern Inn building. Spontaneous happenings, music festivals and hands-on creative experiences enchant both children and adults in the area.

A glowing article published in the *New York Times* in March 2015 describes the Wassaic Project as a "toothsome example of how artists schooled in social practice—that is, art that combines education, community engagement and social activism—can reenergize not just structures but entire towns like this tiny hamlet of just over 1,500 people that is the last stop on the Metro-North Harlem line."

"Many of our artists and photographers have done site-specific work, working with the landscape, the people, the animals and taking photos of

All three Wassaic Project directors during one of their festivals. *Wassaic Project.*

THE VAGABOND TIME KILLERS

Jeff Barnett-Winsby, a photographer, discovered though online research that a photographer named E.E. Ballard had had a darkroom in Wassaic back in the early 1900s. He was taken by a photograph featuring a group of creative-looking young people in tattered theatrical outfits holding banners reading "VTK." Written on the back were the words "The Vagabond Time Killers, 1901, Wassaic, New York." The photograph inspired the 2017 Wassaic Project summer exhibition, which displayed the work of artists who "are part of Wassaic's quirky history and embody the spirit of the Vagabond Time Killers."

The Vagabond Time Killers, 1901. *E.E. Ballard, Jeff Barnett-Winsby and Bowie Zunino.*

the area and the characters who live here," observed Eve Biddle, one of the Wassaic Project codirectors. "We also work with the high schools throughout the Harlem Valley, offering them art programs. Now, the schools are even busing students to come here after school to do their projects."

"Wassaic is an amazing place," said Bowie Zunino. "I love the architecture and how it inspires both our programming and the artists who come to work here. It's a community that reflects the narrative of so many post-industrial,

post-agricultural cities and towns, and yet there's a scrappiness to it—a history of being unrestrained and a little different that opens the door to wild ideas and out-of-the-box solutions. That's what I love about working here."

Jeff Barnett-Winsby, who joined the Wassaic Project in 2009, is married to Bowie Zunino, whom he met in graduate school at the Rhode Island School of Design. On his website, he says, "We are a group of artists who work collaboratively, within a small town....As a rural arts organization we have an immense responsibility to support, nourish, and better the locale which we inhabit. We take our roles as community members very seriously."

Barnett-Winsby has served as chairperson of the Town of Amenia's Zoning Board of Appeals and is a Wassaic Fire Company commissioner. As an artist, he explains how formative his Wassaic Project experience has been for him personally: "It has been the greatest challenge and joy of my life to collaborate with so many talented people to build this project."

Presented here are a couple of the most striking Wassaic Project artists, Adam Eckstrom and Lauren Was of Ghost of a Dream, who were the first artists to buy a house in Wassaic, and Delbar Shahbaz, a former project resident originally from Tehran, where her work was banned. These artists give a sense of the extraordinary range of artists who have found a home in Wassaic both as residents and exhibitors.

DELBAR SHAHBAZ FINDS A VOICE FOR IRANIAN WOMEN AT THE WASSAIC PROJECT

Millbrook Independent, May 26, 2015

Delbar Shahbaz, an Iranian artist-in-residence at the Wassaic Project, says that her generation of Iranian women are caught in the in-between— "neither here nor there, neither traditional nor modern."

In her 2014 exhibit *Terrain of Absence,* she explains that as an Iranian artist, she has a heritage to remember and experiences to forget:

> *Out of nowhere, I arrive somewhere else. No one is like me. No shared history. Everything is brought into question. Years of experiences— unpacked. What I formerly concealed, I begin to share: my body, my identity, my experience through these things. I have a form of freedom, yet I still struggle how to access it.*

I came upon Delbar on a ladder, covering over the windows of her studio with black cloth. She was working on an installation called *Non-Residential*, in which she builds an imaginary land in the middle of her studio that is safe space from outside influences and cannot be destroyed. Graffiti-like messages in Farsi are scribbled on the wall.

The studio cannot be entered or seen except through rows of strings that block it from outside viewers. There are niches with strings in front of them with drawings of tiny people hanging behind the strings. She calls them prisoners.

"There are people who want to forget the disasters of their countries, but you cannot totally forget; you can only put the memories away in a box," she said. Delbar remembers some of the atrocities from the war between Iran and Iraq when she was a little girl.

Delbar writes poetry in a beautiful Persian script on the wall of her studio: "The land that offers you death, offers you her wound…forces you to exit. I do not belong to any Motherland now. I have cut my roots and now have to carry my heritage in my guts." I asked her about what she means by wounds. "It's all about war. It never gives you any resolution. When I was in the middle of the war between Iran and Iraq, for me, as a child, there was no happy ending. I just didn't want to see my mom's worried face; that was my whole concern."

Delbar Shahbaz blacking out her studio windows. *Tonia Shoumatoff.*

The Pregnant Carpet, a controversial installation banned in Tehran. *Delbar Shahbaz.*

Delbar had eight exhibits in Tehran, two of which were not open to the public and had to be kept private because the subject matter was too controversial. One showed images of a "pregnant" carpet and explored the expectations that all women in Middle Eastern countries must have children in order to experience heaven. "In Iranian culture, there is an expression that 'a woman goes to heaven when she becomes a mother,'" explained Ms. Shahbaz, who described the heavy pressure to have babies that is part of the culture.

Much of Delbar's work is sculptural. One series, called Descendants of the Angels, presents colorful painted clay and mixed-media sculptures of women with wings who, she says, aspire to look on the world with the wisdom of the angels: "I look at the city from above. Now, I can understand how people dream but with open eyes. My angels are born in this way.... The world that I like to see is born, and the angels look like me on the days that I feel good."

She describes the condition of women when she was growing up in Tehran in her show called *Terrain of Absence*:

> *Three years old—rules dictated. Seven years old—cover your body. Nine years old—breasts appear and you begin to slouch. Ten years old—your period arrives. You tell no one....Seventeen years old—how do I please everyone, my parents, society? I am discovering ways...but in the process, I forget myself. Only in secret do I allow thoughts of self, concealing my desires.*

In a poster for *Vanish in a Day*, a woman figure is facedown, with pins, voodoo-like, stuck into her body, holding her down. That exhibit depicted women pinned in clear plastic boxes. She said, "In this solo exhibition, I

Delbar Shahbaz with her sculpture *Descendant of an Angel. Delbar Shahbaz.*

have seventeen Plexiglas boxes, and inside each of these cubes, there is a pinned woman trying to live and survive by herself. In the middle of the gallery, there is an interactive installation that includes little aluminum puppets hanging from the ceiling. I ask people to imagine if they were in these boxes and trying to live and survive there."

She said it is difficult for women in America to imagine the repression of women in Iran. "Women in Iran are subject to the regime, can be picked up, questioned and detained for minor infractions. My life in Iran was proscribed by dress and behavior codes enforced by men—every day was accompanied by fear."

Delbar was discouraged from going to art school. She got a degree in biomechanical engineering, was unhappy in that career and went back to school to receive an MFA degree in illustration from Tehran Art University. She came to the United States two years prior to this interview to get another MFA at the Art Center College of Design in Pasadena.

She said she likes to work with actual materials, not just simulations and videos, and showed us a piece she painted from inside one of the charcoal kilns in Wassaic. It shows a woman with extremely long legs dangling twenty feet down from the one window inside the kiln. Phantasms of nature spirits dance on the walls.

She said, "The idea of creating an alternative reality is how I express most of the issues I want to talk about. People are living in our shared reality but from inside, everyone is carrying around this other version of reality that is distorted, insecure and informed by trauma and other experiences. I like to take this inside, out! I am interested in addressing this through metaphor. I work in a way that indicates psychological conditions."

"In my work, you see a woman who is haggling with herself to make sense of her life and her existence." Delbar Shahbaz's installation at the Wassaic Project explored the universal theme of finding a secure space amid the shifting sands of life.

GHOST OF A DREAM CREATES FANTASIES OUT OF LOTTO TICKETS

Two of the earliest artists who exhibited and bought a small house in Wassaic are Lauren Was and Adam Eckstrom, a couple who collaborate under the moniker "Ghost of a Dream." They have been tied to the Wassaic Project ever since they were invited to live here by Wassaic Project directors Jeff Barnett-Winsby and Bowie Zunino back in 2008.

Was and Eckstrom's installations have been exhibited widely in prestigious venues, and they have been written up in the *New York Times*, *Vogue* and *World of Interiors*, among many other publications.

The name Ghost of a Dream is inspired by their projects, which use vestiges and ephemera from peoples' hopes and dreams, such as losing lottery tickets, playing and baseball cards, discarded casino money bags, old art catalogs and carpets—all of which they have combined as installations or collages to create unusual and stunning art pieces. They capture people's lost fantasies and make those dreams into a reality, even if those people did not win the lottery.

One of their early large fabrications (assembled with the help of ten of their students from Rhode Island School of Design) was a Hummer H-3 made out of as many losing lottery tickets as the car actually cost.

They later built another car installation, a Lamborghini Countach (base price in 2022 $2.64 million) made using both American and Chinese lottery tickets as part of a three-month residency in Beijing, also with the help of seventeen assistants. That car was transported back to Wassaic for the Wassaic Project Summer Exhibit in 2013. The car is now part of

Adam Eckstrom and Lauren Was of Ghost of a Dream, working in their studio in the Luther barn at the Wassaic Project. *Lauren Was and Adam Eckstrom.*

the permanent collection at the West Collection, near Philadephia, which features vehicle-based art.

Other manifestations of hopes and dreams led to the creation of a *Dream House* (constructed in Basel, Switzerland), a *Dream Boat* (launched at Art Miami) and a *Dream Vacation* (which now lives in Brussels).

A lot of their work, they say, is about seduction. When they went to Atlantic City to collect materials for their installations, they were able to collect carpets and money bags from the failed Trump Plaza Hotel and Casino from the liquidator of the building. They sliced the carpet and made a starburst out of the shapes, which is now a permanent installation inside the upstairs Art Nest Wassaic Project workspace in the Maxon Mills building.

A stunning installation at the MassArt Art Museum (MAAM) in Boston in the lobby (2020–23), is made up of thirty years of exhibition catalogs from the museum. The Ghost duo cut, sliced and recombined a visual history of past museum exhibits into a memory kaleidoscope of color called *Yesterday Is Here.*

An ongoing project is housed at the original Penn Station below Madison Square Garden and is being curated and commissioned by Art Amtrak. Called *Aligned by the Sun*, its concept was developed during the pandemic. Lauren Was explained: "Everyone is connected to each other by the sun, even if separated by the COVID pandemic."

Holiday River, the artists' daughter, helping out in the studio. *Lauren Was and Adam Eckstrom.*

Ghost of a Dream asked one artist from each of the 195 United Nations countries, including Tibet and many indigenous nations, to submit a seven-minute video of the sun from their location. Stills from the videos can be viewed in full surround and are integrated with the departures and arrivals announcements. It is as if one were standing in the center of the world.

The couple is playful and include their young daughter Holiday in their activities. The six-year-old helps sort and even cut the pieces for the collages that they make out of discarded materials.

Was and Eckstrom moved to Wassaic because they wanted an affordable refuge from the high cost of the city. They say they are now part of a close-knit family of other artists, many with children, who think of the area as a supportive home base. They enjoy the beauty of nature, the access to trails and swimming. They also enjoy the intellectual stimulation of meeting so many other artists and curators. These trailblazers have inspired their friends and other artists to move to Wassaic as well.

A VICE video summarizes their work very well: https://www.youtube.com/watch?v=F6lQFT0IdV8.

WORK IN THE HARLEM VALLEY

For decades, the main employers in the Harlem Valley were three state institutions, the gravel mining and health care industries and schools. Most of the few remaining dairy farms have had to morph from purely milk producers into more diverse operations.

The dairy farms that were able to adapt and survive as dairy prices plummeted were small family farms. A number of these farms joined collaboratives, such as Hudson Valley Fresh, which buys milk and dairy products from eleven regional farms and distributes to schools, food banks and supermarkets. Some CSAs (community-supported agriculture farms) produce specialty dairy products, such as antibiotic-free milk, cheese, yogurt and ice cream. Organic vegetable, herb, flower and meat co-ops are also in the picture, often as CSAs offering shares of the harvest in season to consumers at a fixed price.

The Harlem Valley Psychiatric Center and the Wassaic Developmental Center (Taconic DDSO) employed multiple generations of area families practically from cradle to grave. The benefits paid to civil servants—60 percent of their salary after thirty-five or more years—were a significant draw, even though the work was tough and could result in physical injury. The institutions also provided perks, such as an annual circus, a bowling alley, a greenhouse and indoor and outdoor swimming pools that were open to staff members and vetted members of the local community. These state institutions provided thousands of jobs.

As public attitudes toward mental health care changed and new psychiatric drugs became available, the institutional model of care was no

longer seen as viable medically, socially or financially. In 1994, the Harlem Valley Psychiatric Center closed. The Wassaic Developmental Center campus finally followed almost two decades later. All former residents, now called consumers, are in group homes. As late as 2012, Mary Beth Pfeiffer of the *Poughkeepsie Journal* wrote, "In addition to its 518 institutional jobs [as of 2014], there are the 1,473 employees in 370 group homes, making the Taconic DDSO one of the largest employers in Dutchess County." (The acronym DDSO stands for Taconic Development Disabilities Service Office. The name was changed from Wassaic Developmental Center and Wassaic State School.)

Amenia Sand and Gravel was another of the area's major employers, established by John Segalla, and is still a going concern. Gravel mining was controversial because of its impact on the landscape, which left the land looking like a badly cut up birthday cake in some areas. Many of the applications to mine were contested by local residents, who formed a group called the Oblong Valley Association. It became the bane of local gravel mining concerns.

The health care industry was and is another big player in the area, with a local hospital just over the state border in Sharon, Connecticut, and a multiple-site community health care group that also serves undocumented seasonal workers on area farms. Four Black women initiated this network back in 1983, bringing health care to areas with little access. That effort has mushroomed into forty-three health care locations providing primary, dental, pediatric, OB-GYN and behavioral health care to over 245,000 patients annually. Private prep and public schools are the area's other major employers.

Transitioning to living in the Harlem Valley from the suburbs of New York City entailed finding work. Most of the jobs in the area—on farms or in state institutions, schools or hospitals—did not appeal to me. I knew I could never be an effective state worker. I also realized that in order to survive, many local people had to juggle two or three jobs.

I decided on a whim in my first year to apply for a job picking carrots at the newly inaugurated organic farm entity that later became McEnroe Farm, which, at that point, produced only compost and carrots. The job entailed first thinning the carrots and then pulling them and culling those that were split or damaged, cleaning them off and placing them into boxes in neat rows separated by thick paper. I had not realized that all carrots did not meet the standard for sale. I was given a long-tined pitchfork to loosen the soil first. It was hard work. I was paid eight dollars an hour.

I lasted three days. But I ended up with a nice big box of carrots that lasted us for the entire first winter. Ever since then, I have often been unimpressed by the organic carrots I see in supermarkets that have not been properly culled and are split on the sides. That was the beginning and the end of my foray into farming.

Realizing I would need to find work that I was better suited for, I applied to the local radio station, then WKZE, in Sharon, Connecticut, and was hired. I had worked at WOR-AM radio in New York City for a number of years as a producer for news and talk shows, and I knew how to put together an interesting program. The show I produced was called *Mid-Day Live*, hosted by Sean O'Brien, a veteran radio broadcaster with extensive news experience. The show aired five days a week at noon.

I started doing some investigative reporting in the area. Dumping toxic waste and illegally discarded construction materials had been a common phenomenon throughout the Harlem Valley. I found out that the New York State Office of Mental Retardation (OMRDD) had signed an under-the-table agreement with a disposal company called Remtech that allowed it to bring thousands of tons per week of red-bag waste to be incinerated in the big burn plant at the Wassaic campus. Astoundingly, no one from the institution had informed either the local residents or the town of the plan.

We blew the story wide open. I persuaded Hollis Shaw, then the director of what was called the state school, to be interviewed on our show about it. That was the beginning of my long career as an environmental advocate in the area. I was able to leverage my position in the media and, later, my job as the Housatonic Valley Association's Ten Mile River Watershed manager to help bring attention to and even help remediate threats to the environment.

I also started writing for *Dutchess* magazine and profiling artists in the area. My radio work led to job with a nonprofit known as May Peace Prevail on Earth International. That job took me around the world.

After five years of organizing peace festivals and ceremonies, I worked for half a year as the media specialist for Hudson River Sloop Clearwater, handling the media about PCB pollution in the Hudson River from General Electric's plants north of Albany at a time when the Hudson River was designated the second most endangered river in the nation.

Later, as the watershed manager for the Housatonic Valley Association, one of the oldest watershed protection groups in the nation, I reviewed, with my colleague Elaine LaBella more than twelve applications for development of the beautiful farmlands of the Harlem Valley. Very wealthy developers had cast their eyes on our area.

The State School for the Developmentally Disabled in Wassaic

Originally known as the State School for Mental Defectives when it opened in 1930—and still referred to by old-timers as the state school—the institution is now closed. At one time, it housed five thousand patients. The patients were once called clients but have been referred to as "consumers" since being moved into group homes in the community. There is still a satellite location of the Taconic DDSO (now labeled the Taconic Developmental Disabilities Services Office) at the old Wassaic campus, as well as another one on Route 22 in Wassaic, among others throughout the county.

During the heyday of the institutional period, buses were sent to southern states to recruit more workers. They were offered a job, a place to live and meals. After the 1958 Hungarian Revolution, dozens of Hungarians came to work at what was then just called Wassaic, and they later settled in the area.

My first contact with the state school came when I was a teenager attending Kent School, a prep school in the area. I volunteered with the school's Committee of the Concerned to visit patients in the institution, as

Taconic DDSO sign. *Carola Lott.*

well as at the Harlem Valley Psychiatric Center. It was the late 1960s, before the Willowbrook State School scandal had been fully exposed, graphically revealing acute overcrowding, neglect and a variety of serious abuses in the state's mental health institutions. We were exposed to only the highest-functioning patients. When I first moved to Wassaic, I had night terrors, imagining the trauma of the patients, some of whom had been put into the institution as early as the age of four.

I was shocked to hear that the town had not been informed by the state when dual-diagnosis—developmentally disabled and criminally indicted—people were brought to the institution. In October 2011, the institution's director at the time, John Mizerak, announced the closure of the facility to 530 campus employees. The facility still provided on-site services for 121 severely disabled and medically involved patients and 37 behaviorally dangerous "consumers" in secure local intensive treatment (LIT) facilities. The LIT population—"touched by the law," according to previous administrators, some with records of rape and child molestation—were to be moved to secure state DDSOs in Broome, Brooklyn and Franklin Counties.

Years after my Kent School volunteer experience, I interviewed Dianne Fitzpatrick (not her real name), then in her late sixties, who had started working at the state school in her twenties so she could have a decent retirement. When the facility moved from the brick buildings on the hill, everyone got shipped out to group homes, and not every "consumer" did well. Dianne remembered one woman for whom the institution had been home since she was four years old. When she was moved away from it, she could not handle the trauma and passed away soon after.

When Dianne worked "up on the hill" at the main campus, she had her own classroom teaching vocational rehabilitation. Her clients did piecework, learning how to sew and making paper bags and lining them. She said they loved it and felt that they were important because they had a job:

> I had a classroom of clients where all of them had been put into the institution at the age of four and five years old, but their families never came to see them. There were some girls who had been put in there in their teens because they were promiscuous, but there was nothing wrong with them and they were perfectly normal. But then they became institutionalized. Only one little boy had his family come. My little Mario would be miserable and was inconsolable after his family left.

Young patient at the Wassaic DDSO. *Rebecca Busselle.*

Dianne was also involved in getting the clients little jobs and doing community service, cleaning up parking lots, sweeping and picking up trash. I used to see them sweeping at the supermarket parking lot and raking leaves at the World Peace Sanctuary. Dianne said there had been a respite house at the Delavergne Hotel, what is now the site of the Four Brothers restaurant, where Eileen Strauss made them home-cooked meals. They loved her food, because the institutional food was so awful.

Dianne had older clients who did arts and crafts and made quilts by putting squares of cloth together. She and other staff members would reinforce their work on sewing machines.

She told me about James, an older gentleman who had been there when the institution had its own farm, bakery, garden and laundry. The institution

was totally self-sufficient then. James loved working with the animals on the farm, and he and other clients glowed when they talked about that. Then the state decided it was inhumane to have them work without pay. But Dianne said that for many of them, those were the happiest days of their lives. "Now, they use animals for therapy," she said. "Bureaucracy never catches up."

After Willowbrook was exposed nationally in 1972, everything changed. There had been huge wards with fifty people being taken care of by only four people. The working clients would have to give showers to the more helpless ones. In the old days before Willowbrook, Dianne said, they did not even bother to get the clients dressed. When Dianne worked up on hill after that, she said, it was down to ten clients in the front and fifteen in the back, taken care of by three people—and even that was not enough to handle the severely disabled.

Over the years, Dianne had her hair pulled out, and she was punched, spat at and bitten. She said that a lot of aides were injured, with hurt knees and back injuries from lifting and lugging clients to change their diapers. "I had my finger bitten and could not feel anything for a month."

She described one client who was extremely destructive and who would destroy the walls. Another would swallow cigarette butts and metal, the result of what was called a pica disorder. "One fellow was so bright, the minute you took your eyes off of him, he would scuttle off and find cigarette butts in garbage cans. If he was missing, all we would do was look for the cigarette cans, and there he was."

Another patient, Angel, had microcephaly, and she could not walk. She was finally able to take a few steps and eventually walk after a physical therapist worked with her for years. "She was so happy and proud of herself because one person helped her become more independent. But you could not give all the clients that kind of one-on-one attention back in the day."

She continued, "I worked with them all. Hi-active behaviors where we had to take them down to the ground. It used to be facedown with arms crossed in front, and you could lay across them. Then that was found to be dangerous. Only certain clients could be taken down. You just went with what you had to do....You could only hold them down for ten minutes at a time. If someone was upset and sitting in a chair, you would come up around them and give them a hug from behind."

Dianne described how some of the staff would just walk the clients around in circles and not do anything more than what they were told to do. If she had those people working with her, she knew she would not have backup

Group home resident in Wassaic. *Carola Lott.*

that day. But some of her colleagues were wonderful and worked as a team. "Some of the clients you could really fall in love with, and some of the staff brought them home for holidays—but then they did not want to have to go back on the hill."

She said:

> You would get warnings about which clients were going to go off that day. Some staff could react really quickly. I lucked out and mostly had good people to work with. But there was some sexual abuse, mostly at night, and of course, those people were put out and fired....
>
> I was glad I came in after Willowbrook. Many changes happened then. Some people from Willowbrook were moved up here, and we had to make sure that the paperwork was in order because we would be checked on. You could tell which patients were from Willowbrook; the ones we got from there were very severely disabled. After Willowbrook, things got tighter; we had to get them up, get them dressed, give them breakfast, move them to a room, do arts and crafts or watch a movie.

There were circuses with elephants and animals and clowns that came to the facility. "[The clients] had ice cream socials, the recreation department did events for them to be able to toss a ball and get it into a basket—and of course, food. Because what else did they have? Parties and birthdays were it."

Dianne said that some people liked working at Harlem Valley State Hospital (later the Harlem Valley Psychiatric Center) better than working at Wassaic. She thought that Wassaic "was much cozier; the psych center buildings were cold, scary and unfriendly." Nevertheless, "we were all in the same civil service union (CSEA). The union was there, and the union was strong; if you had problems, the union was there. After they moved into the group homes, the CSEA did not advocate for us as much and got lax."

Over the years, staff tried to make the institution homier by hanging pictures on the walls and installing small kitchenettes. Then the administration started emptying the buildings and moving the clients out. They outfitted houses as group homes with Hoyer lifts that could run all the way along the ceiling from the bedrooms to the bathroom so clients could be bathed and showered.

The shift to group homes did not end abuses. Dianne told me about one couple who kept the clients in an aluminum shed, only bringing them in when the state "checkers" showed up. "They kept the disabled clients there night and day, cold or hot. They had chairs outside. It was not heated. We wondered if the caseworkers knew about it. Some clients escaped."

Dianne was only one of thousands of workers employed at the DDSO. She developed a severe nerve disease after years of being shunted around from one group home to another. She was demoted after falling asleep at night on a ward, and she had numerous car accidents as a result of falling asleep at the wheel. She is typical of many who dedicated their lives to taking care of the severely disabled people at the Wassaic State School.

IAN HOLBACK: A NEW BREED OF GRAVEL MINER

Millbrook Independent, February 17, 2013

Amenia used to be known as the gravel mining capital of Dutchess County. Some of the past operations have not had the best reputation. There have been lawsuits, and local citizens' groups were formed over the years to oppose the abuses of the mining industry in the area.

The Town of Amenia has taken an environmentally sensitive approach to mining in its recent comprehensive plan, which now requires that all mining operations be in the soil mining overlay district. Mining applications need to include an application for special use permits and must also comply with stringent Department of Environmental Conservation (DEC) reclamation plans, which have only been required since the state DEC first opened a mining reclamation department in 1977.

One mining operation, owned by Dominick Peburn of New Milford, Connecticut, sold over $600,000 of gravel in the late nineties to the Metropolitan Transportation Authority to build the Wassaic Metro-North train station. It left behind just enough gravel to claim it was not finished and has now declared bankruptcy. The area has still not been reclaimed fifteen years later.

It's no wonder that the town now has some of the strictest ordinances in the area regarding mining operations.

In the years prior to this book's publication, a new face has emerged on the gravel mining scene in Amenia. This man has done everything possible to comply with the Amenia master plan. His name is Ian Holback.

"Ian Holback has demonstrated that he loves the land, and he leaves it far better than he found it," explained Allan Shope, the architect who lives near the Taconic DDSO. "He understands riparian zones, habitat, gets the long-term plan and does not want areas that he mines to look like a wasteland."

Shope sold 143 acres across from the DDSO to Holback. He succeeded in getting the parcel rezoned by the town to be part of the soil mining overlay district. Holback has planted three thousand trees on the former Shope property. He put together a plan to cap a small ash dump on the property that was created by the Taconic DDSO and obtained a permit for the DEC to cap it. He also bought the 150-acre Harlem Valley Materials mine from Tony Cahill, as well as a 200-acre mined area that was part of the former Amenia Sand and Gravel. "My goal is to reclaim the Cahill property little by little and do it the right way," Holback said.

There are three operating mines totaling 496 acres surrounding the Allan Shope property, all of which Holback now owns and all of which are in the soil mining overlay district. He has thirteen people on staff and supplies gravel to Litchfield, Putnam, Dutchess and Westchester Counties.

Holback's history is interesting. He started out with a construction and excavation company in Wingdale. He reclaimed a one-hundred-acre marble quarry that had provided the marble for the construction of the U.S. House of Representatives. He said,

It was a heavily mined piece of property, last mined in 1977. It was called the South Dover Marble Corporation. They pulled out before the DEC required mining reclamation. It was a very rough piece of property to say the least....

I liked the challenge of turning it into a beautiful piece of property. I hauled in thousands of yards of topsoil and did a tremendous amount of site work to turn an abandoned mine back into agriculture. It is now a working farm and my home. That is my hobby and my passion.

Since Holback arrived in Amenia, he has been a warm and generous presence, attending church suppers and offering to improve fishing access areas. His business partner is Robert Trump, Donald Trump's brother. (Robert Trump died in August 2020.)

"If all goes well and the DEC approves my application, I will be able to mine on the former Shope land this spring," Holback declared. The proceeds from mining the Shope land will be reinvested into mining and reclamation on all the other properties Holback owns in Amenia. His "goal

Ian Holback at the Harlem Valley Materials Mine in Wassaic. *Tonia Shoumatoff.*

Ian Holback and the author at the quarry that provided the marble for the construction of the U.S. House of Representatives. *Oresta Szeparowycz.*

is to eventually have four beautiful farms there, and you'll have a tough time noticing they were mined."

The New York State DEC has a lot of reclamation requirements for the Shope property. Holback is planning to mine only five acres at a time and reclaim them as he goes. "I like to say the grass follows me," he said.

"The old way of mining left a big footprint. You don't need to leave such a big footprint if you clean up as you go along," Holback said. "I like to take a distressed piece of property and turn it into a masterpiece."

"Ian Holback is in the business of selling gravel, but he does it responsibly and according to the Amenia master plan," said Allan Shope. "Ian's approach is entirely different from [that of] most gravel miners. He likes to conceal his work from roads and to protect rivers. He believes that he treats the land with respect and wants it to be better than he found it."

HOW TO GET A LANDFILL CLEANED UP...IN AMENIA

Millbrook Independent, stories from 2011–2013, compiled

The long saga of the Amenia landfill cleanup is finally coming to a close. It started out as an ugly tale of the illegal dumping of hazardous waste by hazmat drivers, mostly from New Jersey, in the middle of the night. It happened in towns up and down Route 22, sometimes with the cooperation of landowners and highway departments, from the late 1960s to the early 1970s. Semitrucks lined up on Route 22 at 2:00 a.m. to dump barrels of evil-smelling red fluids at Amenia's landfill.

PCBs (carcinogenic chemicals called polychlorinated biphenyls) were identified in the old Amenia landfill after inspections by state and county agencies. The town was informed by the New York State Department of Environmental Conservation (DEC) in a 1992 letter that the pollutants were a "serious threat to human health and the environment." In addition to PCBs, lead, mercury, arsenic, copper, zinc and many other noxious and hazardous materials were found in the sediment from years of illegal dumping going back to the late 1940s.

Assemblyman Maurice Hinchey had been investigating the dumping of hazardous waste throughout Dutchess County as well as along the Route 22 corridor, and he had unearthed a major connection between the Gambino crime family and dumping in Dutchess County. The *Poughkeepsie Journal* had been covering the story.

In 1997, when this reporter was head of the Amenia Conservation Advisory Council and a volunteer for the Harlem Valley Aquifer Study run by hydrologist Russell Urban-Mead, I had access to files and folders in the Amenia town supervisor's office. There, I found the 1992 letter from the New York State DEC informing the town about the contaminated site. Then-supervisor Ralph Vinchiarello had not responded. Five years later, the situation had not been reported to the public. I brought the situation to the attention of Assemblyman Hinchey and the *Poughkeepsie Journal.*

It became front-page news. Assemblyman Hinchey thought there was a connection between what he had uncovered in his investigation and the dumping in Amenia. He came to Amenia with an armed bodyguard for a secret meeting with town officials. Federal (FBI and EPA) and state investigators later arrived and began the slow process of identifying PRPs—potentially responsible parties—for the dumping. The Amenia landfill was declared a superfund site. With the resultant publicity, the Amenia landfill

jumped from number 100 to number 1 on the list of New York State superfund cleanup sites. Soon, the FBI was all over town, talking to people about the illegal dumping of hazardous waste.

That is what started the town on the long road to remediating the site.

The twenty-eight-acre parcel had belonged to Salvatore "Ben" Surico and later John Segalla. It adjoins the Harlem Valley landfill (where the body of a prison guard was found in the 1980s). After Segalla defaulted on his taxes, the county took over the property, and eventually, the town purchased it for $40,000.

Janet Reagon, the town supervisor at the time of the investigation, led the long process of dealing with state officials, attorneys and engineers. She authorized the attorney for the town, Kimberlea Rea, to negotiate with the PRPs, among them corporations such as IBM, Pitney Bowes, British Petroleum, Union Carbide, Ashland Chemicals, Curtiss-Wright, Syngenta and several pharmaceutical companies. Sharon Hospital, the Town of Sharon and the Town of Westport were also identified as PRPs. A total of twenty PRPs were identified.

Kimberlea Rea persuaded eight of the PRPs to avert court proceedings, hire a joint attorney and contribute their fair share, putting the money into a fund to pay for the remediation engineering. The entities that settled agreed to pay $1 million of the remediation cost. "It is very unusual that we did not have to fight [the companies] over this," Rea said. "And it is quite unique that the companies are sharing the bill to help clean up the site."

The actual cleanup began in March 2012, twenty years after the town was informed that the PCBs had been detected in the landfill.

The remedial construction work was performed by Sevenson Environmental Services, a firm from Niagara Falls, and was supervised by the New York State DEC, as well as C.T. Male Associates of Latham, New York, the engineering firm under contract with the Town of Amenia.

Approximately 830 tons of hazardous, PCB-contaminated soils were removed and disposed of at a DEC-permitted hazardous waste landfill in Model City, New York. Another 5,800 cubic yards of PCB- and heavy metal–contaminated sediment were dredged from the wetland (West Pond) adjacent to the former landfill, dried and placed on the surface of the landfill to be capped. Slopes were regraded in preparation to receive the landfill cap.

According to engineer Liz Rovers of C.T. Male:

The cap, a geo-membrane with a non-woven filter fabric, has been placed on top of the landfill. Then there is a gas-venting layer with two gas-venting

vertical PVC pipes providing an outlet through the cap for the methane gas that is generated from the landfill waste. The gas-venting layer, liner, drainage layer and sand barrier layer all together are more than two feet thick. They have been installed over approximately six acres of the landfill. Finally, the cap is topped with a topsoil and vegetative cover layer seeded with a wildflower-grass seed mix.

By November 2013—and five supervisors later—the cleanup, capping and closure of the landfill were nearing completion. The trucks and heavy machinery had left. All that remained to be done was the seeding and landscaping. C.T. Male Associates, the consulting engineers, issued a report to the town, stating, "The wetlands have been restored." The report also noted that "up to seventy-five construction workers and professionals worked on the project during the remedial construction."

The Town of Amenia plans to open the site as a twenty-seven-acre park. The plans call for hiking paths around the property and along the pond. Additional walking paths are to be cut through the wildflower meadow once it is established. A small parking area has been constructed. The town will name the site for the founder of Amenia, Thomas Young.

The Town of Sharon, Connecticut, one of the responsible parties, is also responsible for the cost of maintaining the landfill park. The agreement with the New York State DEC calls for long-term monitoring and inspections to ensure that the integrity of the landfill cap is intact and that no hazardous chemicals are leaking into the nearby pond or wetlands.

The final cost of remediation, once estimated at $12 million, came to $7.6 million. The town's share was approximately $2.15 million but was reduced by the state to $1.07 million.

Former supervisor Janet Reagon had this to say: "I am very pleased that the long process of cleaning up this hazardous waste site is reaching a conclusion. I hope that the town will make every effort and find appropriate the necessary funds to make it into a beautiful public park that residents and visitors can enjoy year-round." Two other supervisors, Bill Flood and Victoria Perotti, worked with the firms and agencies in finalizing the cleanup.

STEWARDING THE WATERSHED:
TAKING IN THE STREAM...IN A COOL RAVINE

Millbrook Independent, May 10, 2012

I get to walk in streams as part of my job. I am privileged to be able to see some of the most remote and pristine parts of eastern Dutchess County and make sure they stay that way. The Housatonic Valley Association (HVA), where I serve as the Ten Mile River Watershed manager, was started in 1941. It is one of the oldest watershed protection groups in the country.

One early morning, I went out into the Mill Brook Stream, which flows from Sharon, Connecticut, into South Amenia. Dave Reagon of the Amenia Conservation Advisory Council and Henry Perkins, a twenty-one-year-old college student from Mobile, Alabama, who recently assessed damage from the oil spill along the Gulf Coast, joined me. Henry was staying at the Occupy community in Wassaic.

We hiked down into the beautiful woodland creek at the bottom of what is called a cool ravine near Smith Road, a remote dirt road off Route 4 near Sharon Audubon. We were immediately immersed in an alternate world of step pools with water gurgling over boulders, mossy glades, skunk cabbage, jack-in-the-pulpit, hemlock and thirty-foot-high banks. We had clipboards and forms to take notes for the National Resource Conservation Service (NRCS). This stream had never been officially assessed before. The assessment of this obscure tributary was part of a stream study initiated by members of St. Thomas Episcopal Church in Amenia Union in 2011 and carried out by the HVA.

As we progressed up the stream, Henry, who has done archaeological work on a Native mound in Alabama, picked up pieces of metal gridwork that were quite obviously part of the significant mill industry in the area. Sure enough, as we continued, we saw remnants of an old mill operation, with a small waterfall cascading over a thirty-foot-high stone dam and a brick sluiceway on the side that was covered with moss but provided a nice little alleyway next to the stream. Dave found a blue and white piece of antique pottery.

We subsequently found out from Amenia historian Ann Linden and Sharon historian Ed Kirby that this stream along Smith Road powered a gristmill that was built in 1746 by Theophilus Smith. The mill was part of the Mudge Mill on East Street and was part of the eastern flow of the stream that created Hatch Pond. In the 1880s, this became part of the newly

The author taking notes while assessing a stream for the National Resources Conservation Service. *Dave Reagon.*

formed Sharon Water Company. By 1928, there were three reservoirs, including Beardsley Pond, which is still in use as part of the public water supply for Sharon, Connecticut, a town that borders Amenia, New York.

I had been hearing loud staccato drumming on trees in Macedonia Brook State Park and a strange loon-like call for several weeks on my daily walk on the old Civilian Conservation Corps (CCC) road that goes through the park, but I had not recognized the source as a pileated woodpecker. It was not until I traipsed through this obscure tributary called the Mill Brook that I got an opportunity to see a quick flash of its red head and sleek black body—it is an extraordinarily impressive and large woodland bird that can grow up to nineteen inches in length—streaking from tree to tree.

Henry also spotted a live specimen of the orange wood frog with thin yellow streaks behind its ears. The coloration makes a perfect camouflage among the rust-colored leaves. It was quite thrilling to make out the form of this strange frog hidden in the leaves.

The water quality was pristine, and there were virtually no impacts on the stream. Walking through cobble and hopping over boulders among

a colorful variety of rocks, we saw some that really stood out, with red rusty striations, green limestone, granite and some quartz. Dave Reagon, an Earth Science teacher at Webutuck High School, explained that as the ice sheet melted, it left a blanket of material called glacial till that was transported into the stream. The large rocks, called erratics, that look like they stopped still in the middle of nowhere were part of something called the terminal moraine, according to Reagon. When asked why they stopped, Reagon said, "They are still on the move. Human time is nothing compared to geological time."

By the end of the walk, I felt rejuvenated by the refreshing beauty of the stream and am grateful to have been able to see it. Maybe we will all remember to say, "Thank you, streams," next time we turn on the tap and assume that clean water will come out. Since our forebears obviously valued the power of water for small industries and valued land where water existed, maybe we can become more mindful of our water supplies as well and work harder to appreciate and preserve our watersheds.

How Four Women of Color Changed the Face of Health Care in the Hudson Valley

Millbrook Independent, December 20, 2009

Health care is a right and not a privilege. When you talk about healthy communities and healthy families, you need access to primary and preventive services for the most underserved and the most vulnerable. Many times, people see the underprivileged as less than. Health services should be provided with the proper dignity and respect for all people. And indeed, we can all be classified as vulnerable.
—*Reverend Jeannette J. Phillips, founding mother, executive vice-president, Hudson River Health Care*

Hudson River Health Care (HRHC, now Sun River Health), a network of primary care health centers located in some of the most underserved and low-income areas of the Hudson Valley, provides affordable and humane health services for people throughout the Harlem Valley as well. The story of how this organization came about exemplifies the ways in which community advocates can catalyze change.

In 1971, Mary Woods, who became one of the "founding mothers" of HRHC, had to change buses four times and travel with her large brood of children for more than two hours from Peekskill to Valhalla to get health care, because Grasslands Hospital in Valhalla was the only place in the area where care for the indigent was provided. The complicated series of bus transfers took so long that she missed her connecting bus on the way home, and her kids were left stranded, crying and hungry in the middle of Ossining.

The next day, Woods was talking about her ordeal to some friends around her kitchen table. She told them that this did not make sense and that there should be health care for the underprivileged in their own community, in Peekskill. The executive director of her local Community Action Program told her that she would have to conduct a needs assessment survey. Woods and her friends went door to door and found out that health care, housing and education were indeed the biggest needs in their area.

They called a community meeting at the United Methodist Church on Main Street in Peekskill. More than two hundred people showed up—people from local churches, synagogues and charities, as well as poor families. Willie Mae Jackson, another of the founding mothers and herself a mother of twelve, spoke eloquently about the concerns of the people. Her story moved Dr. Phyllis Koteen, the commissioner of health of Westchester County and the director of the Medical College of Grasslands, to help the founding mothers write a grant proposal for a regional medical program. They received $285,000 in startup funding.

Reverend Jeannette Phillips explained that after they got their grant, President Richard Nixon rescinded and impounded all discretionary domestic grant funding, and the group filed a class action suit. They also marched on Washington, D.C., as part of the National Mobilization Day. They got their funding back.

In 1975, the four founding mothers were finally able to open the doors of what was then called the Peekskill Ambulatory Health Care Center, with a staff of twelve serving all the needy families in the community in what was formerly the Big Scot Department Store on Main Street. They were able to get in-kind services from the Westchester County Health Department, Hudson Valley Mental Health and Coordinated Human Services and soon were offering complete primary care and family planning services.

Their health care center in Peekskill became part of a network with three other community centers, Mount Vernon and Greenburgh Neighborhood Health Centers and Ossining Open Door, in order to receive federal funding. Soon, they were designated as having their own unique "medically

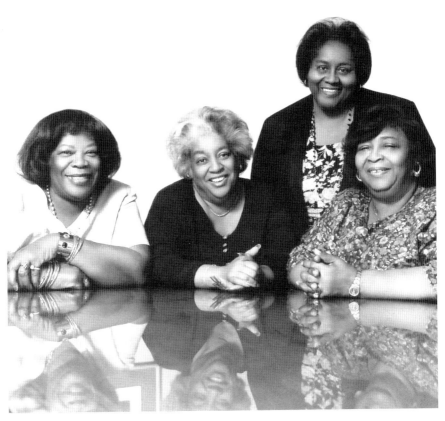

Founding mothers of Hudson River Health Care: Willie Mae Jackson, Pearl Woods, Reverend Jeannette J. Phillips and Mary Woods. *Joanne Giganti.*

undisturbed area" (a federal category for medically fundable areas) and were able to get federal funding on their own.

In the mid-eighties, they expanded into Beacon, in Dutchess County. The emergency room at St. Francis Hospital in Poughkeepsie had closed, and many people who had depended on the emergency room for episodic primary care were left with no health care. The New York State commissioner of health asked the group to discuss the possibility of opening a health care center in Beacon. Their meeting was held at the African Methodist Episcopal Zion Church (AME Zion), where founding mother Jeannette Phillips served as a newly ordained minister with her husband. Jeannette was also the first chairman of what became Hudson River Health Care. She is now the last surviving founding mother, and she is still an executive vice-president of the health care center.

The certificate to operate in Beacon enabled them to open two more sites in Poughkeepsie at Hamilton Avenue Family Partnership and St. Francis Hospital. They were asked to facilitate and expand an existing Dutchess County migrant farm worker health care program. Over the next few years, they expanded into sixteen primary care facilities on both sides of the Hudson River and in Westchester. So, what started with four Black women sitting around a kitchen table has now had a major effect on the region.

Meanwhile, in the Harlem Valley in Amenia, a group practice called Foothills Family Practice was organized in 1990 with three doctors: Dr. Robert Dweck, Dr. William Elman and Dr. Anna Timell. The practice was losing money, because it was serving so many poor people in the Harlem Valley. Medicaid would reimburse only twelve dollars a visit. By 1996, it was clear the practice could not effectively continue to offer services to the underprivileged of the area without more financial help. Sharon Hospital was immersed in red ink as well and could no longer afford to give the practice support. The hospital was being acquired by a for-profit health care company called Essent, which subsequently changed its financial structure. (The hospital is now owned by Nuvance.)

The family practice, the only primary care provider covering the impoverished in Dover Plains and Amenia in that part of the Harlem Valley, was relieved when Hudson River Health Care offered their umbrella to operate under. The practice knew this would help them better serve their underprivileged patient population. Private donors, as well as the Berkshire Taconic Foundation, helped tide over the center until HRHC could start raising funds.

The HRHC Amenia group felt strongly about advocating for outreach, preventive medicine, diet, childhood nutrition, exercise and lifestyle changes to enable the underprivileged to take more responsibility for their health. They formulated a mission statement: "To increase access to comprehensive and preventive health care and to improve the health of our community, especially the underserved and vulnerable." By 2009, they had over fourteen thousand patients at three sites, including those in Pine Plains and Dover Plains. In addition to primary care, they offer podiatry, mental health services, dentistry and gynecological, prenatal and family planning services. In 2008, they had thirty thousand patient visits. About 25 percent of their patients are uninsured.

A growing number of Latinos have been moving into the region. Some of the HRHC Amenia patient advocates and staff found community funding sources to help people to navigate the medical system. HRHC in Amenia

hired several staff members who spoke Spanish. The Latino patient group now represents 30 percent of HRHC's patient population, according to Amenia HRHC's patient navigator for Latino outreach Ed Frederick. The nurse practitioner who saw many of the Latino patients was Louise Lindenmeyr (now retired), who has offered free medical services in third-world countries, particularly Haiti. Both of them are deeply committed to their patients.

Mr. Frederick explained, "We got grants for the five towns of the Harlem Valley from United Way, Planned Partnership and the Eastern Duchess Rural Health Network to train Hispanic patient advocates called 'promotores' to go into their own communities and provide health education." The program started a nonprofit called Somos la Llave del Futuro ('Key to the Future') that enabled the undocumented to get vaccinations and was seeded by HRHC Amenia staff."

"It is very difficult to disseminate information into this community," said Louise Lindenmeyr, "because there is a lot of mistrust about being in the system, since so many people are 'illegals.' They are afraid they will be reported if they are undocumented. So, we provide basic services like family planning education and screening services in their homes."

Ed Frederick added:

> A big part of my job with HRHC Amenia is to get people rides. The most important way we help these people is with interpretive services—we make appointments for them with specialists, drive them to the hospital when needed, because we have a van. Sometimes, we even have to drive them as far as Kingston, Albany and Hartford. [But] nobody gets special treatment here. When people come in here and do not have insurance, it goes by their income in a sliding scale. We help all people fill out applications.
>
> We also inform people about home heating, social services, food pantries and our dental van. The majority of our patients are low income. We help people in the indigent program get reduced fees for lab testing.
>
> It's a medical home for people, a family and a family practice in the real sense of the word. We also help negotiate deals with the farmers to pay some of the bill because they really depend on these workers on horse farms, dairy farms, apple orchards and vegetable farms. A lot of these people are working six or seven days a week, ten to twelve hours a day, doing back-breaking work.

Louise concurred: "One guy milks 320 cows two times a day with another worker. One of our 'promotores' from Guatamala got kicked in the head by

a horse on a horse farm and can no longer do physical work." She donated a car to him, "and now he gets by giving other members of the Hispanic community rides. The whole idea was to help them organize themselves to give help to one another, and now, that is happening."

In 2018, Hudson River Health Care merged with Brightpoint Health to form a health care network with forty-three federally qualified health centers (FQHCs) "better positioned to meet the needs of underserved communities across the Hudson Valley, New York City and Long Island." The new entity was rebranded as Sun River Health in 2020. Reverend Jeannette J. Phillips remains as founding board chair and executive vice-president of community development of Sun River Health.

The Last Dairy Farm in Amenia: Coon Brothers Farm

The Coon family has a formula for succeeding in the dairy business: they love what they do. And their children are following in their footsteps. With 310 cows milked daily and 320 calves born per year, the work is quite a handful. They employ six people full time and four part time, and four family members work in the business. Year after year, they win prizes and ribbons in multiple classes at the Dutchess County Fair. Now, the fourth generation of kids, five children aged three and a half to twelve, show and dote over their cows at the Dutchess County Fair.

Every other day, two huge tanks on a tractor trailer haul seven thousand gallons of Coon Brothers Farm milk to the Hudson Valley Fresh plant in Kingston. The farm is part of the Hudson Valley Fresh and Cabot Creamery cooperatives, which enables it to get top dollar for its milk. At the moment, it's getting twenty-seven dollars per hundred-weight (equivalent to 112 pounds). Hudson Valley Fresh, founded in 2005, produces top-notch dairy products, including milk, cream and yogurt, from the milk it collects. And customers are willing to pay a bit more because of the quality, knowing they are supporting local farms.

The farm is doing well and has not lost money since joining the cooperatives. It helps that the Coons get the New York State agricultural tax write-off. The Dutchess Land Conservancy helped them put some land into conservancy.

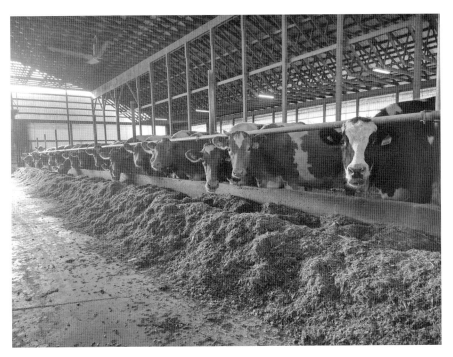

Coon Brothers Farm cows. *Jessica Coon.*

The Coons own 200 acres and lease another 1,800 to graze their heifers in the summer and fall, and they produce their own feed. They grow alfalfa, corn and soybeans, which are ground up into sileage. They have both Guernseys and Holsteins. Third-generation farmer Isaac Coon explained that the Guernseys are friendlier and more docile and have a higher fat content in their milk. All the calves get named by the children. The vet comes twice a month to check on all the cows.

When asked why he and his brother decided to stay in the dairy business, Isaac said, "We love cows, and we like doing the work."

And it is a labor of love. It shows in the quality of the milk and the happiness quotient of the kids and the cows.

Epilogue

NEW FARMING ENTITIES EMERGE

*A*s I draw this modest history to a close, the reader may wonder why I have focused so closely on one particular area of the Harlem Valley when other towns in the valley have equally fascinating stories. Pawling, for example, boasts pioneering broadcasting explorer Lowell Thomas, as well as the father of positive thinking, Norman Vincent Peale. Their stories are already well known but warrant telling in another regional history book to do them justice.

Lewis Mumford reflected on the importance of local history in a paper he presented at Troutbeck in 1926 that was published in the 1927 yearbook of the Dutchess County Historical Society:

> *The historian could reconstruct a large part of the history of the whole country, with no more than the existing names, places, houses, legends and histories that have to do with so small a part of Dutchess County as the Amenia Township. Local history implies the history of larger communities....Just as the story of each person's life would make at least one novel, so the story of any community's life would make at least one history.*

The demise of the family farms and of the huge dairy and iron ore industries and the closing of the state hospitals in the Harlem Valley—all of them once-dominant local employers—are perhaps indicative of a larger story happening around the state and even the country. What is broken in agriculture is not just broken here. Farms are struggling throughout the country.

Since I started this book talking about farms, it behooves me to end the book with an update. Even though the Harlem Valley is no longer "Milk Valley," somehow, the gap is being filled by smaller businesses and creative enterprises that reflect the changing times. These entities have attracted a younger generation and brought new life to the area, changing the equation with multiple CSAs (community-supported agriculture farms) and colorful creatures, such as alpacas, llamas and emus, as well as less-common species of more traditional farm animals, such as sheep and goats. Cheese and soap making and flower and herb farms are flourishing, as are orchards and vineyards, with on-site production, tours and apple- and berry-picking. New wineries and artisanal beer breweries and distilleries have appeared in the area. In the town of Dover, just south of Amenia, Madava Farms—"stewards of the trees"—produces pure maple syrup and sells products under the Crown Maple name. All of these are replacing the more labor-intensive grain farming and haymaking related to the dairy industry. Locally sourced vegetables, fruits and meats are now what appeal more to the restaurant industry and the tastes of customers, and they are therefore in vogue. Some of the area's many artists are producing fiber art, dyeing their own yarns and felts and sharing their enthusiasm with others by offering classes.

The dairy entities that have survived best have joined cooperatives, such as Hudson Valley Fresh, or have branched out into the production of gourmet cheeses, yogurt drinks, crème fraîche and other items. The success of these ventures has helped some surviving family farms provide a hormone-free alternative to mass-produced milk. One-third of the milk products made by Hudson Valley Fresh are sold to places like Whole Foods and markets in Westchester and Manhattan. Nearby Ronnybrook Farm Dairy produces non-homogenized milk in glass bottles with a lip for the cream, and it is thriving despite having to charge a higher price for its products. Raw milk producers, strictly inspected monthly, have also found customers. All of these surviving local farms have figured out how to do something different, and it is working.

BIBLIOGRAPHY

Arinori, Mori. *Mori Arinori's Life and Resources in America.* Edited by John E. Van Sant. Lanham, MD: Lexington Books, 2004.

Benham, Stanley. *Rural Life in the Hudson River Valley.* Poughkeepsie, NY: Hudson Books, 2005.

Casey, Bart. *The Double Life of Laurence Oliphant, Victorian Pilgrim and Prophet.* New York: Post Hill Press, 2015.

Cuthbert, Arthur A. *The Life and World-Work of Thomas Lake Harris, Written from Direct Personal Knowledge.* First printed in 1909. Reprint, New York: AMS Press, 1975.

Du Bois, W.E.B. *Amenia Conference: An Historic Negro Gathering.* Amenia, NY: Troutbeck Press, 1925. (Troutbeck leaflet no. 8.)

Foreman, John. *Old Houses in Millbrook.* Millbrook, NY: Stephen Kaye, 2012.

Goi Masahisa. *The Future of Mankind.* Chiba, Japan: Byakko Press, 1985.

Kaplan, Carla. *Miss Anne in Harlem: The White Women of the Black Renaissance.* New York: HarperCollins, 2013.

Lewis, Candace J., ed. *Women of Dutchess County, New York: Voices and Talents, Part I.* Dutchess County Historical Society Yearbook 99. Poughkeepsie, NY: Dutchess County Historical Society, 2020.

———. *Women of Dutchess County, New York: Voices and Talents, Part II.* Dutchess County Historical Society Yearbook 100. Poughkeepsie, NY: Dutchess County Historical Society, 2021.

Mills, Stephanie. *On Gandhi's Path: Bob Swann's Work for Peace and Community Economics.* Gabriola Island, BC: New Society Publishers, 2010.

Reed, Newton. *Early History of Amenia with Impressions of Amenia by Dewey Barry.* 5th ed. Rhinebeck, NY: Epigraph Books, 2012.

Renehan, Edward J., Jr. *John Burroughs, An American Naturalist.* Post Mills, VT: Chelsea Green, 1992.

Saionji Masami. *The Essentials of Divine Breathing.* Columbia, SC: Goi Peace Foundation, 2017.

Schneider, Herbert W., and George Lawton. *A Prophet and a Pilgrim, Being the Incredible History of Thomas Lake Harris and Laurence Oliphant; Their Sexual Mysticisms and Utopian Communities. Amply Documented to Confound the Skeptic.* First printed in 1942. Reprint, New York: AMS Press, 1970.

Smith, DeCost. *Indian Experiences.* Caldwell, ID: Caxton Printers, 1943.

———. *Martyrs of the Oblong and the Little Nine.* Caldwell, ID: Caxton Printers, 1948.

ABOUT THE AUTHOR

*T*onia Shoumatoff is a writer, producer and media commentator with a longtime professional commitment to environmental protection. She has lived in the Harlem Valley since 1987. She hosted her own radio program, *Planet Blue*, on Vassar College's WVKR. Her work as senior reporter for the *Millbrook Independent* newspaper gave her a unique perspective on local affairs and the area's rich history.

As the Ten Mile River Watershed manager for the Housatonic Valley Association, Shoumatoff monitored the watershed and reviewed Harlem Valley development proposals, encouraging low-impact development and stream protection.

Shoumatoff helped promote worldwide peace activities as a staff member of a United Nations–affiliated NGO, May Peace Prevail on Earth, International. Over several decades, she helped dedicate a number of peace schools in Ukraine, including one proposed to be built on land that formerly belonged to her family.

Visit us at
www.historypress.com